S0-AAZ-295

THE ART OF
PHOTOGRAPHIC
LIGHTING

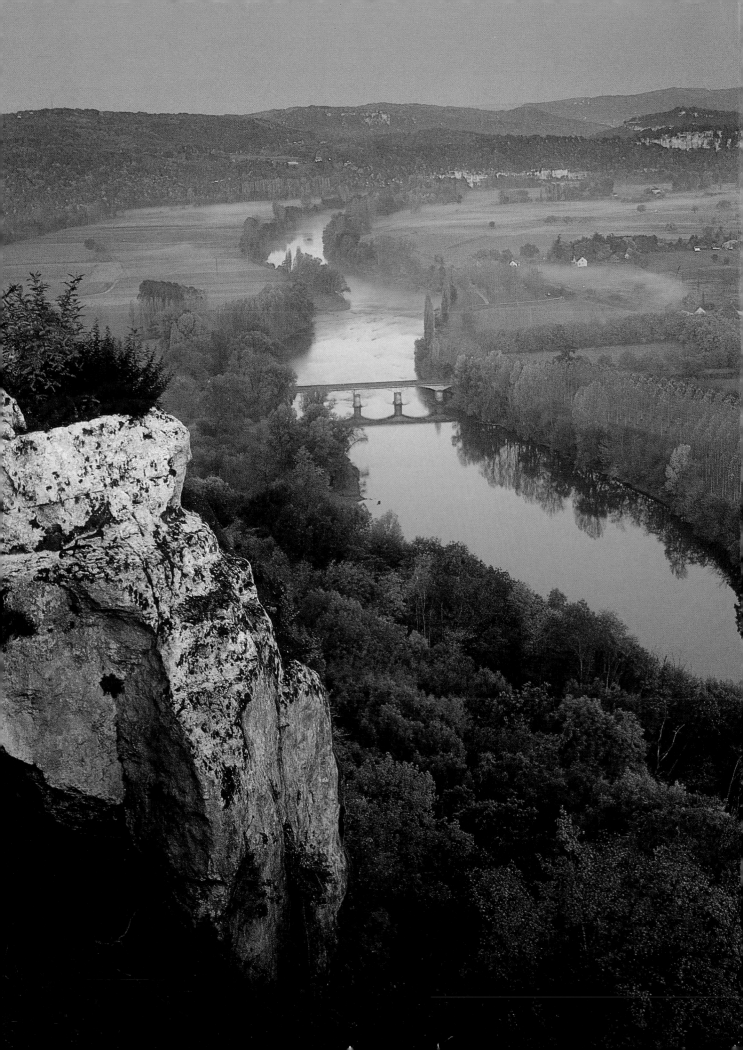

THE ART OF
PHOTOGRAPHIC
LIGHTING

MICHAEL BUSSELLE

David & Charles

A DAVID & CHARLES BOOK

Copyright © text and photographs: Michael Busselle 1993

Copyright © photographs on pages 98-99, 103, 116: Simon Wheeler

First published 1993
Reprinted 1994, 1995

Michael Busselle has asserted his right to be identified as author of this work in accordance with the Copyright, Designs and Patents Act 1988.

All rights reserved. No part of this publication may be reproduced, stored in a retrieval system or transmitted, in any form or by any means, electronic or mechanical, by photocopying, recording or otherwise, without prior permission in writing from the publisher.

A catalogue record for this book is available from the British Library.

ISBN 0 7153 9805 9 (Hardback)
ISBN 0 7153 0282 5 (Paperback)

Typeset and designed by Les Dominey Design Company
and printed in Singapore by Saik Wah Press PTE Ltd
for David & Charles
Brunel House Newton Abbot Devon

Previous page This view of the River Dordogne is from the village of Domme. Photographed a few minutes after sunrise I used a Mamiya 645 with a 50mm lens fitted with a neutral graduated filter to retain colour in the sky. The film was Fuji's ISO 50 film and the exposure was bracketed around 1/8 sec at f11

Contents

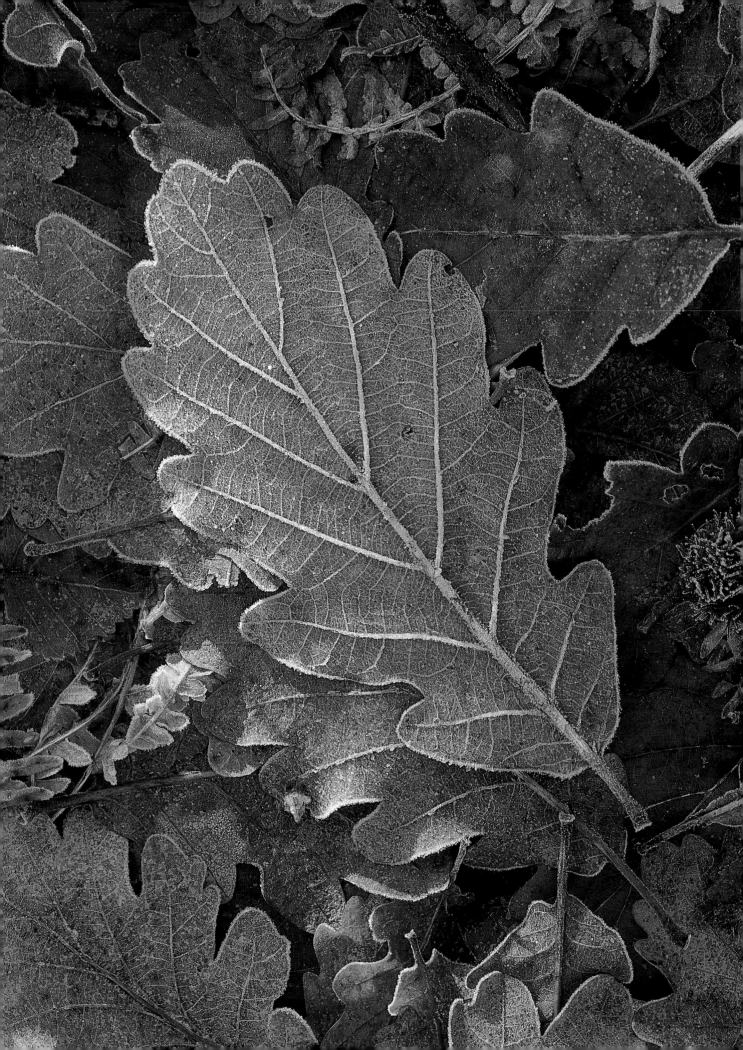

Introduction

Of all the factors which determine the success or failure of a photograph, light is by far the most crucial and, at the same time, the most elusive. Light affects every phase of the image-making process and an awareness of light and its numerous qualities and moods is crucial to those who aspire to making great photographs

Light rays travel from a source to the subject it illuminates. They are then reflected, focused through a lens and passed through filters and attachments finally reaching the film where their effect can be controlled by shutter speeds and apertures.

At each of these stages the behaviour of light and its effects can vary enormously and, when combined, they create an almost infinite number of possibilities. The cameras, equipment and techniques used by photographers are primarily designed to control light in as many aspects as possible.

The Art of Photographic Lighting describes the numerous ways in which light can influence the visual elements of an image. It explains and illustrates how its effects can be seen and judged together with the many techniques which can be used to control it.

There is a wide gulf between a photograph in which the illumination was simply adequate for it to be recorded successfully, and one in which a particular quality of light has been used to create a powerful and striking image. Perhaps the most telling factor which distinguishes an experienced and creative photographer from a casual shooter of snaps is that the former is acutely sensitive to the quality of light in his or her pictures.

For that reason I hope that this book will increase the reader's awareness of the subtle qualities of light and how they can be best employed to create powerful and atmospheric images.

Opposite Taken in the early morning the sunlight had just begun to reach this frosted leaf. I used a 150mm lens with an extension tube on my Mamiya 645 and gave a series of bracketed exposures around 1/4 sec at an aperture of f16 for maximum depth of field using Fuji's Velvia film. This frame had one-third of a stop less than the indicated exposure

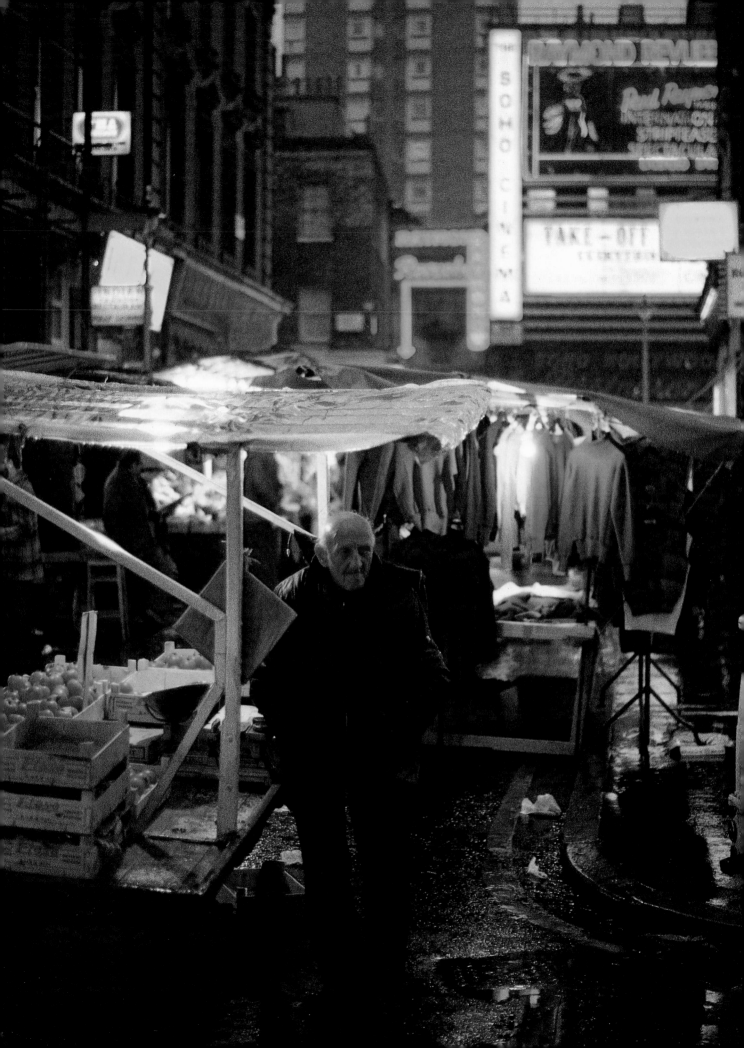

1 The Nature of Light

Light is the most transient element involved in making a photograph. It is infinitely variable in terms of both quality and quantity, and when these factors are combined with the reflective qualities of the objects upon which light falls the possible permutations of its visual effects are too enormous to imagine.

In photographic terms the effect of light is further complicated by the fact that although some of its qualities are not visible to the eye, or are very difficult to see, they can, nevertheless, have a marked effect on the film.

The most important qualities of light to a photographer are its intensity, its colour quality and the degree to which it is diffused. Its intensity determines the exposure required. In the early days of photography light intensity was a very limiting factor owing to the first sensitive materials needing a very bright image to record a satisfactory image.

Daylight was vital for the first attempts at making a photographic image and even in bright sunlight very long exposures were required. This is one of the factors which contributes to the special quality of early photographs. Indeed, so long was the necessary exposure time that in Victorian portraits the model had to be held still with metal frames and brackets. It is remarkable how well the

Opposite Photographed at dusk in London's Berwick Street market this shot was taken using a 50mm lens at an aperture of f2.8 on a Nikon with an exposure of 1/15 sec. The film was Kodak's High Speed Ektachrome pushed one stop in processing

Below Lit by bright Mediterranean sunlight, this shot of a farmer in Spain's province of Almeria required an exposure of 1/250 sec at f8 using Fuji's Velvia film. I took a close-up reading to avoid the risk of underexposure caused by the blindingly white wall behind him. I used a Nikon F3 fitted with a 35-70mm zoom

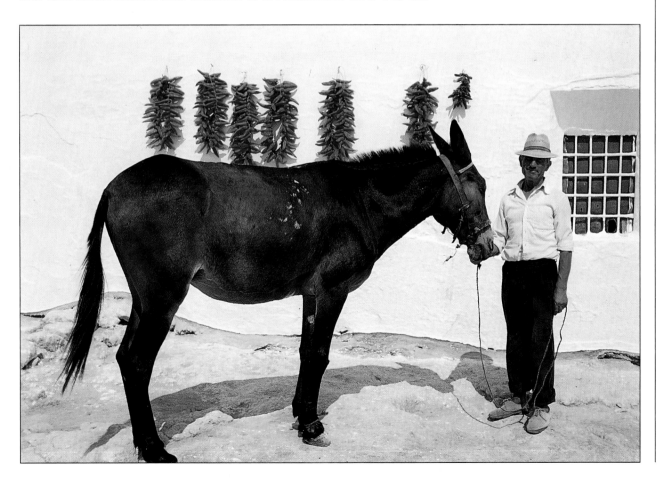

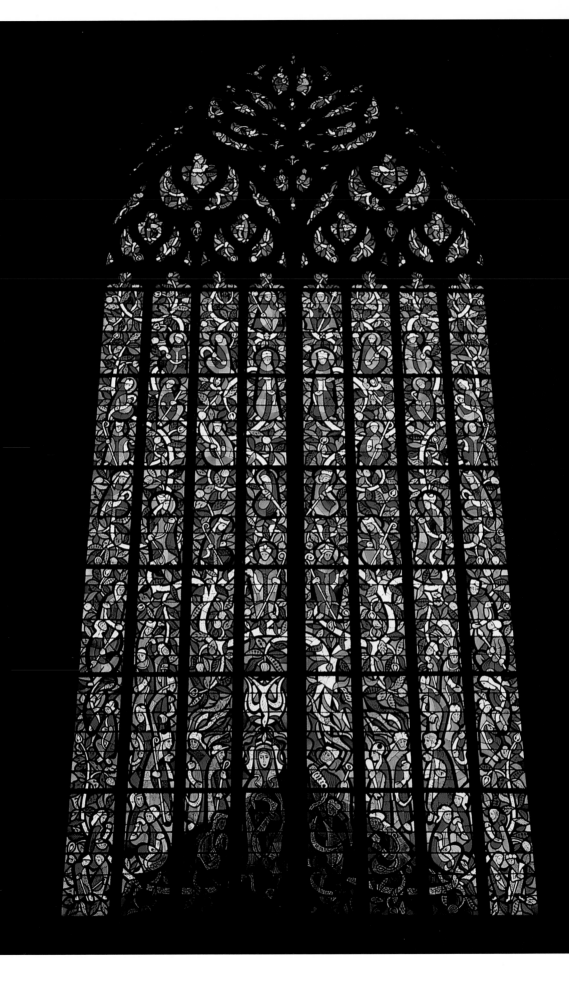

first photographers overcame the limitations of light and film sensitivity when you look at some of their portrait and landscape work, and even more so when you consider some of the documentary photographs taken on heavy and cumbersome equipment.

Today's highly sensitive films and fast lenses mean that light intensity is seldom a limiting factor in taking a photograph. Satisfactory pictures can now be made when the light level is almost too low to read by and, of course, with artificial lighting, natural light is not necessary at all.

The Colour Quality of Light

What we call visible light is only a very small part of the electromagnetic spectrum, energy travelling in wave form. This ranges from the very short wavelengths of Gamma and X-rays to the infinitely longer wavelengths of television and radio signals.

The visible spectrum lies between these two extremes, sandwiched between the ultra-violet waveband and that of infra-red. The varying wavelengths of visible light are responsible for our perception of colour. It's like tuning into a radio programme; each part of the waveband sends a different signal to our brain and causes it to see a range of colours.

One of the difficulties associated with colour photography is that the perception of colour is a very individual and subjective thing. To a large extent human vision is little more than an optical illusion. Light rays of various wavelengths reflected from the scene we are viewing are focused on to the sensors at the back of our eyes which are stimulated into sending a message to our brains. Here the signal is interpreted, forming an image in our mind.

When two people look at a scene they will not see quite the same colours. Indeed, individual response to colour can vary enormously, with colour-blind people being unable to distinguish, say, red from green. In the same way people who might appear to mix the colours they wear in a strange way might not have bad taste, but simply see the relationship between the colours in a different way to you. Or, indeed, it may be that your perception has distorted what, in fact, seems an attractive blend of colour to most other people. It can probably be said that everyone is colour blind to some degree.

If all this sounds rather complex and daunting it really only stresses the fact that a truly objective assessment of colour can only be achieved with the aid of science and a photographer, particularly one interested mainly in the creative possibilities of the medium, must depend upon his own taste and judgement.

This can be aided, however, by an understanding of the basic colour quality of light. We are all very familiar with the way the different wavelengths of 'white' light can be separated to form the basic colours of the spectrum. A rainbow does this very effectively with the longest wavelengths creating red through orange, yellow, green, blue and indigo to the shortest visible wavelength of violet. Beyond this is the invisible band of ultra-violet which although invisible to the eye can be 'seen' by film. So too can infra-red light with a film which has a specially formulated emulsion.

White light is simply that created by a source with all the wavelengths present. If any are absorbed, or filtered out, then a definable colour will be perceived. The colours visible in a subject are created when the objects within it absorb some of the wavelengths. This can

Opposite The exposure for this shot of a stained-glass window was made in the normal way using TTL metering. I made no modification as, although it was lit by transmitted light, its tonal range was similar to a reflected-light subject. I used a Nikon FE2 fitted with a 35-70mm zoom and the camera was tripod-mounted for exposures bracketed around 1/30 at f8 on Kodak's ISO 64 Ektachrome

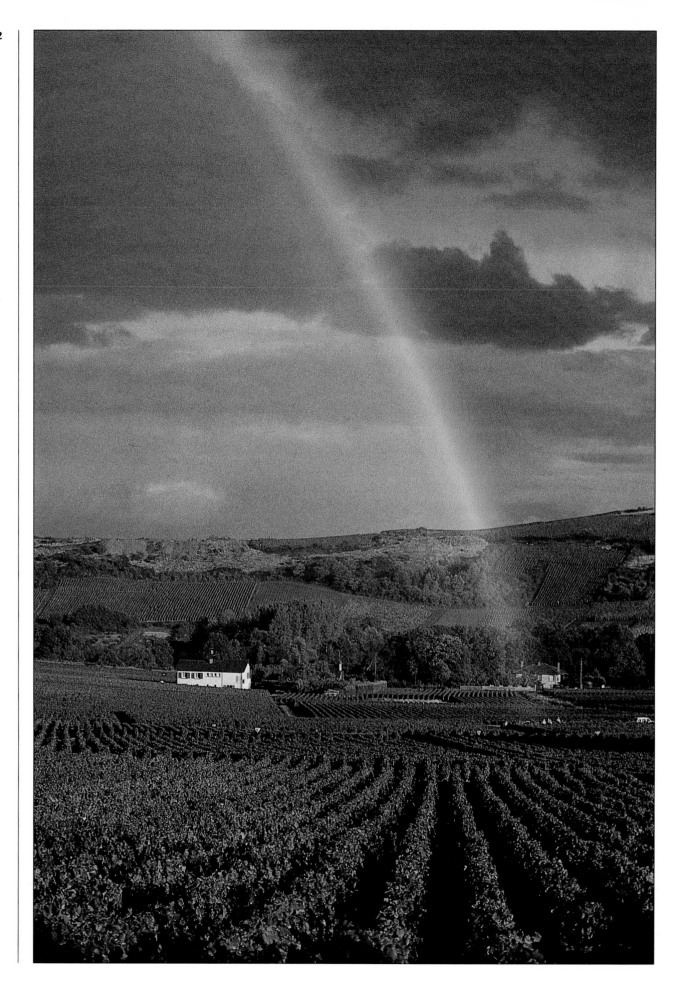

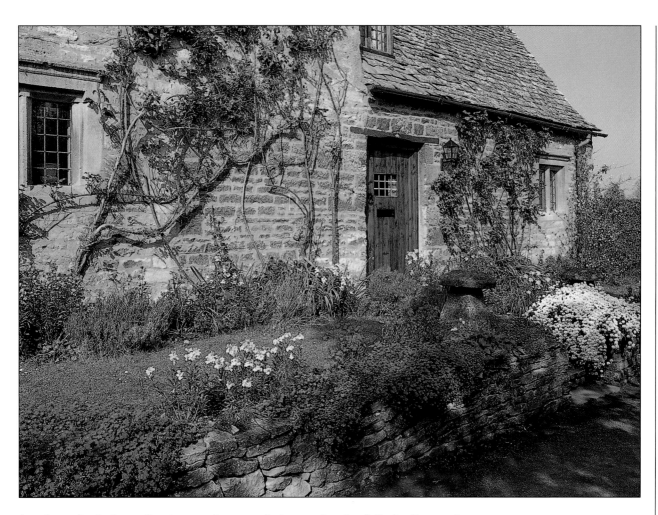

be done both by reflection and transmission: a bowl of fruit, for instance, will reflect different wavelengths and a stained-glass window will transmit them.

The colour quality of the light source itself can also be varied by filtration, or absorption. Sunlight, for example, can vary enormously simply by the position of the sun in the sky. As it moves closer to the horizon its rays pass more obliquely through the atmosphere and more of the longer wavelengths are absorbed. This is the cause of the yellowish quality of sunlight close to the end and beginning of the day. Clouds and mist can absorb some of the shorter wave-lengths, giving sunlight a bluer quality, and a similar effect is created when daylight is reflected from a blue sky, as in open shade.

This variation in the colour quality of a light source is meas-ured, for photographic purposes, in degrees Kelvin, known as colour temperature. It is the temperature to which an inert black material must be heated in order to emit a particular wavelength of light. For photographers white light is usually deemed to be just under 6,000° Kelvin. In theory, this is the colour temperature created by direct summer sunlight from a clear blue sky between the hours of 10am and 4pm in Washington DC in the USA. However, the colour temp-erature of daylight can very enormously, from 20,000°K when reflected from a blue sky and 9,000°K when filtered through a hazy sky to 3,500°K just before sunset.

Artificial light sources create a further range·of variations. The light emitted by a photographic flash tube is very close to that of summer sunlight, but other sources vary widely. A 100-watt domestic tungsten bulb, for example, is just under 3,000°K and a carbon arc light about 5,000°K. Some artificial-light sources, like fluorescent

Opposite This rainbow, photographed in the vineyards of France's Macon region, shows most of the colours of the spectrum quite clearly. About half a stop less than the indicated exposure was used to ensure the detail was retained in the lighter tones and the sky remained dark

Above In this shot of a cottage near Chipping Camden in Gloucestershire the natural warmth of Cotswold stone and the rich colours of the flowers have been enhanced by the mellow quality of early-morning sunlight. I used my Mamiya 645 with a 50mm lens and Fuji's Velvia film

tubes for instance and sodium street lamps, do not emit all the wavelengths in the spectrum so can never be made to create a true white light even when filtered.

Because of our very subjective means of perceiving colour it is extremely hard to actually see these colour variations. The human eye and brain can combine to create highly convincing deceptions. Because we know what ought to be the colour of most things we see, that is usually what we do see, regardless of the colour quality of the light source by which we are viewing them.

A good example of this is when reading a book by a tungsten light. We know that the page of the book is white so that is how we see it, but it is in fact quite yellow. The only way it is usually possible to see such colour variations is by comparison. If you were to hold the tungsten-lit pages of the book close to a daylit window, then you would be able to see that it is yellow.

In the same way, if you work in an office lit by tungsten or fluorescent light then, usually, the colours of the objects you see will appear quite true. However, if you go outside the office block and look at the illuminated windows in comparison with the building's exterior in daylight you will see just how unwhite the artificial light sources really are.

Although it is possible to train your eye to see variations in colour temperatures in some, usually more extreme, circumstances, as a rule it is necessary to rely upon experience and knowledge of the potential colour casts which are likely to take place in given circumstances.

For very exacting work it is possible to buy a colour-temperature meter. Working on a similar principle to an exposure meter, it indicates the precise value of the filtration needed to match the colour temperature of the light source to that for which the film is balanced.

Light and Film

The colour quality of light is an important factor in determining the nature of a photographic image. Even in the early days of photography, when colour film was still a distant dream, the colour content of light played an important role in the quality of the black-and-white images. The first films were not sensitive to all the wave bands which make up daylight, and the tonal range and quality was, to some extent, due to the uneven response of the film to the invisible colours which make up the 'white light' of the sun.

The early black-and-white films were orthochromatic, insensitive to longer wavelengths and more sensitive to shorter wavelengths. It was safe to process black-and-white films in those days by the use of a red safelight simply because the film was unable to respond to it. This had the effect of recording the green hues of foliage, for example, as a lighter tone than that we are familiar with from today's panchromatic films. These are much more evenly sensitive to the visible wavelengths. The additional sensitivity of orthochromatic films to greens and blues also contributed to the rather misty quality of many of the early landscape photographs, and the lack of sensitivity to reds helped to give portraits the typically rich skin tones of the period.

The effects of orthochromatic film can be simulated by using a deep blue or green filter. Coloured filters can be very useful in helping to control the tonal rendition of a subject when photo-

Opposite The effect of this shot, of water swirling below a weir, was created by using an orange filter (designed for black-and-white film) with colour-transparency film. Half-a-stop less exposure than indicated was given and the reading was made with the filter in place. I used a Nikon F2 with a 150mm lens

graphed in black and white. The principle is simple enough. A filter absorbs certain wavelengths of light and so prevents them reaching the film, making objects which emit that wavelength darker in tone.

It is necessary at this stage to consider the colour quality of light in the terms which photographic film understands. For this purpose, the individual wavelengths of visible light are grouped into three broad bands: red, green and blue. By balancing the proportions of these three colours, known as primary colours, any hue can be created and if all three are equally balanced the result is white.

If you have three projectors and place a primary-colour filter over each and superimpose the three coloured lights white emerges. If you switch off the blue-filtered projector, a mixture of red and green light creates yellow and this is known as the complementary colour to blue. When the red projector is switched off the green and blue lights create cyan, the complementary colour to red, and when the green projector is switched off the mixture of blue and red light combines to create magenta, the complementary colour to green. This is known as additive colour.

If you hold filters of the three complementary colours, cyan, magenta and yellow, against a light source they will absorb all wavelengths of light, creating black. The cyan and magenta filters alone will absorb red and green, leaving blue light to pass through. The magenta and yellow filters absorb green and blue, passing only red light, and the cyan and yellow filters combined absorb red and blue, passing only green light. This is known as subtractive colour.

In this way, with black-and-white film if you place a red filter

Right I used a diffused studio flash on a low-power setting for the general lighting in this nude shot on daylight-type transparency film. The light from the anglepoise lamp, with a much lower colour temperature, has produced a pool of light with a warm glow. I used a Rolleiflex SLX with a 150mm lens and Kodak's EPR Ektachrome

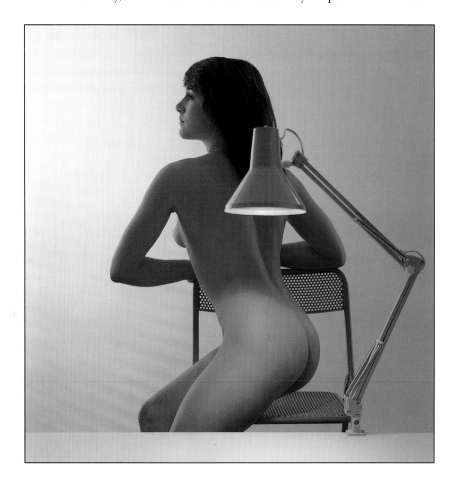

over the lens it will make red objects in the image appear lighter in tone, and greens and blues darker. A blue filter will make red and green objects darker, and blues lighter, and, similarly, a green filter will make its own colour lighter, and blues and reds darker.

The effect created will depend upon the density of the filters and the purity, or saturation, of the colours in the scene you are photographing. A primary red filter would make a deep-blue sky record as almost black, for example, whereas an orange filter would make a pale-blue sky just a slightly darker shade of grey.

To a large extent, lighting conditions dictate the best type of film to use for a specific assignment. Low light levels, for instance, would require the use of a fast film where a moving subject was involved and fast shutter speeds were needed. Where the subject was static, however, and slow shutter speeds could be used, the film speed would not be important. A subject where maximum clarity and image definition was needed would suggest the use of a slow fine-grained film. Shots taken in artificial light would need tungsten-type transparency film and where longer exposures were needed Type L colour-negative film would be the choice.

Colour film is manufactured to create 'true' colours in very specific lighting conditions. With daylight-type film it requires a light source of about 5,800°K to create unbiased colours. If the colour temperature is higher a blueish colour cast will result, and if the colour temperature is lower the image will have a yellowish bias. In practice, modest variations in colour temperature are really only important with colour-transparency film since a colour negative with

Below This industrial scene was photographed at dusk on Fuji's Velvia film. No filter was used as I felt the blue quality of the remaining daylight would contribute to the sombre mood of the scene. I bracketed the shot and selected a frame which was given two-thirds of a stop less than the 'correct' exposure. I used my Mamiya 645 fitted with a 55mm lens

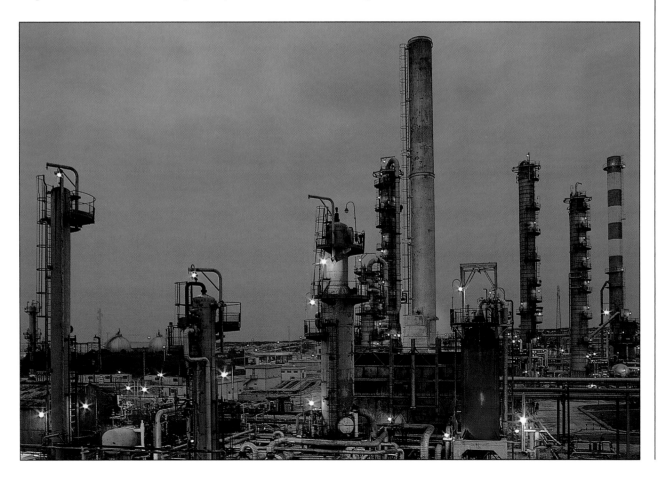

Opposite, above The hazy blue quality of this landscape, shot in the Sierra de Fibrales in Spain's province of Almeria, is a characteristic of the strong presence of UV light which often exists in these circumstances. Its effect could have been greatly reduced and the colour cast eliminated by using a warm filter like a Wratten 81C, but in this case I felt both the hazy quality and the blue cast contributed to the mood of the picture

Opposite, below Tungsten light flooding from the door of this boutique in the Provençal village of Ste Agnes has created an orange colour cast, establishing a marked contrast with areas of the scene lit by daylight. I used a Mamiya 645 and a 55mm lens with Fuji's ISO 50 film

a slight colour bias can be easily corrected when the print is made. With colour transparencies, however, it is vital to match the colour quality of the light source to that for which the film is balanced if the accuracy of the image is at all important. If you were photographing a painting, for example, where a faithful reproduction was vital it would be necessary to use controlled lighting, like studio flash, and make test exposures to establish whether any filtration was necessary.

Light and Filters

Even if the colour temperature of the light source is carefully matched to the film, other factors can also introduce variations. Individual lenses can influence the colour quality of the image, film can vary from batch to batch and even the processing line can alter the colour balance of a transparency. Colour-negative film is far more tolerant of variations in colour temperature, especially in non-standard or mixed lighting conditions.

However, most photographers are, in practice, more concerned whether the colour quality of a photograph pleases them than whether it is accurate. For those engaged in, say, landscape or portrait photography a direct comparison between the transparency and the original subject is not necessary or even possible. As long as the skin tones are flattering, and the quality of the sky and foliage creates an interesting and appealing quality, who really cares if it is strictly accurate?

Much of my work is landscape photography and, although I am concerned that my pictures should not give a completely false impression of the scene I am photographing, I have no scruples about using the characteristics of a film or filters to enhance the visual and atmospheric quality of a subject. In short, I'm happy to use any form of artifice as long as it is not too apparent in the finished photograph. In practice, many subjects which feature in illustrative or creative photographs would be rather dull and uninteresting if the qualities of the photographic process did not make some positive contribution to the image.

It is important to appreciate that, in spite of all the great advances in film technology, the colour quality of light is still moulded by the characteristics of a particular film and the way it responds to different wavelengths of light. The fact that, in most cases, we cannot actually see the colour quality of the light means that we have to rely upon trial and experience to judge the effect which will be created by particular circumstances. A good example of this is when taking photographs in the early or late part of the day. Pictures taken close to sunset time will, as we know, generally have a warm orange quality but the precise colour quality of the image is very hard to predict. Pictures taken at dusk or sunrise, and in situations where there are mixed light sources, also often have a very unpredictable colour quality.

I'm sure that most photographers will have experienced the surprise of seeing a processed colour film taken under such conditions recording hues which were not visible to them in the subject and which they had not anticipated. This is one of the great pleasures, and frustrations, of the photographic process, and part of mastering its skills lies in learning from unexpected results and trying to anticipate them on future occasions.

This is one reason why it is a good idea to find a film you like

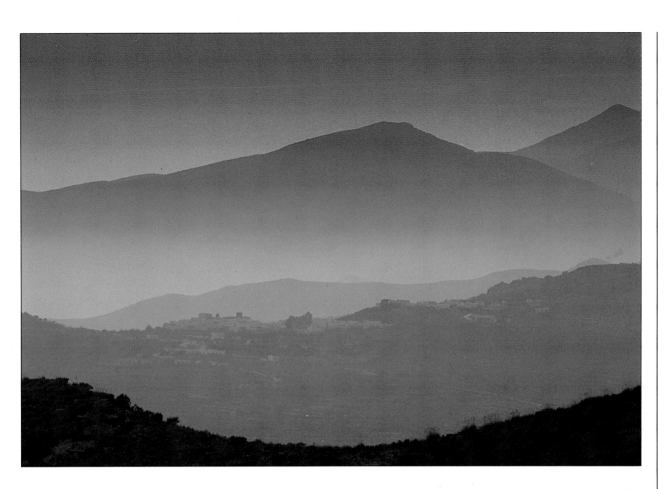

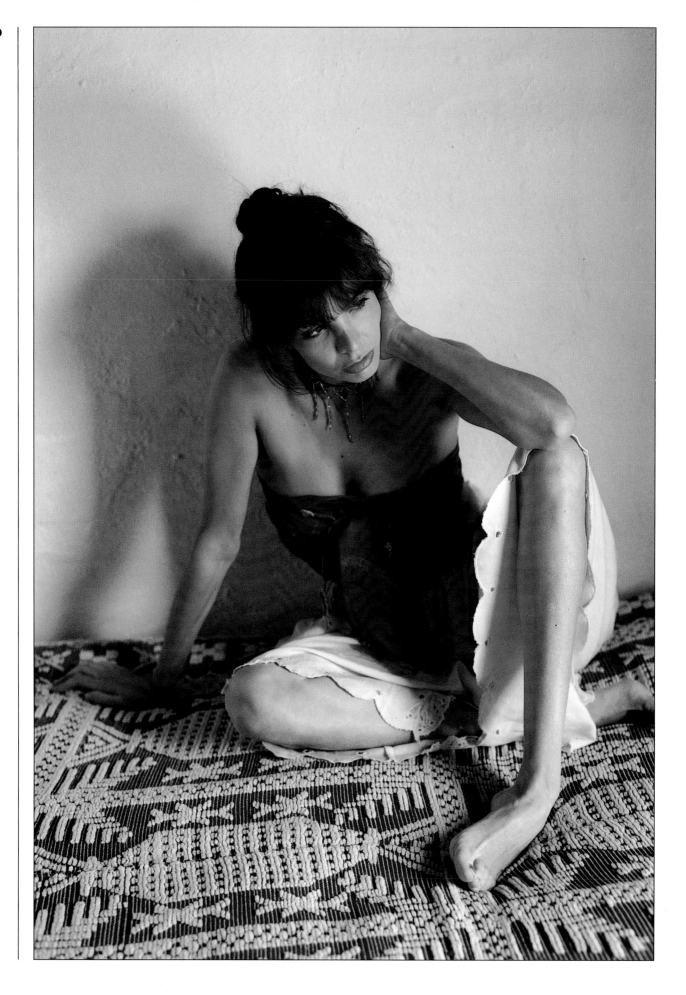

and then stick to it. Only in this way can you begin to anticipate the subtle effects which will be created by a given set of lighting conditions. In practice you will find that you will need to call on several different types of film for changing circumstances, but most photographers have a basic work-horse film which they normally use.

One of the most informative ways of discovering the potential qualities of a film is to take a series of photographs in a wide variety of lighting conditions and at different times of the day. There are a number of locations near my home which I visit from time to time and, if I am trying out a new type of film, I will visit them in turn taking pictures in sunlight, under heavy cloud, at dusk, sunset and dawn. Comparisons like this soon reveal the film's best qualities and its drawbacks as well as helping you to anticipate the effects you will get when you are confronted with a similar set of lighting conditions.

When making such tests it is also helpful to include situations where there are mixed light sources. Pictures taken in urban settings where, perhaps, you might have daylight, illuminated shop windows and street lighting all combined in the same image. The ways in which different films respond to such demands vary enormously.

When shooting on colour-transparency film in particular the use of filters to control the colour quality of the image is vital. To a large extent a simple colour cast with colour-negative film can be corrected easily at the printing stage but, with transparencies, it is important to eliminate potential colour casts by the use of filters.

The most common situation in which a filter is needed is in avoiding the blue cast created by the invisible ultraviolet wavelengths

Opposite The light from a window on a dull day has produced a slight blueish cast and enhanced the atmosphere in this shot of a pensive model made for a calendar. I used Kodak's High Speed Ektachrome without a filter and the exposure was 1/8 sec at f8 on a 150mm lens with a Pentax 6x7 camera and a 105mm lens

Below It had been raining shortly before I took this shot of peppers on a French market stall. The soft light of a bright but overcast day has helped to accentuate the rich colour of the subject and I gave an exposure of half a stop less than that indicated to obtain maximum colour saturation. I used a Nikon F2 fitted with a 105mm lens and Kodak's ISO 64 Ektachrome

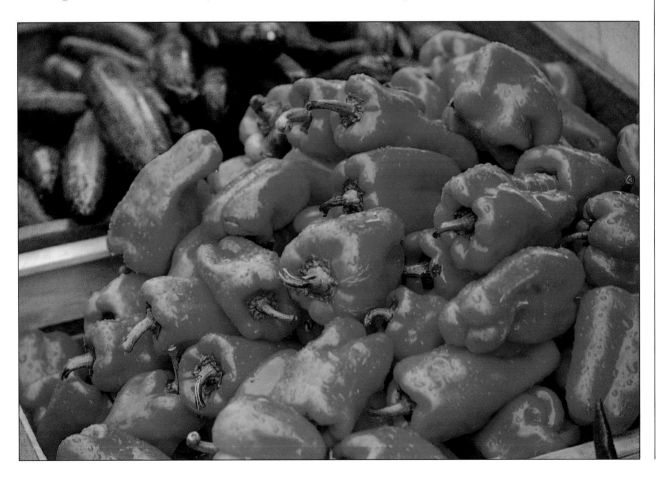

of light. They are always present in some degree in daylight hours, but they can be exceptionally strong on overcast or hazy days at high altitudes and near the sea. Many photographers have a UV filter fitted permanently to their lenses but, since I am invariably using at least one other filter which will also eliminate UV light, I prefer not to use them at all.

A blue cast is unquestionably the most common colour fault with colour transparencies shot in outdoor settings. It is also, usually, the most unattractive of the colour casts normally encountered, with the exception of green. This is usually only experienced in artificial, fluorescent light or when there are film or processing faults.

There are numerous lighting conditions when the colour temperature is significantly higher than that for which the film is balanced and which will, if uncorrected, cause a blue cast. Summer sunlight in the middle of the day when there is a deep-blue sky, in open shade on a sunny day, when it is hazy or overcast, near the sea and at high altitudes are those most commonly encountered.

The solutions to all of these conditions are the filters in the Wratten 81 range, from 81A, the weakest, to 81EF, the strongest. As a general rule a warm colour cast is more attractive than a blue cast, so it is usually best to err on the side of over-filtering. An exception is with portraits, where excessively warm skin tones can easily look unappealing.

It is seldom required to eliminate the warm colour cast created by late afternoon sunlight since this is usually considered to be attractive and atmospheric. However, when it is undesirable, with a portrait for instance, then a filter in the Wratten range 82A to 82D will be necessary.

Conversion or correction filters are also needed to correct the imbalance of a film type to the light source used. Daylight-type film used in artificial light, for instance, requires the use of a blueish Wratten 80B filter, and tungsten-balanced film used in daylight needs an orange-tinted Wratten 85B.

In addition, filters are also very useful for creating effects and altering the quality of an image. Strong-coloured filters, like those used in black-and-white photography, can be used to create monochromatic images on colour film. Graduated filters, in which just one half of the filter is tinted, can be used to selectively darken or add colour to part of the image. In landscape photography they can enhance the colour of a sunset, for instance, or make the sky a darker and richer tone.

One of the most useful filters in colour photography is the polarising filter. Its main use is to control reflections in non-metallic surfaces. It works on the principle that light normally travels in waves on different planes. When light is polarised its wave forms are made to vibrate on a single plane, as if it were passed through a grid. Light reflected from a non-metallic surface causes it to be polarised. If a polarising filter is placed over the camera lens with its angle or polarisation at right angles to that of the reflected light the reflections will be eliminated.

This can have some very useful applications, because the filter itself is neutral in colour and it will not affect the overall colour quality of the image, although it does require an increase of exposure of between one-and-a-half and two stops. An obvious use for a polarising filter is to eliminate mirror-like reflections in surfaces

Opposite I used Kodak's High Speed Ektachrome (ISO 200) for this shot of a windsurfer to allow the use of a reasonably fast shutter speed of 1/250 sec, enough to stop the movement of a subject which was moving towards the camera. I also wanted to use a smallish aperture to ensure there was enough depth of field with a 250mm lens on a Rolleiflex SLX, as precise focusing was rather difficult to guarantee

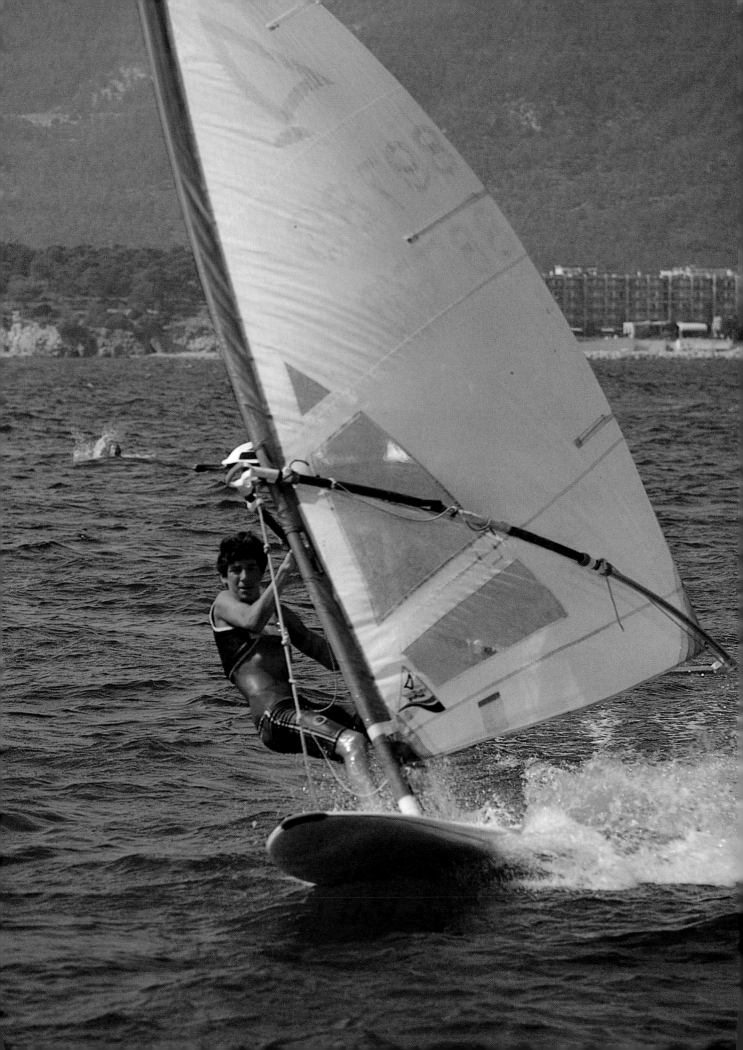

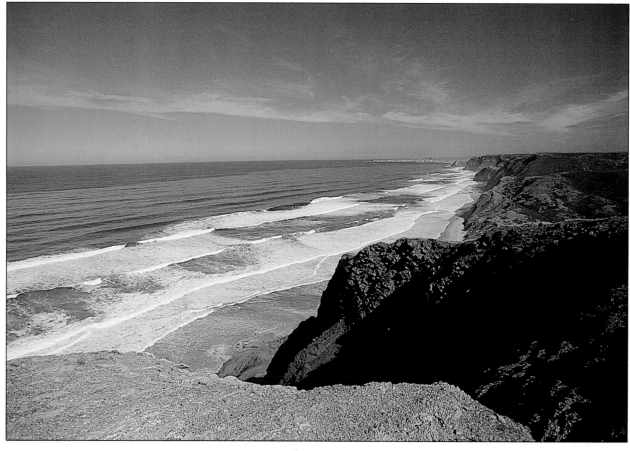

such as glass, thus enabling the objects beyond it to be seen more clearly. Photographing a shop-window display is a good example.

However, there are many more subtle types of reflection where the filter can be extremely effective. Blue sky, for instance, reflects light and when photographed with a polarising filter it can be recorded as a much deeper and richer colour, with clouds standing out in dramatic relief. Even surfaces like foliage and blades of grass can be given much stronger colour when photographed with a polarising filter. The sea, too, can be made to appear a much richer and more translucent colour and the filter can also be used to reduce the effect of strong highlights on backlit water.

Hard and Soft Light

The degree to which a light source is diffused is also a vital factor in defining the quality and effect of a photographic image. Sunlight is the most widely used light source for photography and, when it is unobscured by cloud or mist, it creates a point source. This means that the light rays travel in parallel waves casting hard-edged and dense shadows. Even a slight amount of diffusion caused by cloud or atmospheric haze will, to some extent, scatter the light rays, softening the edges of the shadows and making them less dense. On a day with thick cloud the sky itself becomes the light source and the light rays are completely diffused, often almost eliminating shadows completely.

The degree to which a light source is diffused will affect the modelling of the subject and its brightness range, two of the main factors which control the quality and effect of an image, whether it is to be photographed in colour or black and white.

Modelling is determined by the tones which the lighting creates. A hard light, such as direct sunlight, will create strongly defined areas of highlight and shadow with little graduation between them. A partially diffused light, on the other hand, will cause a more gentle graduation from highlight to shadow and a fuller range of tones between. A very diffused light, like that in a heavily overcast sky, will create only barely discernible shadows with little or no graduation. Pictures taken in these conditions rely almost exclusively upon the inherent tones of the subject to define the image.

The nature of the shadows and degree of modelling created by a light source also depends upon the direction of the light. If a hard or barely diffused light is directed from close to the camera position, the modelling it creates will be almost non-existent because the shadows will be cast behind the objects being illuminated. If the light source is directed from right angles to the object, the shadows and the tones they create will be both visible and dominant, creating well-defined modelling.

The relationship between hard and soft light, its direction and the modelling it creates, can be understood readily by taking a three-dimensional white object, like a sphere or a cube, and placing it on a piece of white paper. By moving the light source, or the viewpoint, you can observe how the size and shape of the shadows change and by diffusing the light with a piece of tracing paper you can see how the density and definition of the shadows can be varied.

This is a very easy way of learning to see the effects of lighting. It also illustrates clearly the influence the light source has on the brightness range of the subject. This is the difference between the

Opposite, top The soft-magenta colour quality of this shot, taken in the vineyards of the Savoie region in France, was the result of shooting some time after sunset. I bracketed six exposures from 10 to 40 seconds at an aperture of f5.6 on Fuji's Velvia film and the frame which worked best was about half a stop less than the central exposure. I used a neutral graduated filter to retain the sky colour and ensure adequate detail in the foreground

Opposite, below This shot of the Portuguese coastline has a slightly cool colour quality in spite of using an 81B filter. The lack of warm colours in the scene has heightened this effect and so too has the polarising filter I used to increase the colour saturation of the blue sky and water. I used a 28mm lens on a Nikon F3

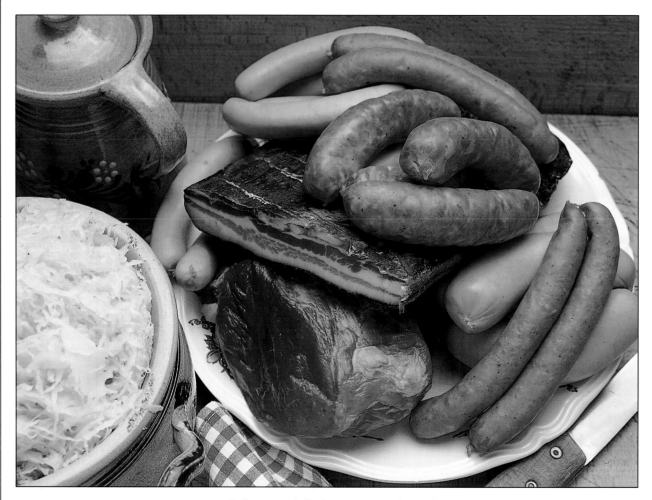

Above I used artificial-light transparency film for this still-life shot of French charcuterie which was lit by a single halogen lamp placed above the arrangement. A diffusion screen was introduced between the lamp and the subject to create a softer light and a white reflector used close to the camera to lighten the shadows. Photographed on a Mamiya 645 with a 150mm lens, it needed an exposure of 1sec at an aperture of f16 to obtain sufficient depth of field

lightest and darkest tone in the subject. If the white object is lit from the front with a very soft source which casts no shadows, there will be an almost-zero brightness range since the subject contains only a single white tone. If, however, a hard directional light source is used which creates bright highlights and dense shadows, the subject will contain tones from white to black and will have a high brightness range.

When the subject of a photograph consists of a single tone or colour, like the white sphere or cube, the brightness range is created solely by the nature of the light source. In practice, however, most subjects have an inherent brightness range: a man in a black suit photographed against a white wall, for example, would have a very high brightness range even if he were illuminated by a very diffused frontal light which cast no shadows. In most photographs, the brightness range is a combination of the inherent tones and colours in the subject combined with the shadows and highlights created by the lighting. One of the keys to understanding photographic lighting lies in being able to distinguish these two elements of a subject's tonal range and to see how one affects the other.

Light and Contrast

It is the brightness range of the subject which establishes the contrast of the image, and this in turn determines the way the image is recorded on film. Films have only a limited ability to record a range of tones, and when this range is exceeded detail is lost in either, or

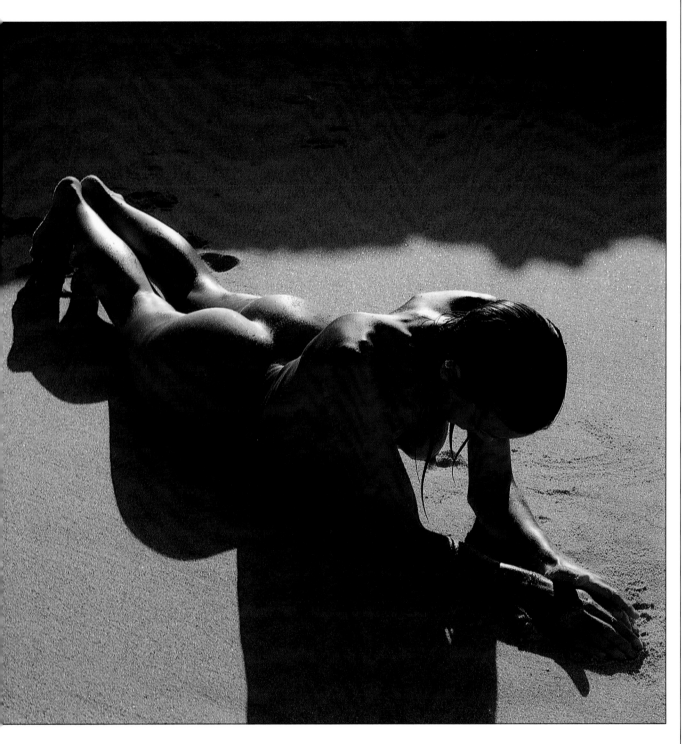

Above The sunlight on this backlit nude has created a very high brightness range resulting in a very contrasty image. I exposed for the mid-tones allowing the brightest highlights to burn out and the darkest shadows to become black in order to obtain a dramatic effect. It was shot on a Rolleiflex SLX with a 150mm lens using Kodak's EPR Ektachrome and an exposure of 1/60 sec at an aperture of f16 for adequate depth of field

Overleaf A beach on the island of Bali was the location for this shot taken during the rainy season when splendidly dark clouds crowded the sky. It was the combination of the blue boats and grey sky which appealed to me, and I used a neutral graduated filter to help retain the rich tones in the sky. Shot on a 24mm lens on a Nikon FE2 I used the smallest aperture of f16 to obtain maximum depth of field with Kodak's ISO 64 Ektachrome

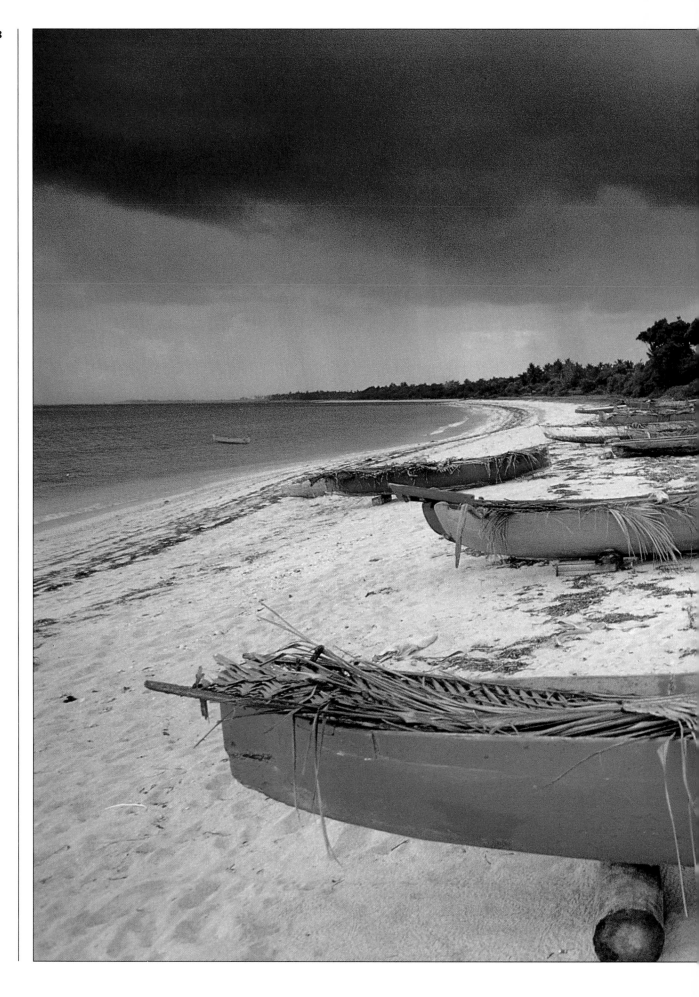

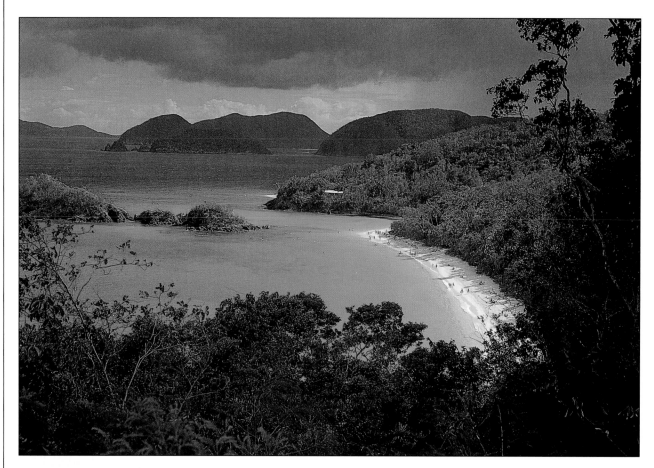

Above This seascape was taken on the US Virgin Island of St John just after a storm. I used a polarising filter to increase the colour saturation of the sea and a neutral graduated filter to retain the dark tones in the sky and distant headland. I waited until a pool of sunlight cast by a hole in the passing clouds lit the white-sand beach. It was shot on Nikon F3 with a 35mm lens using Fuji's Velvia film

both, the lightest and darkest areas of the image.

Most photographers have experienced the disappointment of seeing a picture which has lost important detail, either in dense, blocked-up shadows or in light tones being burnt out. It's easily done for two main reasons. Firstly, it is important to appreciate that most films increase the contrast created by the subject's brightness range. Secondly, our eyesight tends to give a misleadingly low impression of subject contrast because our eyes have the ability to adjust very rapidly between light and dark areas. An effective way of judging the potential contrast of an image is to look at the subject through half-closed eyes, or to view it through the camera viewfinder with the lens stopped down.

In colour photography the greatest problem lies in dealing with excessive contrast, since colour film has a quite limited tolerance and, unlike black-and-white photography, the contrast of the final image cannot be controlled by processing techniques and the choice of different paper grades. As a rule, colour-negative films can deal more satisfactorily with excessive contrast than colour transparency.

In most cases, the control of contrast in outdoor photography has to be achieved by the choice of viewpoint and the way in which the image is framed. The choice of viewpoint can help to control the size and position of highlights and shadows, and the image can be framed in a way that eliminates the extremes. In some cases, fill-in flash or reflectors can be used for subjects which are fairly close to the camera in order to illuminate shadow areas and to reduce the contrast. With studio lighting it is a relatively easy matter to control contrast simply by varying the position and balance of the lighting.

Low contrast is usually only a problem with colour photography if the subject does not contain strong, or positive, colours. Indeed, very brightly coloured subjects, like flowers for instance, often benefit from a soft diffused light which only creates a limited brightness range. Strong highlights and bold shadows can often diminish the subtle effects of colour.

The most important control of contrast in outdoor photography stems from the choice of viewpoints and the framing of the image to introduce bold colours, strong shadows or bright highlights into the picture area. In black-and-white photography, contrast can also be controlled by varying the development of the negative and by the choice of paper grades. There is a more limited degree of contrast control in colour photography, although slow colour-transparency films tend to have greater contrast than fast emulsions. The choice of colour-negative films offers some control with more contrasty emulsions such as Kodak's Vericolor HC and softer emulsions like Kodacolor Gold.

Light and Exposure

To some extent, exposure calculation is far less of a problem than it was a decade or two ago. The sensitivity and sophistication of modern exposure systems are astonishing to those of us who were brought up with the Weston meter, admirable though it was. Because most cameras are now built with a light-measuring device as an inherent part of the viewing system linked to the exposure control mechanisms, it means that this important aspect of photographic

Below This shot of a cat is a good example of a subject which contains a full range of tones. The soft shadowless light of an overcast day was enough to create good contrast and the image would look equally pleasing in black and white. It was shot on a Nikon FE2 with a 150mm lens and an extension tube using Fuji's Velvia film with an exposure of 1/30 sec at f5.6

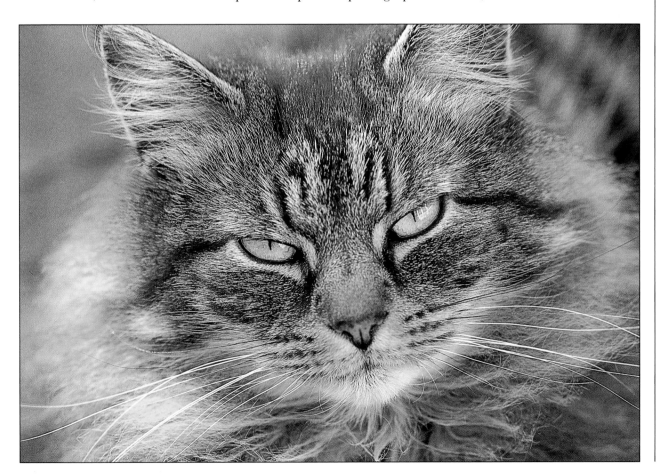

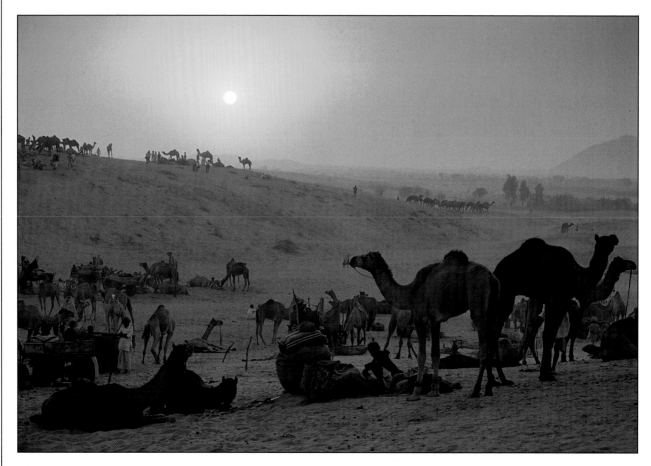

Above Photographed close to sunset at the Pushkar camel fair in Rajasthan this shot was taken on a 200mm lens. Although the sun was weakened by atmospheric haze it was necessary to use a neutral graduated filter to prevent it burning out and to retain some colour and density in the sky

Opposite Taken in the dark, narrow back streets of Naples, the soft but strongly directional lighting has produced a pleasing luminous quality in this impromptu group shot.
I used Ilford's FP4 in my Nikon F2 with a 35mm wide-angle lens and the final image quality was the result of trying various paper grades together with shading techniques in order to produce the effect I wanted

technique is much easier to master than it once was.

The fact that incorrect exposure is still a common source of error only goes to demonstrate that the truly automated camera is still some way off. In truth, with a good through-the-lens (TTL) metering system, exposure only remains a problem for a small proportion of subjects and for those shooting colour-transparency film or seeking the highest degree of black-and-white image quality.

The exposure tolerance of most colour-negative films is such that for average subjects shot with a modicum of care and thought, and the help of a good TTL metering system, a satisfactory print is a foregone conclusion. I would guess that, given these circumstances, poor colour prints are more likely to be the result of the short-comings of the automated printing machines, or their operators, rather than be due to badly exposed negatives.

Colour-transparency film is, however, a different matter. While the final effect of a colour print made from a negative can be controlled at the printing stage, the quality of a colour transparency is almost entirely dependent upon giving the right exposure to the film at the time of shooting. And it can be very critical indeed if the highest-quality results are sought.

A black-and-white or colour negative is only a half-way house in the process of creating an image, and at this stage there are several further control options open to a photographer. A colour trans-parency, however, by-passes this point and the crucial conversion of negative to positive is an entirely automatic aspect of the chemical process. For this reason the making of the unseen negative, which is destroyed during the reversal process, must be very finely controlled

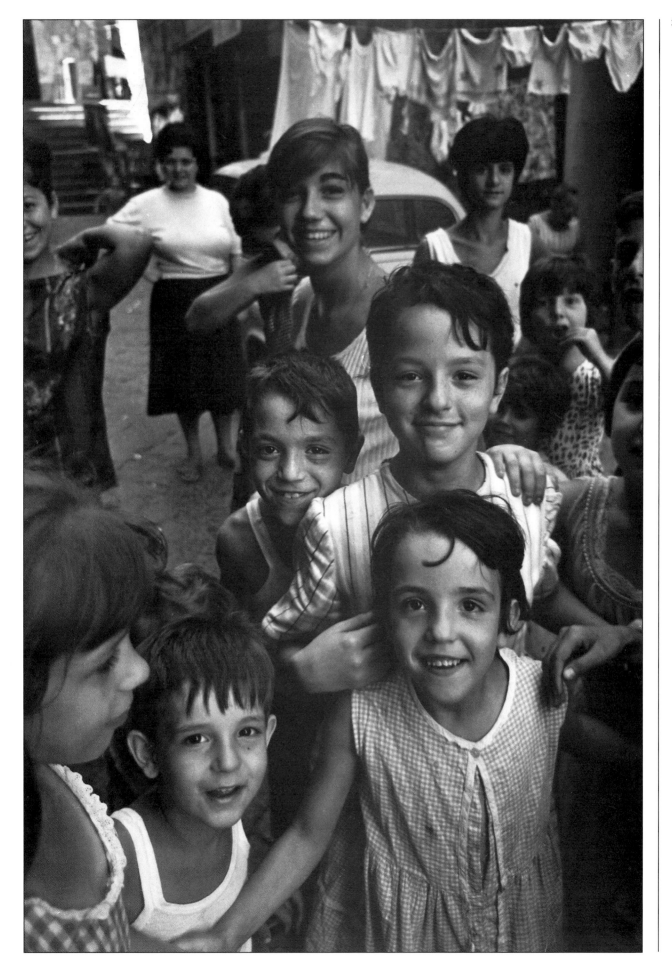

Opposite This portrait of a young Gambian woman was given a stop less exposure than indicated by the meter in order to keep the skin a dark, rich colour. This has emphasised the bright white eyes and teeth and added a touch of drama to the shot. I used the soft light of open shade to keep the contrast as low as possible

Below Shooting towards the sunlight on a winter's day with a dark stormy sky has created a fairly high-contrast image in this shot of a Kentish hop field. I calculated the exposure to give adequate highlight detail allowing the shadow areas to record as dark tones

in order to create the desired quality in the finished transparency.

In many ways, transparency film is something of a photographic dinosaur. When you consider what can be achieved electronically, video images can be switched from negative to positive at will and the colours and tones completely altered by means of a computer, then the relatively hit-or-miss colour-transparency process seems strangely out of date. However, the definition and colour quality of a good transparency · are still not completely matched by colour-negative materials, and the printing methods used by many publishers still resist the use of prints.

I feel that in the near future the movement of all photographic colour processes will move towards negative films, since they offer far more control, although it will take some time before all the current users of transparency films can be lured away from them. In spite of being fully aware of all the advantages of the colour-negative system, I have to confess that all the reproductions in this book are from colour transparencies.

However, good exposure techniques are still vital to all photographic processes and automation is not, and never will be, the answer where creativity is involved. The basic principle of exposure is simple. Film requires a specific amount of exposure in order to reproduce the tones and colours of a subject accurately. The correct exposure depends upon the speed, or sensitivity, of a particular film and the amount of light reflected from the subject. The exposure is regulated by varying the size of the aperture, or iris mechanism, and the period of time for which the shutter is allowed to open.

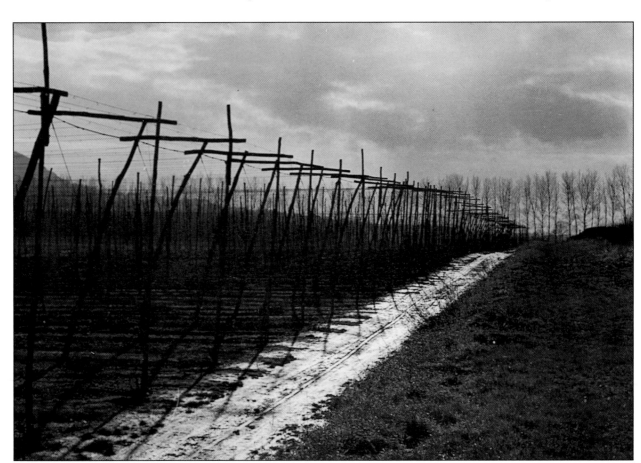

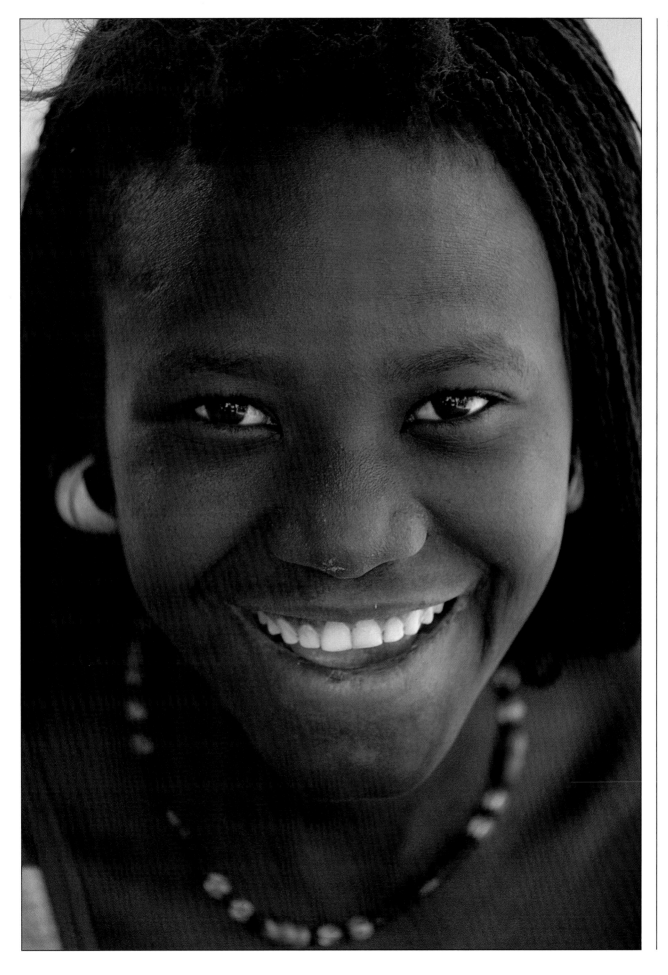

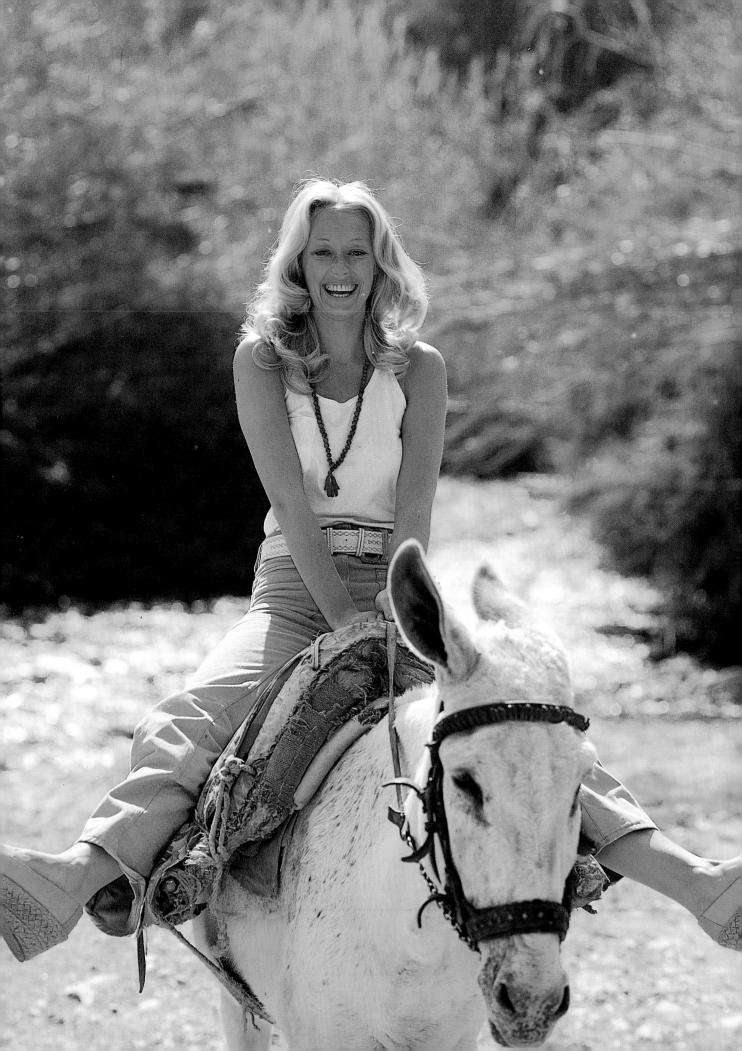

The subject brightness is measured by a light-sensitive cell, calibrated so that the overall brightness of the scene which it measures is related to a specific tone on the film. It has to be assumed that if an average were taken of tones within a scene they would be recorded satisfactorily as the mid-tone for which the meter is calibrated.

In practice, this system works quite well and since exposure meters have become even more sophisticated, by measuring and comparing the light reflected from different parts of the subject, they work even more effectively. But they are not infallible: for example, they don't allow for the fact that a better-quality image may in some cases result from giving more, or less, exposure than the meter indicates. In short, for the creative photographer a correct exposure is simply that which produces the desired effect.

It is accepted that if you shoot negatives the ultimate quality of the image lies in the skill used in making the print. Few self-respecting printers would go into the darkroom and accept the first print made as being the best that could be achieved. Indeed, most creative photographers will make numerous tests and many printed versions of a negative before they are satisfied.

It makes little sense to me that a creative photographer working with transparency film should assume that a careful exposure assessment will automatically result in a perfect image. Making different exposures, or bracketing, when shooting a subject is really the same technique as making prints of varying density in the darkroom. The subtle variations in tone and colour which this can create are one of the most important ways of exercising fine control over image quality when using colour-transparency film.

With a static subject, like a landscape for instance, I will make six or more different exposures, usually in third- or quarter-stop increments, to at least one stop less than the meter indicates and half a stop more. If the subject is variable, like a portrait, it is more satisfactory to make a clip test. This involves shooting the entire roll of film at, say, a half-stop less than the meter indicates and cutting the last two frames from the roll to process first. The processing time of the remainder of the roll can then be adjusted to ensure that the density and colour quality of the transparencies are exactly right. It is a simple matter to 'push' process films by two stops or more, reducing the density, and to 'pull' by up to one stop, increasing the density. This is common professional practice and most laboratories offer the service as a matter of course.

In addition to the fine tuning of image quality there are several quite predictable situations in which the reading given by an exposure meter is likely to be inaccurate and for which an allowance must be made. Since the meter calibration is based on an average mixture of tones any subject which is predominantly light or dark will result in a misleading reading. A measurement taken from a bride in a white wedding dress, for instance, will indicate an exposure which will record it as the calibrated mid-tone and which will underexpose the film, recording the dress as grey. Similarly, a reading from a man in a black suit will result in overexposure, rendering it as a grey tone.

If the subject contains very bright highlights – a backlit shot, for instance, or a picture which includes light sources, like a street scene at night – the exposure meter will indicate less exposure than is actually needed. Another common situation in which a TTL meter

Opposite Shooting against the light has created a pleasing halo of light around this picture of a girl on a donkey. I took a close-up reading to establish the exposure necessary to obtain good detail and colour within the model's face and clothes. This has resulted in the brightest parts of the scene being burnt out, which I considered acceptable. It was shot on a Pentax 6x7 camera with a 150mm lens using Kodak's EPR Ektachrome

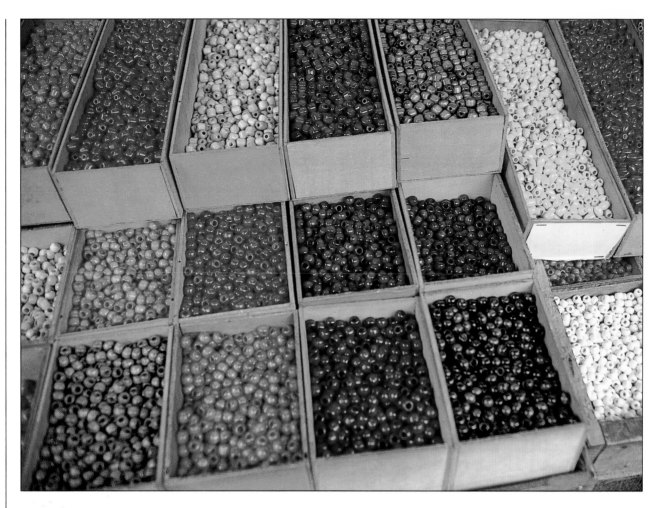

Above These boxes of brightly coloured beads in a Moroccan market were photographed in the soft light of open shade, resulting in an image with well-saturated colours, aided by a slight amount of underexposure. I took the picture on a Nikon F3 using a 50mm lens using Kodak's ISO 64 Ektachrome

can be misleading is in landscape photography where the sky is very bright. This problem is most commonly encountered on dull days when the landscape itself is quite dark in tone and the sky, effectively, becomes the light source. The resultant meter reading can be too high, leading to underexposure.

The brightness range of the subject, and the image contrast, will also affect the exposure calculation. If this exceeds the tolerance of the film it is necessary to decide which are the most important areas of the image and expose accordingly. If, for instance, you are photographing a scene with areas of deep shadow and perhaps a bright sky, an averaging exposure reading would be satisfactory for the mid-tones of the subject, but it might well cause the shadows to be very underexposed and the highlights overexposed. There would be lost tone and detail in both areas.

If the shadows contain important details you must give more exposure than is indicated, but if you want to retain detail in the lighter tones less than the indicated exposure will be necessary.

It is in such cases that those who habitually use their cameras on automatic settings will experience disappointing results. The solution to all these situations is to switch to manual and to take a close-up reading from a small part of the subject which has a more representative tonal range, or to take a substitute reading from an object with an average tone which is illuminated in the same way as the subject.

2 Artificial Light

While by far the majority of photographs taken by amateurs are lit by natural light, the use of artificial light can extend enormously the range of creative possibilities. An understanding of artificial-lighting techniques will also help considerably to appreciate and evaluate the effect of daylight.

In many ways it is easier to use artificial light rather than daylight to learn how lighting can be used to control the quality and effect of an image. This is largely because, unlike sunlight, an artificial-light source can be moved at will to alter its direction in relation to the subject and it can be readily diffused and reflected to create a wide variety of effects. It is not even necessary to take photographs, since much can be learned from simply taking an interesting three-dimensional object, or small still-life arrangement, and by moving a light source around it observe the changing quality of the image.

Many amateur photographers fear that lighting equipment is both expensive and complicated to use, but this is far from the truth and very modest equipment can be used to create powerful images. Unfortunately, the one piece of lighting equipment which most photographers own is a flash gun and this is no help at all in

Below This simple still life of a trout was lit by an ordinary domestic lamp which was diffused by a tracing-paper screen. A white reflector was placed in front of the set-up to lighten the shadows. The background was a slate tile flooded with water. The exposure on Ilford's XP2 was 1/2 sec at f22 using the 150mm lens on my Mamiya 645

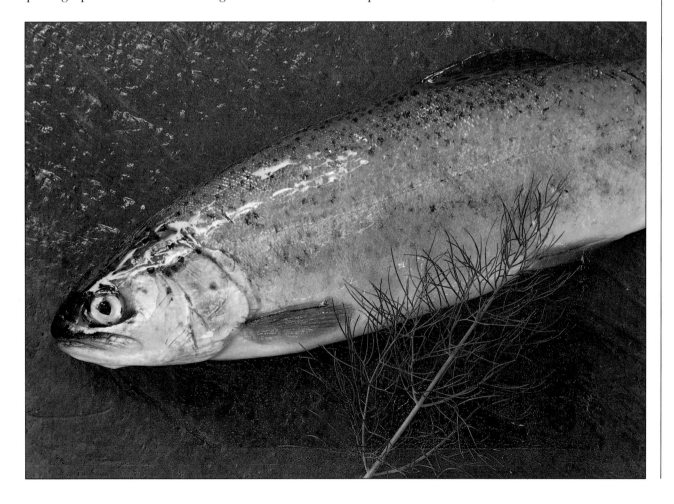

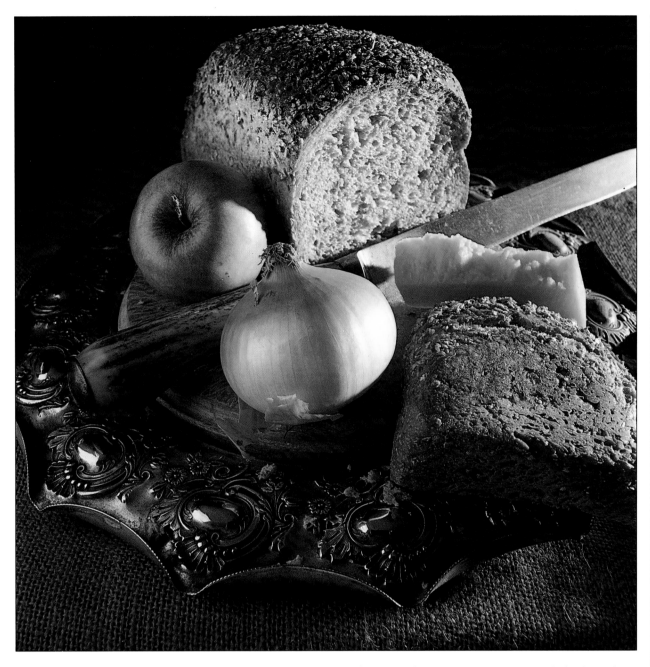

learning lighting techniques because its effects cannot be seen by the naked eye. To fully understand lighting techniques it is necessary to use a continuous light source like tungsten or halogen lamps.

Tungsten Lighting Equipment

The simplest and most inexpensive piece of lighting equipment is something which many people have already in their homes or offices, an anglepoise lamp. When shooting on black-and-white film an ordinary domestic bulb can be used quite satisfactorily for static subjects, like a still life for instance, since the colour quality of the bulb is not important. The relatively low intensity of, say, a 100-watt bulb is also not important when using a tripod to photograph fairly small static objects, since you will be able to give long exposures. You will need, however, to carry out your lighting arrangements in a fairly dark room as the low intensity of the domestic bulb will be overwhelmed by any ambient light.

A small still-life arrangement of interesting objects can be lit very effectively with a small lamp like this, and a great deal can be

Opposite The hard-shadowed light for this abstract nude was created by the use of a single undiffused flash placed just to the right of the camera. No other lighting or reflector was used

Above The spotlight effect of this food still life was achieved by the use of a slide projector using film balanced for artificial light. The highlights on the left-hand side of the picture were produced by a carefully placed mirror and I used a white reflector just in front of the set-up to lighten the shadows

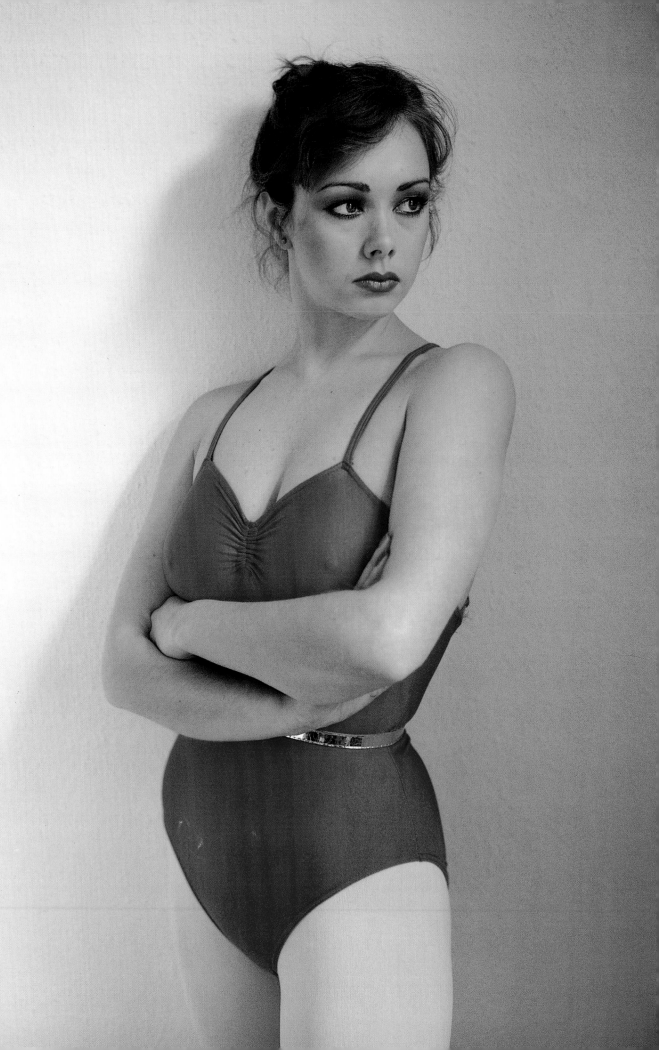

learned by doing so. The direct light of a tungsten bulb will give a quite hard light, but without the sharply defined shadows produced by a point source like the sun. A varying degree of diffusion can be introduced by making a wooden frame and covering it with a large sheet of tracing paper. By placing this between the lamp and the subject, different degrees of diffusion can be obtained by varying the relative distances between the light, the screen and the still-life set up. With the screen close to the subject, and the lamp some distance away, the light will be very diffused with barely definable shadows. As the screen is moved further from the subject, and the lamp is moved closer to it, so the degree of diffusion is reduced, creating denser and more defined shadows.

A large piece of white card or polystyrene can be placed close to the arrangement on the opposite side to the light source in order to bounce light back into the shadows, thus reducing contrast and revealing more detail. A stronger fill-in effect can be achieved with the use of a mirror or crumpled aluminium foil.

A harder light, closer to the effect of a point source, can be obtained by replacing the ordinary tungsten bulb with a spotlight bulb. Another means of creating a harder light to give more sharply defined and denser shadows is with a slide projector. Although rather awkward to angle and direct, a projector gives a tightly focused beam of light similar in quality to a photographic spotlight.

The limitations of the domestic bulb – non-standard colour quality and low intensity – can be overcome by using a photoflood lamp instead. These are the same size and shape as a domestic bulb, but they contain a special over-run filament which gives a much brighter light at the cost of a far shorter life, just a couple of hours or so. The colour temperature of these lamps is 3,200°K, and they are suitable for use with type-T transparency film or type-L colour-negative film. With daylight-type film an 80B conversion filter must be used, but it is not very satisfactory as there is a considerable loss of film speed.

Although photoflood bulbs may, with care, be used in ordinary domestic lampholders they do get very hot and must not be left burning for too long. It is better to buy specially designed photo-graphic lights with ventilated reflectors. A good dealer will be able to supply this type of equipment at relatively modest cost. The lights can be fitted to adjustable stands, making it much easier to control the direction and angle of the lighting. In addition, different types of reflector can be fitted allowing considerable control over the degree of diffusion and the quality of the light.

Photoflood lamps are bright enough to make possible less static subjects, like a portrait, for instance, especially when a fairly fast film is used, say ISO 400 or more. It must be borne in mind, however, that the intensity of a light source diminishes in inverse proportion to the square of its distance from the subject which it illuminates. At 8ft from the subject it will deliver only one-quarter of the brightness that it does when it is just 4ft away. This means that it will require a four-times-slower shutter speed or two-stops extra exposure. The intensity of the light source will also be significantly reduced when a diffusing screen or soft reflector is used.

Thus greater-intensity lamps are required when the lighting has to be further from the subject, heavily diffused, or when slow films or fast shutter speeds need to be used.

Opposite An undiffused photoflood was placed slightly above the model's head and almost at right-angles to the camera for this shot. I used a second lamp bounced from a large white reflector on the opposite side and placed close enough to the model to make the shadows very much lighter. It was shot on a Rolleiflex SLX with an 80mm lens using artificial-light film

Right This beauty shot was lit by three flash heads fired through a diffusing screen placed directly in front of the model with a hole for the camera lens to see through. Two flashes were aimed just above the model's head close to the camera and one immediately below the camera. A fourth flash was placed behind her to illuminate the background

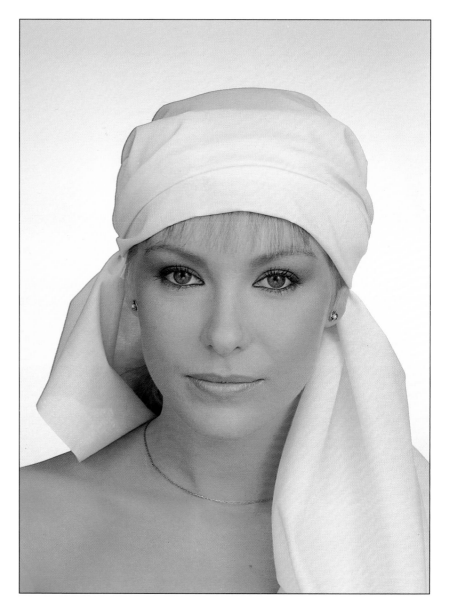

Opposite The duration of a studio flash set at a lower power is usually brief enough to freeze movements like this picture of a model jumping. The flash was fired through a diffusing screen placed at about 45° to the camera with a large white reflector placed on the opposite side to lighten the shadows

Halogen lamps are the choice of most professional photographers where continuous light is preferred. These bulbs are filled with halogen gas which prevents the build up of deposits on the quartz envelope, and which also prevents the gradual reduction in colour temperature that affects ordinary tungsten bulbs as they age. Halogen bulbs become very hot and it is important to use them with the specially designed reflectors and fittings. Replacement lamps are expensive and must be handled with care to prevent damage. It is recommended that the bulbs are handled with gloves since oil from the skin can affect them adversely. This equipment is quite light and portable, and it can be purchased in kits and carried in fitted cases together with accessories for controlling and diffusing the light.

Flash Equipment

By far the most popular choice, however, for professional photographers is studio flash. Unlike portable flash guns, studio flash is fitted with continuous tungsten bulbs within the flash tube. These are known as modelling lights and give a very accurate impression of

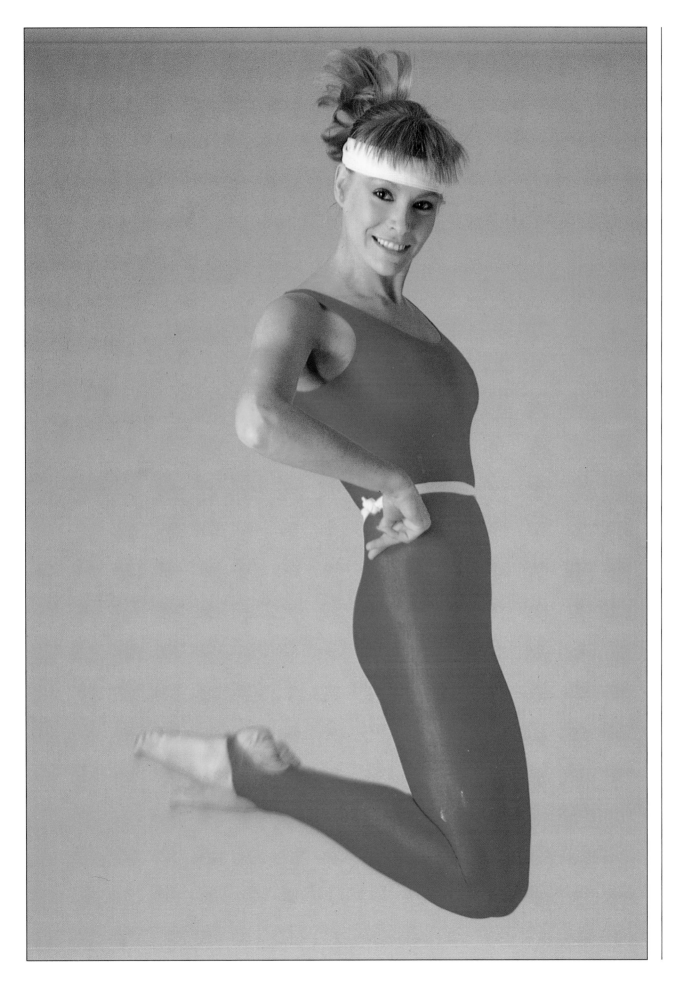

Right Two photoflood lamps bounced from white reflectors placed each side of the set-up were used to illuminate this shot of an antique camera. I used an exposure of 1 sec at f45 on Ilford's FP4 to ensure adequate depth of field. The camera was an Arca Swiss 5x4 with a 150mm lens

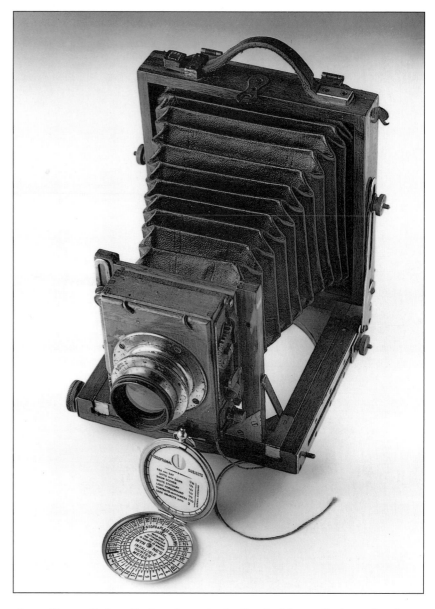

Opposite A flash fitted with a soft box was placed slightly behind and to the right of this model with a large white reflector positioned on the opposite side at a distance which made the shadows just a little lighter. I took the shot on a Rolleiflex SLX with a 150mm lens using Ilford's FP4 with an aperture of f11

the effect of the flash when it is fired. Many flash units have modelling lights which are coupled to the variable power of the flash so that when two or more flashes are used at different power settings the balance between them can still be judged accurately.

Studio flash has several very positive advantages over tungsten or halogen lights. Its colour quality is very stable and matched to the colour temperature of daylight-type film. The flash is very brief, which means that in normal circumstances any subject movement will be frozen, thus ensuring very sharp images. The modelling lights are not as bright or as hot as halogen lamps, and this creates a more comfortable environment for models.

There are some disadvantages, however, with flash equipment. The main difficulty is that, because the flash is so brief, the shutter speed is irrelevant. Exposure control can only be achieved by the choice of aperture, the distance the flash is from the subject and its power setting. In practice, this means that once a lighting arrangement has been set up the only way of increasing the exposure is by opening the aperture or by increasing the power of the flash.

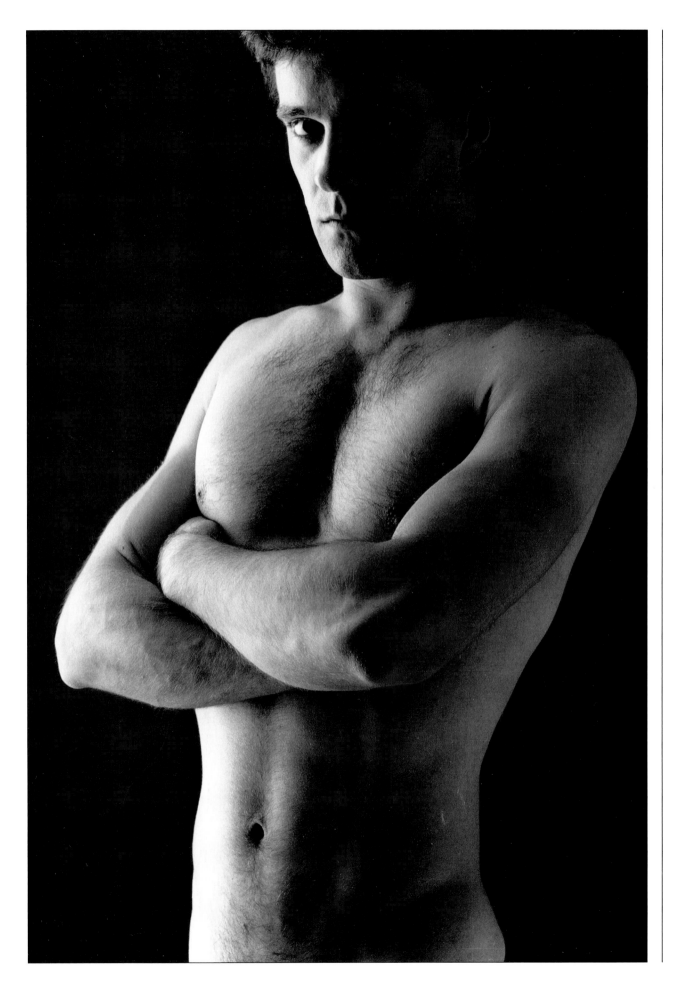

With a high-output flash, or with subjects requiring only a relatively small depth of field, this is not a serious problem. But in cases where a small aperture is needed to give a large depth of field – a still-life arrangement, for instance – the maximum power of the flash can be quite a limiting factor.

With a continuous light like tungsten you can simply give a longer exposure, but with a flash at its maximum setting the only way to give more exposure without opening the aperture is to expose the film to additional flashes. One-stop extra exposure will need two flashes, two stops four flashes and so on. This technique is only suitable for completely static subjects. Professional photographers overcome the problem by the use of very powerful, and expensive, flash generators of 5,000 joules or more. Although small studio flashes with a modest output can be ideal for subjects such as portraits, fashion or nudes, if you have a limited budget continuous lighting can be a better choice for subjects like still lifes.

Studio flash units are made in two basic forms, the monobloc and the powerpack. The monobloc is designed so that each flash tube is combined with its own power source in a single portable unit. The powerpack has a much larger floor-standing generator which can power a number of separate flash heads. Although some of the monobloc units have considerable output, the most powerful flashes are obtained with the separate powerpacks. However, if this power supplies two or three heads the result can be individual flash heads with less power than a monobloc.

Monobloc units, on the other hand, being larger and heavier than a flash head, are less convenient when used on boom stands, for instance, or when you want to hide a flash behind the subject. With the monobloc system the camera needs only to be synchronised to one unit with slave cells firing the other heads simultaneously. In addition to the conventional synchronising lead which connects the camera to the flash unit, it is also possible to buy remote-radio or infra-red controls which avoid having cables trailing across the studio floor.

Exposure calculation can be made for continuous-lighting set-ups with the normal daylight-photography TTL metering, but flash requires the use of a special meter in order to take a reading during the very brief duration of the flash.

Most flash meters are used in the incident mode, which means that they are held in front of the subject being illuminated and aimed towards the camera position. In this way they read the light level of the source, instead of that reflected from the subject. In some cases, this can be a more accurate means of measuring exposure but it has to be said that most professional studio photographers also use polaroid film as a double-check on both lighting balance and exposure.

In studios where the same type of lighting arrangement is used regularly, the flash meter is often dispensed with and the polaroid alone used for exposure assessment. I am never completely happy when using flash unless I can shoot a polaroid and, like most professional photographers, consider that polaroid equipment is an essential accessory for studio flash lighting.

Light Control

The light source itself is only part of the equipment needed for arti-

Opposite A flash fired through a large soft box was placed almost at right-angles to the model on the right-hand side in this nude shot, with a large white reflector positioned very close to her on the opposite side to lighten the shadows. I used a 150mm lens on my Rolleiflex SLX with Kodak Ektachrome and an aperture of f11

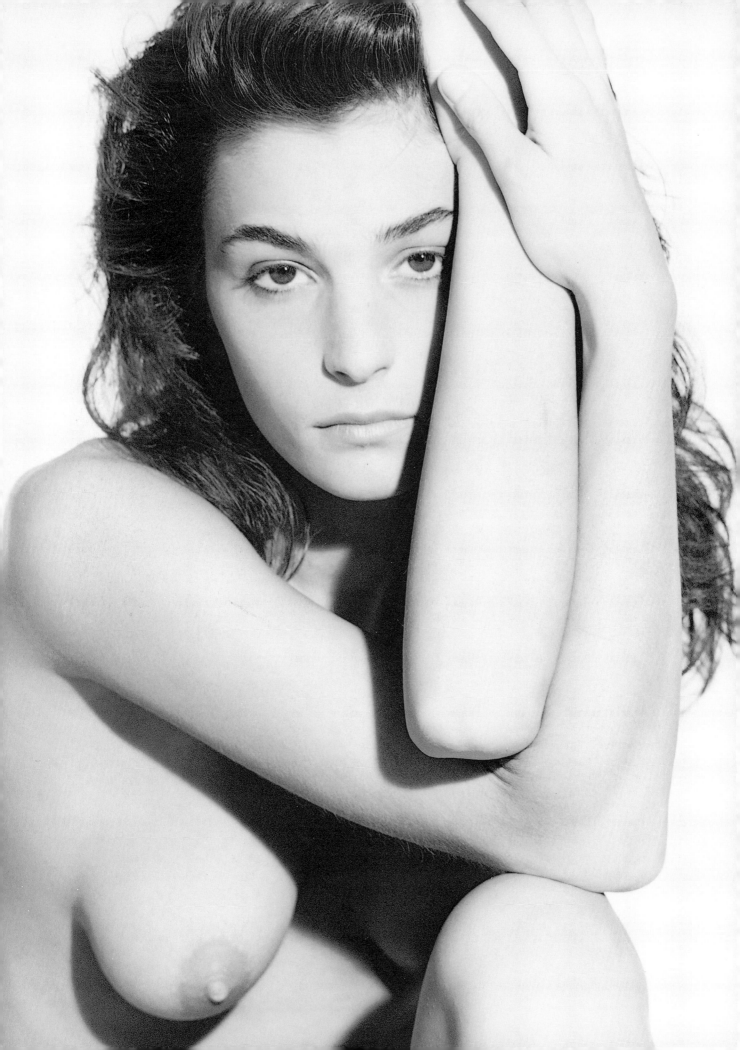

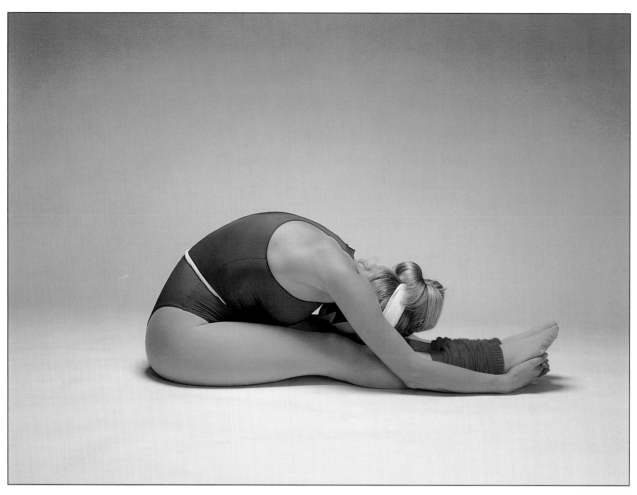

range of sizes, from small ones which can be fitted to portable flash guns up to giant affairs, known as swimming pools, used in professional studios.

The need for a large diffuser stems from the fact that the degree of diffusion depends partly upon the size of the diffusion screen in relation to the size of the object being illuminated, and also its distance from it. When an umbrella reflector is placed quite close to the subject it will create a very diffused light, but as it is moved further away its light becomes both harder and more directional. A point is reached where it will be no more diffused than the direct light from the lamp. The beautifully soft, often overhead, light used frequently in food and still-life photography is created by using a diffuser which covers a larger area than the subject it is illuminating, virtually enveloping it in light.

Ready-made diffusers are not essential. I often prefer to use a large wooden frame, about 6ft x 4ft, covered with frosted plastic or tracing paper which I made years ago. Placed quite close to a model, with one or two light sources about 10ft behind, it creates a lovely soft, even light which needs almost no fill-in. Its limitation is that it is only really convenient for fairly horizontal lighting, as it is too awkward to set up high above a model or still-life arrangement. It is in these situations where a specially designed soft box is much more convenient to use.

Other essential items of lighting equipment are reflectors. They are often more satisfactory in revealing detail in shadows and

Above A large soft box was used to diffuse the flash, which was held about four feet above the model on a boom stand, for this softly lit model shot. A large white reflector was placed in front of her on the floor and angled to throw some light back into the shadows. I used the 150mm lens on my Rolleiflex SLX with an aperture of f11 on Kodak EPR Ektachrome

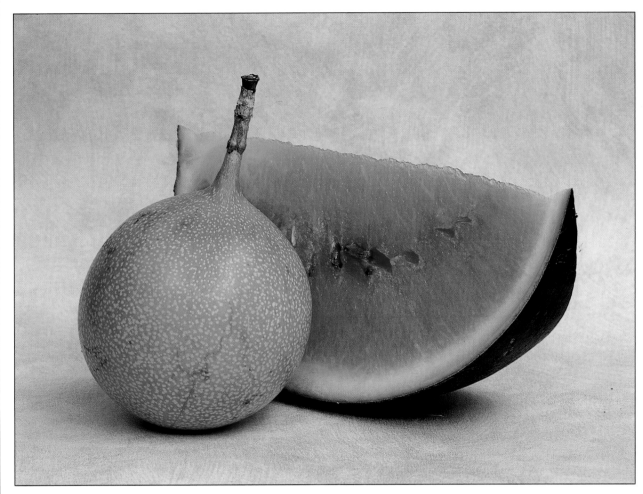

Above A flash fitted with a soft box was suspended directly above this still life of fruit to create a soft and nearly shadowless light with no other lighting or reflector used. It was shot on my Mamiya 645 with a 150mm lens using an aperture of f11 with Fuji's Velvia film

ficial lighting. The methods of controlling and diffusing the source are also important. A bulb or flash tube in an ordinary metal reflector creates a quite hard light with well-defined, but not sharp-edged, dense shadows. For really sharp black shadows some form of focusing spotlight is needed. These can be bought either as a self-contained unit or as an accessory to fit many flash and tungsten-light sources.

Another method of concentrating the light source into a confined beam is by the use of honeycombe grids placed over the front of a reflector. These can be very effective for creating pools of light and illuminating selective areas of a subject, like the hair in a portrait, for example, A snoot has a similar effect and a perfectly satisfactory makeshift device can be made with a cone of black paper taped to the front of the reflector.

The simplest and most convenient way of creating a more diffused source is to use a white umbrella; it is also very light and portable. Most flash lights and halogen lamps have a fitting in the reflector which accepts the stem of an inverted umbrella. The lamp is simply aimed into the umbrella and the light is diffused by reflection. A translucent umbrella can also be used, so that the light is aimed through it, creating a more direct diffusion.

The soft box is a more elaborate way of diffusing a light source and it gives a more even, softer, spread of light. It's really little more than a screen of translucent plastic at the front of a light-tight, often fabric, box which fits over the flash lamp. They are made in a wide

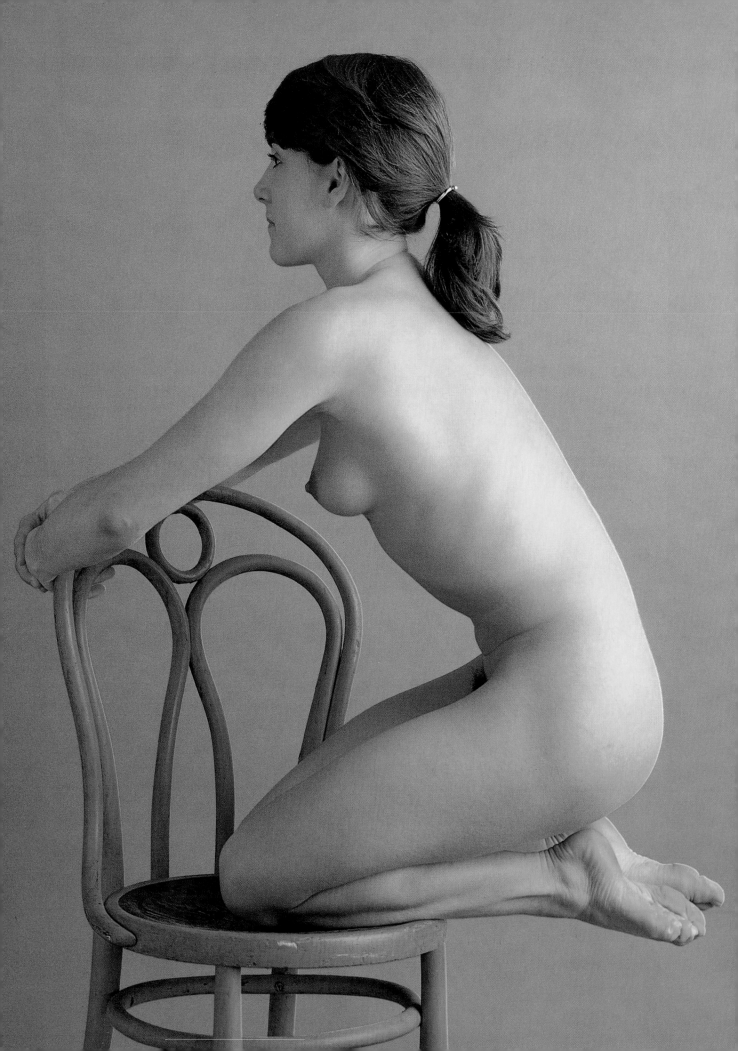

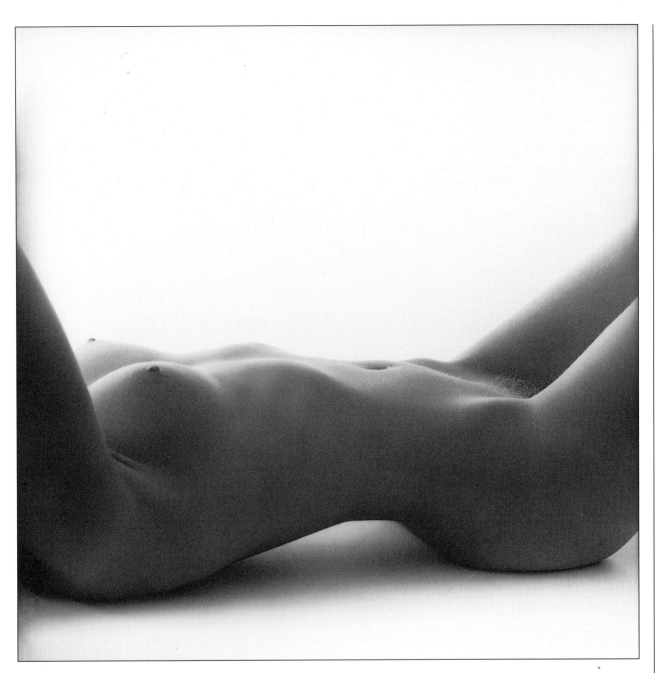

reducing contrast than are fill-in lights. They also pose no risk of creating secondary shadows and cross-lighting effects.

The simplest and least-expensive type of reflector is simply a large sheet of inch-thick polystyrene, the type used for insulation. They are very light and rigid enough to be propped against a light stand. A good builder's merchant will supply them in 8ft x 4ft sheets and they can be easily cut, or even just snapped, to the size required. It is a good idea to paint one face black. In this way the other side can be used as an anti-reflector on occasions when you want to create as much contrast as possible for dramatic or theatrical effects. The disadvantage with the polystyrene sheet is that it is not really very portable. For this purpose semi-silvered or white-fabric reflectors can be bought from professional photographic dealers; they are simply stretched over a collapsible metal or plastic frame.

Good stands are also important for the comfortable and convenient positioning and adjustment of lights. The most basic type, and quite portable, is the tripod-base stand. They can be bought in a variety of weights to hold everything from the lightest reflector to

Opposite I placed an undiffused halogen lamp fitted with a fresnal lens close to the camera on the right-hand side to photograph this spotlit nude. A second light placed behind the model was used to illuminate the background

Above A single flash aimed at a white ceiling above and slightly behind the model was the sole illumination for this shot. The model was placed on a plinth upon which a roll of white paper provided a seamless background

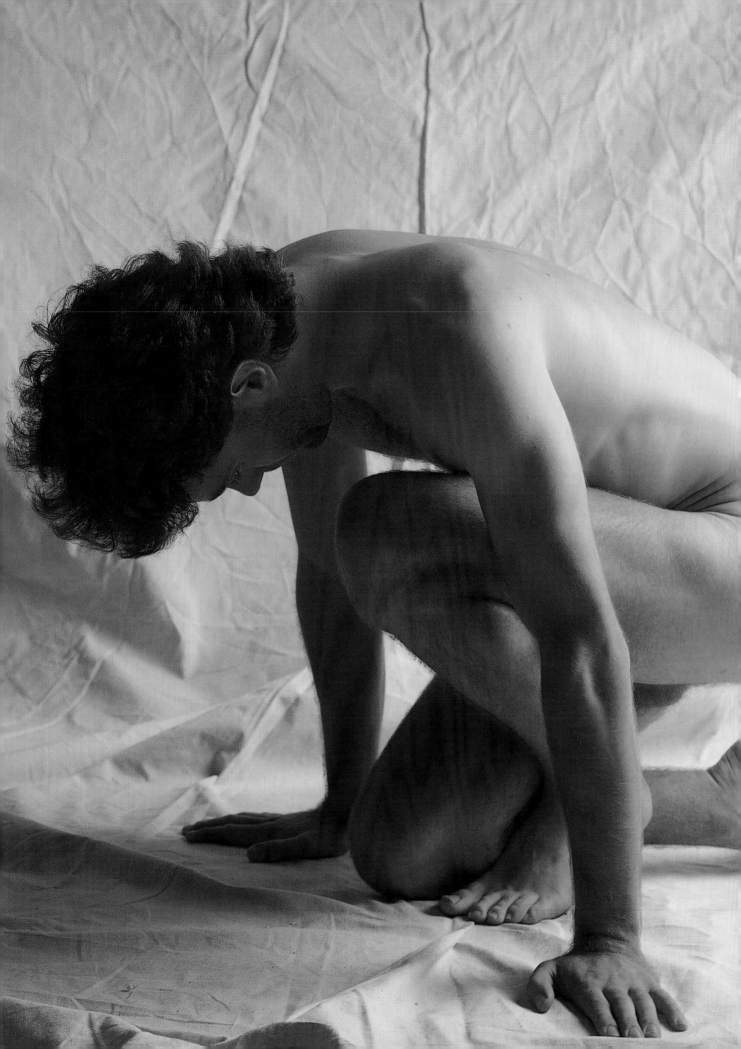

large soft boxes. A wheel-base version is useful for heavier lights, and a boom attachment invaluable for situations where you want to suspend a light source above a set-up or model (to light the hair, for instance). Small single-stem stands with a flat base are useful for occasions when you want to place a light immediately behind a model to illuminate the background.

The pole-type stand is useful if you have limited floor space, as these are held between floor and ceiling by means of a spring and lights can be attached anywhere between by adjustable brackets. They can also be used to support backgrounds. A permanent studio space can be fitted with overhead tracks, which leaves the floor completely clear, but these are quite expensive and are, of course, not portable.

The question of how many light sources are needed must also be considered. The answer is that it very much depends upon the type of work you want to do. A considerable variety of lighting effects can be achieved with just one light and a selection of diffusers and reflectors. Many professional food and still-life photographs are taken with just a single diffused source and reflectors to fill in.

However, the possibilities are greatly increased by the addition of a second source. It can be used as a fill-in to reduce the contrast created by the main light, or to establish rim lighting or deployed as a hairlight in a portrait, for instance. A second light may also produce interesting background effects, especially when used with a focusing spotlight attachment or with a honeycombe grid or snoot.

A third light source allows, for example, the successful combination of key light, background light and hairlight. For basic portrait, fashion, nude and still-life photography it is unusual for more than three light sources to be needed, although extra lights are sometimes required for more difficult lighting arrangements or for bigger subjects – a car or a large interior, for instance; or to light a large area of background evenly.

The portable flash gun, as I mentioned earlier, is of fairly limited usefulness because it is not possible to view its effect. If you have a polaroid back for your camera, you can use this to check the set-up before you start to take your shots on regular film. A portable flash gun is usually, therefore, at best, a compromise. When aimed directly at the subject from the camera position the lighting quality is not likely to contribute much to the photograph.

For this reason, an off-camera flash gun, either bounced from a reflective surface or diffused by an umbrella or soft box, is much more useful than an inbuilt or hot-shoe version. It is also helpful to have a fairly powerful flash gun, as the intensity of a low-powered gun limits the distance at which it can be used from the subject and the degree to which it can be diffused or reflected. Lower-powered guns can also take an excessively long time to recycle, which is very irritating when you are photographing people.

Setting up a Studio

A studio set-up does not have to be expensive or complex, particularly if it is to be used on a casual, part-time basis. Providing you have a room of reasonable size that can be partly cleared of furniture, it will only need a moderate investment in some lighting equipment to expand both the range and the style of your pictures considerably.

Obviously the larger the room you have available the better, but

Opposite A large piece of crumpled canvas was used as the background for this male nude. I used a flash fitted with a soft box from above the model and almost at right-angles to the camera with a large white reflector placed just to the left of the camera and quite close to the model to bounce a little light back into the shadows

Overleaf, left A boom stand was used to suspend a flash behind and slightly above the model in this portrait to create a rim of light around her hair. It was fitted with a snoot to limit the spill of stray light. The main light was a soft box from close to the camera position and I placed white reflectors each side of the model and under her chin to minimise the shadows

Overleaf, right A length of calico painted with acrylic paints was used for the background in this portrait picture. It was lit by placing a flash fitted with a large soft box at about 45° to the camera on the right-hand side, and a large white reflector was positioned close to the model on the opposite side to lighten the shadows. I used Fuji's ISO 50 film at an aperture of f11 using the 150mm lens on my Mamiya 645

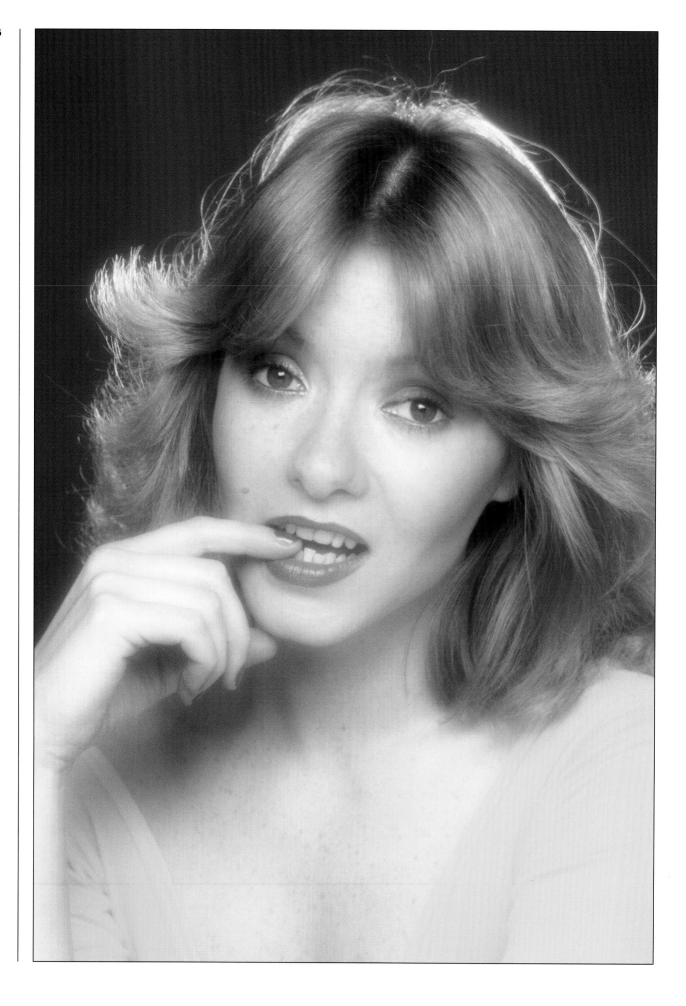

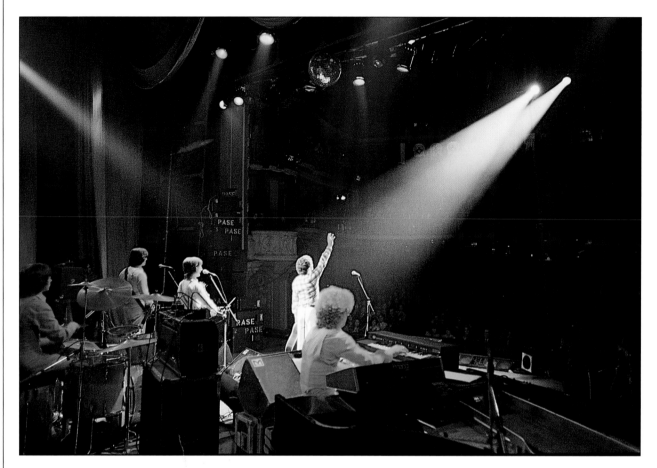

Above This shot was taken from the wings at the end of a performance using artificial-light transparency film in a Nikon FE2 with a zoom lens set to about 70mm. The exposure reading was made by zooming into the central portion of the image in order to avoid the large area of black background influencing the reading. The very high brightness range has meant that some detail has been lost in the highlights

Opposite The long-legged lady in this studio shot was photographed standing on a raised plinth which was covered by a large mirror. A roll of white paper, lit by two flashes one each side and behind the model, provided the background and reflected in the mirror to create a pure white surface. The legs were lit by a flash fitted with a soft box placed almost at right-angles to the camera

it is possible to cope with a wide range of subjects in a quite modest space. For many years I had a studio of about 1,200sq ft but for many shots I would often find myself working in just one small corner of it.

Simple still-life arrangements can be photographed easily on a kitchen table, for example. For portraits you will need to have about six feet between your camera and the model, and a yard or so at least between him, or her, and the background. Naturally for three-quarter and full-length pictures you will need substantially more than this. However, remember that you can always increase the distance between the camera and the model by shooting from outside a doorway.

The width of the room is also significant since you will need to have sufficient space each side of the model in order to position lights at a comfortable distance. Where width is limited the pole-type stands described on page 55 can be especially useful as they allow the lights to be placed right back against the wall. A reasonably high ceiling allows you to use low camera angles more readily. It is necessary to have curtains or blinds so that daylight can be excluded. When relatively low-powered tungsten lighting is used, any ambient light dilutes the lighting effects you create and it is also far more difficult to see the effect of modelling lights when using studio flash.

If your room has plain, painted walls they can sometimes be used as a background for pictures. However, it is far better to have a moveable background and to be able to vary the colour and tone to suit a particular shot. Rolls of cartridge paper in a wide range of colours up to a 9ft width are obtainable from professional photographic dealers. These can be taped to the wall or supported on light

60

Right This very simple arrangement of spinach leaves was lit by a flash fitted with a large soft box placed behind and above the set-up, with a white reflector positioned on the ground in front of the subject and angled to throw some light back into the shadows. The background was a paving stone sprayed with water. I used my Mamiya 645 with a 150mm lens stopped down to f22 for maximum depth of field with Fuji's Velvia film

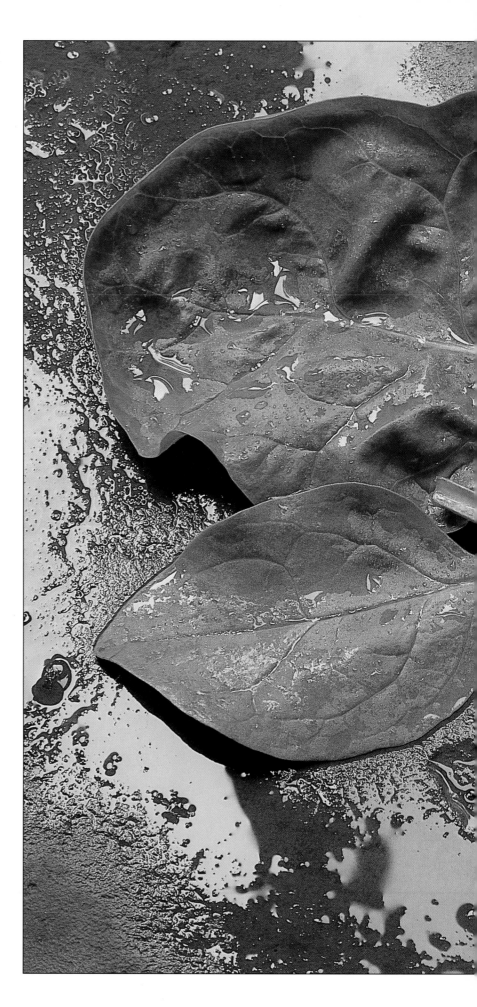

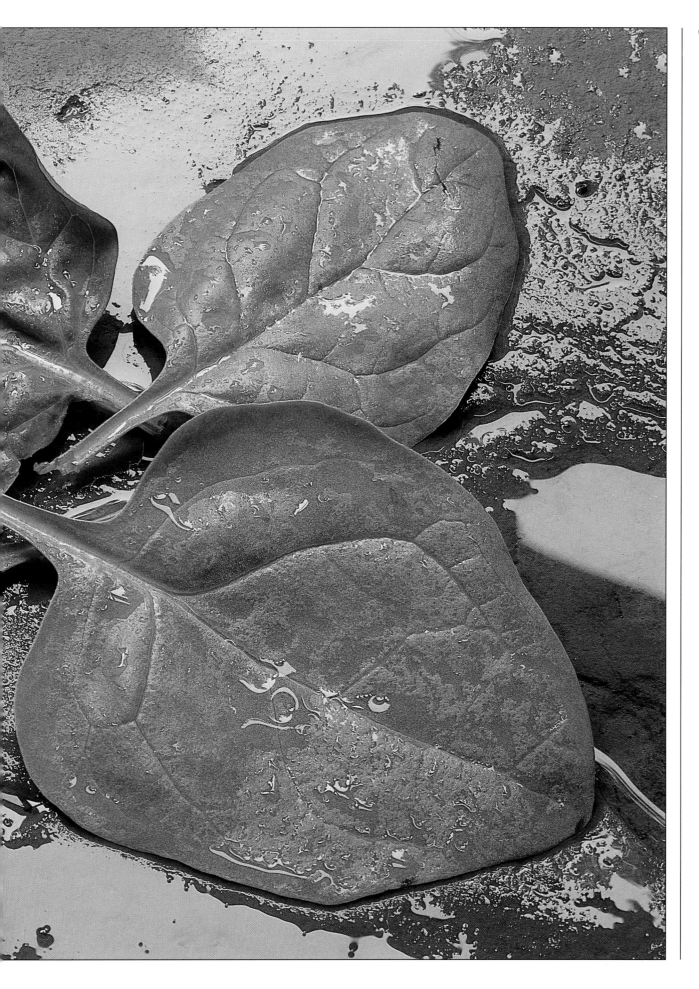

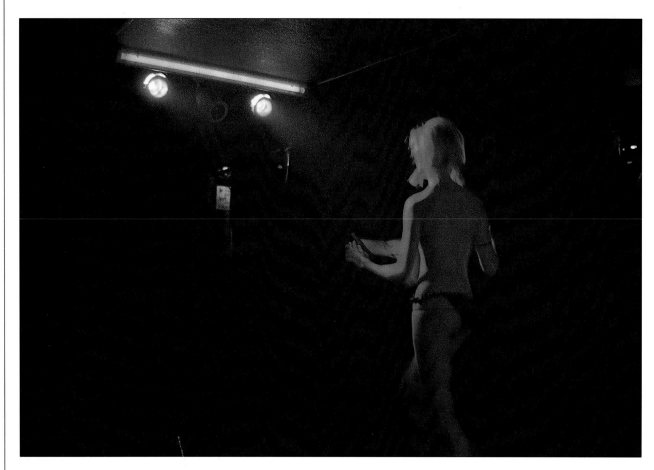

Above I used a fast daylight-type transparency film pushed two stops in processing for this shot of a strip club with an exposure of 1/60 sec at F4 on a standard lens with a Nikon F3. The exposure reading was taken by angling the camera down to avoid including the light sources and reduced by two stops to allow for the large area of background. I made a clip test for a final assessment and pushed the balance of the film half a stop more than anticipated

stands or the sprung poles described on page 55.

Fabric may also be used successfully, although be sure to iron it carefully and to stretch it so that it is crease-free. Another useful form of background is painted canvas. This is quite fashionable at the moment, especially for portrait photography, and it can be bought readymade from professional dealers in a range of colours and effects. However, it is much cheaper, and the effects more subtle and individual, to make your own. Canvas and calico can be bought inexpensively in widths of up to 10ft or more from theatrical suppliers, and then painted with water-based acrylic paints using either brushes, spray guns or rollers.

A Permanent Studio

If you want to carry out studio sessions frequently, and have the space available, it is naturally much more satisfactory to have a permanent facility. You will save a great deal of time in preparations, and can so arrange things to have a comfortable and convenient working environment with a readily-to-hand place for everything you need.

The ideal space is one in which you can shoot a full-length figure when using a standard lens; indeed, in some circumstances, it is even an advantage to use a long-focus lens. Either way, it is worth setting up a trial shot in a proposed space before committing yourself to it. If you intend to use the professional cartridge-paper background rolls, then you will also need at least 3ft each side of the 9ft paper width in order to position your lighting, making a minimum of 15ft studio width. Ceiling height can also be an

important factor, especially for full-length pictures, since a 6ft model, placed a couple of yards in front of the background, needs at least a 10ft background to clear his or her head with comfort. If you use a low camera angle an even higher ceiling will be needed.

The cartridge-paper rolls supplied by professional dealers are ideal as backgrounds, because they can be suspended and allowed to curve on to the floor, thus creating a smooth, join-free sweep for full-length shots. A more elaborate, and expensive, system is the modular plastic coving which can be painted between sessions as required.

Paper background rolls are best supported on the specially made stands or wall brackets. These can take up to three or more rolls at once, making background changing during a session a quick and simple affair.

A good firm tripod, or even a wheel-based camera stand, should be considered an essential piece of studio equipment. One with a centre column enables you to adjust the camera height quickly and easily, and a camera stand allows you to move it from floor level up to a height of 10ft or so in seconds. Such a stand also makes it a simple matter to shoot directly down on to a subject from above, a facility that is often essential for still-life arrangements.

A table or bench is another prerequisite for still-life photography. Ideal is one which allows a sweep of paper or laminate to be attached from a bar or bracket at the back. It is also useful to be able to change the normal surface for translucent plastic, thus allowing objects such as glassware to be lit from below. Special still-life benches can be bought from professional dealers, but it is easy

Below Discothèques are notoriously difficult to photograph successfully. This shot was taken by using a longish exposure of 1/4 sec on a fast daylight-type transparency film pushed one stop in processing, using a 50mm lens at f2.8 on a Nikon F3. I used a small amount of fill-in flash. The effect of the movement was heightened by the fact that the disco lighting included some strobes

Above The interior of this rather splendid fishmongers in Lille was shot on Kodak's High Speed Ektachrome and lit by a mixture of tungsten, daylight and fluorescent sources. I used a 10 magenta filter to offset a potential green cast from the latter. I gave a series of bracketed exposures around 1/8 sec at f8 using a 28mm lens on my Nikon FE2. A third-of-a-stop lighter than the central exposure worked best

Opposite This children's party picture was lit by a mixture of mainly daylight mixed with some ordinary domestic lighting, and I used Kodak's high Speed Ektachrome – daylight-type film – pushed one stop in processing. Although some of these pictures were none too sharp I felt, overall, they had a more interesting and pleasing quality than if flash had been used

enough to construct one from materials like Dexion.

If you plan to photograph people on a fairly regular basis some facility for changing and preparation is vital. A small curtained area with a good light and a full-length mirror is fine; a small bench for accessories and a garment rail with some hangers is also helpful. Good heating is essential, and background music helps to create a more relaxed atmosphere.

The range of backgrounds may be extended by the addition of two or three wall flats. These are simply hardwood frames covered in hardboard or plywood. They can be joined together with G-clamps in a variety of ways to establish small room settings, and covered with paper or fabric, or painted, to achieve a variety of effects. A plinth is also useful: it is easily constructed from a wall flat placed on a number of plastic crates or stout wooden boxes to raise it to the required height. The same methods can also be used to create different levels and supports, which, when covered with fabric or cushions, help models to pose.

Using Available Lighting

When light levels are low many photographers reach automatically for a flash gun. There are, however, many occasions when the use of a flash gun is either impractical, not allowed or simply undesirable. The light from a flash gun can completely eliminate the atmosphere of a shot. In a restaurant, for instance, the romantic evening spent in a charming small bistro is seldom evoked by a photograph taken with the cold, impassive light of a flash gun.

At many public functions, like concerts and theatre perfor-

mances, flash guns are often simply not permitted and even when they are it's not always feasible to use one. At any large venue, such as London's Wembley Arena, you will see dozens of people popping off flashes from seats hundreds of feet from the stage when the light from the flash will be lucky to reach more than a few rows in front of them. There are also occasions when flash would be too much of an intrusion. All of these situations leave the use of available light as the only practical option.

Although the vast majority of pictures taken in the home are shot with the aid of flash, it is often better not to use it and preferable to make use of the existing domestic lighting. This technique is especially useful when the lighting in a particular location or situation is a crucial element of its mood or appearance. Indoor lighting is often a very significant aspect of the character and appearance of a room, and if it is flooded with a completely alien form of lighting it sometimes becomes almost unrecognisable. In these cases it is distinctly advantageous to make use of the available light.

There are, however, a number of factors to consider when shooting in these conditions. Firstly, it is highly probable that the level of illumination will be quite low, making it necessary to modify your usual camera technique. Even using a faster-than-normal film you will invariably need to use both slower shutter speeds and wide apertures. Both accurate focusing and a means of supporting the camera will be vital to ensure sharp results. A tripod is the best type of support for fairly static subjects, but a monopod can also be helpful. If nothing at all is available then it is advisable to find some natural support, like a wall or door frame for example, against which you can lean your camera.

However, supporting the camera and using a slow shutter speed is of limited help if the subject is moving and, in these circumstances, it may be necessary to uprate and push-process the film to allow the use of a faster shutter speed. Most colour laboratories offer a service whereby the speed of even very fast films can be further increased by one or two stops; this is done by modifying the development times. It results in a loss of quality and an increase in the grain size of the image but, in many circumstances, this adds to the impact and mood of a shot.

Image contrast is also sometimes a problem with this type of picture. Available light often creates areas of both deep shadow and bright highlights, and this produces poor-quality pictures if some care is not taken. The best solution is to choose a viewpoint and to frame your pictures in such a way that extremes of brightness are avoided. Ideally, you should aim for the picture area to be either predominantly in shadow, with only small areas of highlight, or to keep the shadow areas very small. As a general rule, it is best to frame pictures quite tightly on such occasions, when the brightness range can be very high indeed.

For the same reasons, exposure calculations must also be made carefully. It is best to take close-up readings from the subject and to ensure that the meter is not influenced by either deep shadows or bright highlights. Alternatively, you can use the averaging method: this involves taking an average of a reading from each of the darkest and lightest areas in which you want to retain detail.

When shooting in black and white, the main consideration is the intensity of the light sources and the speed of the film you use.

Opposite The interior of the casino in Germany's spa resort of Baden Baden is lavishly ornate and although this shot was lit predominantly by tungsten light I decided to shoot on daylight-type film to enhance the golden quality of its decor. I used a 28mm lens on a Nikon FE2 with a tripod-mounted camera to allow a small aperture and slow shutter speed to be used

Above This section of Tokyo's fish market has a rather sinister aspect with mist rising from the chilled bodies of tuna fish laid out like corpses for the ensuing auction. Lit by a mixture of mainly tungsten light, I used 3M's 640T artificial-light film without filtration, with exposures in the region of 1/15 at f4 on a wide-angle lens with Nikon F3

Opposite Lit mainly by conventional spotlights, I shot this circus performer on artificial-light film using a 150mm lens on a Nikon F2. The subject was well lit enabling an exposure of 1/60 sec at f4. I gave half a stop less than the indicated exposure to allow for the black background

With colour photography, however, you must also consider the colour quality of the illumination. In a purely technical sense, you should try to match your film to the colour temperature of the light source, using colour-correction filters if necessary. In practice this is not always feasible, since unless you use a colour-temperature meter it might be very difficult to establish the filters needed for accurate colour. Furthermore, there will often be several light sources in a room, each with a different colour temperature and there might also be some ambient daylight. From a creative point of view, it is also not always desirable to attempt to reproduce a completely neutral colour balance. In such situations colour casts often contribute to the mood and atmosphere of a picture.

When shooting on colour-transparency film it is best to simply use the film type closest to that of the colour temperature of the most dominant light source, allowing the rest to fall into place. Bear in mind, however, that a warm, or yellowish, colour cast is invariably more attractive than a blue or green bias. It is important too to appreciate that the seemingly white light of most fluorescent tubes will, in fact, record a rather nasty shade of green on the transparency. If this light source is dominant a quite strong degree of magenta filtration is needed to neutralise it. With most daylight-type tubes, filters in the region of CC 20-30 Magenta will be required when daylight-type film is used.

It is also worth remembering that different transparency films have a very varied response to mixed and non-standard lighting. If you intend to take many pictures under these conditions, it is well worthwhile experimenting with different makes and speeds of film

to see which gives you the most satisfying results.

As a general rule, however, where unknown and mixed light sources are concerned it is far safer to use colour-negative materials. Not only can the colour balance of the image be altered enormously by filtration at the printing stage, but also the film itself tends to be more tolerant than transparency film of discrepancies in colour temperatures. It also seems to be better able to cope with the high brightness ranges of this type of lighting and it is more lenient with exposure errors.

Many public events, both outdoor and indoor, offer exciting visual possibilities for the photographer. The lighting effects used at pop concerts, for instance, are often a great deal more interesting and exciting than the performance they are illuminating. Unfortunately, the troubled nature of some aspects of our society means that at certain of these events photography is often restricted to those who have official accreditation. However, it is always worth approaching the promoter to see if permission can be obtained.

It is usually possible, though, to take equally satisfying photographs of more modest events, even if they do not perhaps have the same news value. While it would doubtless be difficult, or impossible, to obtain permission to shoot pictures at a major theatre production in London's West End or Broadway, for example, your interest in photographing a local amateur-dramatic group's performance could well be welcomed with open arms. In the same way, pub rock bands and jazz clubs are often both more accessible and interesting for a photographer than a concert at a major venue, even

Opposite Shooting at dusk, before all the light has left the sky, means that this picture of Copenhagen's Tivoli gardens avoids having a completely black background. I used a tripod-mounted camera to allow a smallish aperture and a slow shutter speed to be used with a 35mm wide-angle lens on a Nikon F with daylight-type film

Below Tokyo's Ginza Street was the location for this nocturnal scene. Shot at dusk, the street was well lit and I was able to use exposures in the region of 1/30 at f5.6 with Kodak's High Speed Ektachrome. I used a 35mm wide-angle lens on my Nikon F3 for this shot, and made the exposure readings by ensuring that the brightest light sources in the scene were not included

if permission were to be granted for the latter. At a smaller, less important, event the choice of viewpoints is usually far less restricted and you are able to get much closer to the action.

As a general rule, the light levels at concerts, theatre performances and indoor sports are considerably higher than those encountered in domestic interiors. However, the element of movement is likely to be of more concern and faster shutter speeds will invariably be necessary.

The problems of light sources, colour temperature and film are, however, very similar. Stage lighting is very unpredictable since it constantly changes, often coming from numerous individually filtered sources. There is frequently even little point in choosing between tungsten and daylight-type transparency film, since during a brief period of the performance the overall colour quality of the light may change from blue to red and then to green. This again is a situation where colour-negative film is a safer choice.

The lighting at indoor sports and illuminated stadium events like football is, however, relatively stable and predictable. If you intend to use transparency film at these events fairly frequently it is worth making some test exposures to establish the best film and filtration. While weird colour casts sometimes enhance the effect of pictures of rock concerts, sports photographs look better with a reasonably neutral colour balance.

The other quite common occasions on which it is necessary to shoot by available light are when photographing night scenes or illuminated buildings. Peopled nocturnal streets present much the same sort of problems as available-light photography at concerts and theatres. A fast film is usually necessary to allow the use of fast shutter speeds and to eliminate the risk of subject movement.

Push-processing techniques can be used with both colour-transparency materials and black-and-white negatives to further increase the stated speed of the film, allowing ratings of ISO 3,200 and more to be used. This produces a considerable amount of grain and loss of image quality but, in many cases, this contributes to the mood and effect of the pictures.

Exposure calculations can also be problematical in nocturnal street scenes, since the image area will often include some of the light sources, such as street lamps and illuminated windows. It is important to take readings without allowing these to influence the exposure measurement, as this would cause significant underexposure. A close-up reading from a representative mid-tone in the subject is the best solution.

The risk of excessive contrast is also somewhat greater with this type of picture than it is with other forms of available-light photography. It is very easy to underestimate the brightness range, especially when the scene contains a number of strong light sources. It is best to choose viewpoints and to frame your photographs in ways which allow large areas of shadow to be excluded. In general, the mid and upper range of tones are the most important in pictures of this type and when the exposure is set for these lighter tones, darker areas of the image will become black voids.

A very effective way of reducing the contrast of street scenes at night, and particularly of illuminated buildings, is to shoot before the sky loses all its light. The period of dusk for an hour or so after sunset is the best time, since residual light in the sky allows the

Opposite Taken well before darkness set in, this shot of Danish sailors in the Tivoli gardens was lit by some residual daylight as well as the bright fairground lights. I was able to shoot hand-held exposures of around 1/30 sec on Kodak's High Speed Ektachrome pushed one stop with a 50mm lens at an aperture of f2.8 on a Nikon F

Above Taken more than an hour after sunset, I was obliged to wait until the illumination was switched on for this shot of Cologne cathedral. By this time it was too dark to see the camera settings, and the shot needed an exposure of 30 secs on Fuji's Velvia film using a zoom lens at about 50mm at f4. In order to obtain a reading I had to set the film-speed dial to ISO 1000 and give 20 times the indicated exposure of 1 sec, bracketing from 10 secs to one minute outlines of details which fall outside the illuminated area to be seen clearly. When shooting on daylight-type film the sky is usually recorded as a rich dark blue and the warm tone of the illuminated areas can look especially attractive in contrast. Pictures of this type, which don't include people, allow the use of a tripod and much longer exposures, which means that you can use slower films for maximum definition and image quality.

3 Artificial Lighting Techniques

Using a Flash Gun

A small flash gun is probably one of the first accessories to be acquired and, with many of today's 35mm cameras, a flash facility is often an integral part of the camera body. There's no doubt that it's very useful and convenient to be able to carry your own supply of light around in a tiny container, to be dispensed at will. However, if a flash gun is used indiscriminately, the resulting pictures can be very disappointing and some care and thought is needed to produce a pleasing quality of light.

The applications of an in-camera flash gun or the hot-shoe version are quite limited. Probably the most basic fault in flash photography is the failure to allow for the reduction in light intensity as the flash travels further from its source.

Flash exposures are determined by the power of the flash, usually expressed by a guide number, combined with the speed of the film and the aperture selected. The guide number is indicated in feet and metres for a particular film speed. If the guide number of a

Below A flash gun bounced from a white reflector positioned above and behind the model was the sole source of illumination for this abstract nude. I shot a polaroid to confirm the effect of the lighting and the exposure, which was f8 on Kodak's ISO 64 Ektachrome, was measured with a flash meter

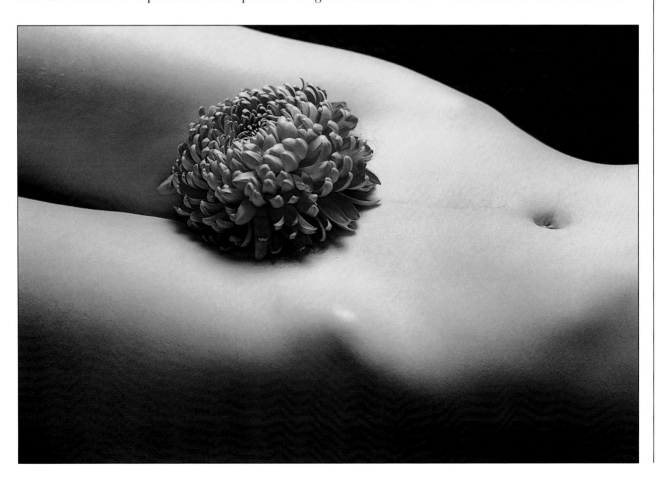

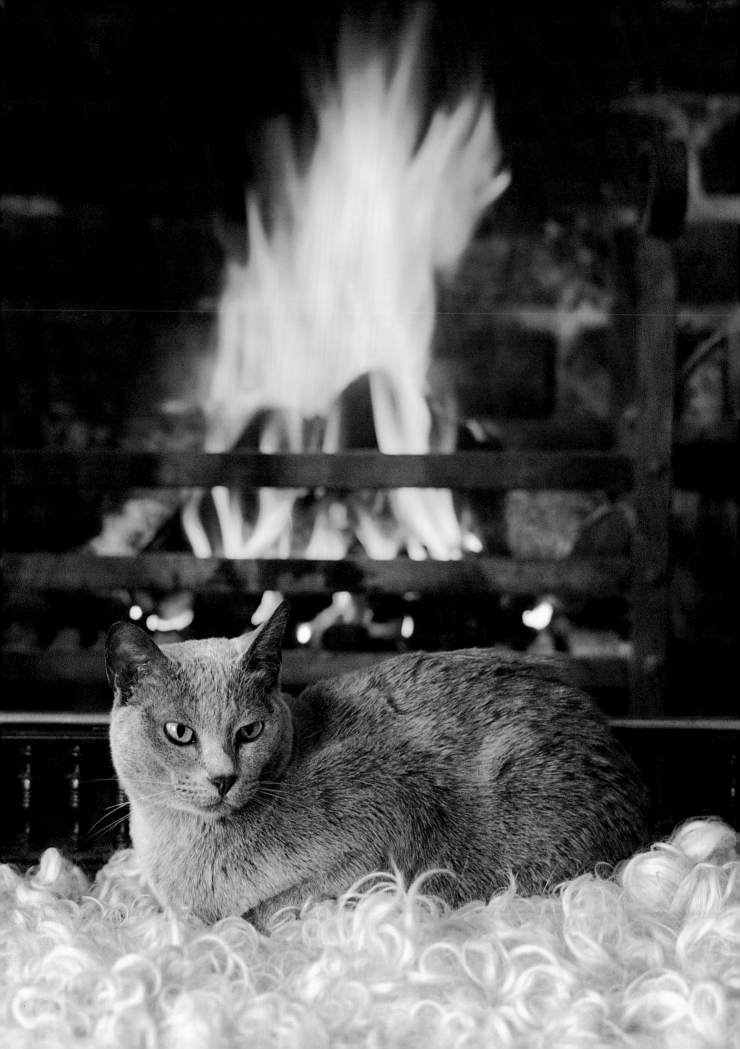

flash gun is, say, 80 (in feet) with an ISO 100 film, the correct exposure will be given if the aperture is set to the number obtained by dividing the guide number by the distance of the flash from the subject. If the subject was 10ft from the flash an aperture of f8 would be needed.

It can be seen that objects in the picture area which are at greater distances from the flash would be underexposed. At 20ft they would receive only a quarter of the light falling on the subject, resulting in two stops under-exposure. This is the main reason why many flash photographs have the main subject correctly exposed but seemingly suspended in a black void. In the same way, objects closer to the flash than the subject will be overexposed. In a group photograph, for instance, if some of the people included are significantly closer to the flash they will be overexposed resulting in pale, bleached-out faces.

One solution to this problem is to ensure that all the objects included in the picture area are at a similar distance from the camera. Even a background, like a wall for example, should be as close behind the subject as possible, especially if it is dark in tone.

Instead of the need to make exposure calculations in the way described above, many modern flash guns have built-in sensors which measure the light reflected from the subject and which regulate the flash so that the exposure is automatically controlled. Some flash guns are dedicated, which means that the camera's own exposure-metering system performs this function.

Automatic flash exposure is, however, subject to the same misleading situations and conditions as ordinary daylight readings. Subjects of an inherently light tone, like a man in a white tuxedo, for instance, create underexposure, and subjects which are predominantly dark in tone result in overexposure. The same principle applies to scenes containing large areas of bright highlights or dense shadows. With automatic flash guns you can compensate for potential errors of this type by setting the exposure-compensation dial on the camera to the required plus or minus value.

Another way of using flash-on-camera lighting to create a more pleasing quality is to harness any existing ambient light. When using flash it is normal to set the camera's shutter-speed dial to the flash-synchronisation setting. This is usually somewhere between 1/60 sec and 1/250 sec. Since most flash pictures are taken in low light levels, relatively fast shutter speeds like these, combined with the smaller apertures invariably used with flash, mean that the ambient light will not record on the film at all, leaving the flash as the only form of illumination.

By selecting a much slower shutter speed it is often possible to record at least some of the ambient light, giving more detail in the darker areas of the image and helping to preserve the atmosphere of the available light. This technique is very useful for subjects such as an illuminated Christmas tree or when there is a log fire burning in the background of a shot.

You simply use the normal TTL metering in the camera to establish the shutter speed required for the ambient light when using the aperture needed for the flash exposure. In some cases this might mean using a quite slow shutter speed, but this does not matter providing there is no subject movement and the camera is supported in some way to prevent camera shake. In some cases it is

Opposite A slowish shutter speed of 1/15 sec was used to enable the log fire to record strongly in this shot of a cat. The flash gun was fired into an umbrella from about 45° to the camera position and an aperture of f5.6 was used with Kodak's High Speed Ektachrome. I shot the picture on a Rolleiflex SLX with a 150mm lens

Overleaf A flash fired into an umbrella, which was placed just above the camera position and slightly to its left, was used for this portrait of a woman. There was some ambient daylight present and a shutter speed of 1/15 sec was used to allow some of this to record, avoiding the need to use a reflector to lighten the shadows. I used a Pentax 6x7 with a standard lens at f8 on Kodak's High Speed Ektachrome

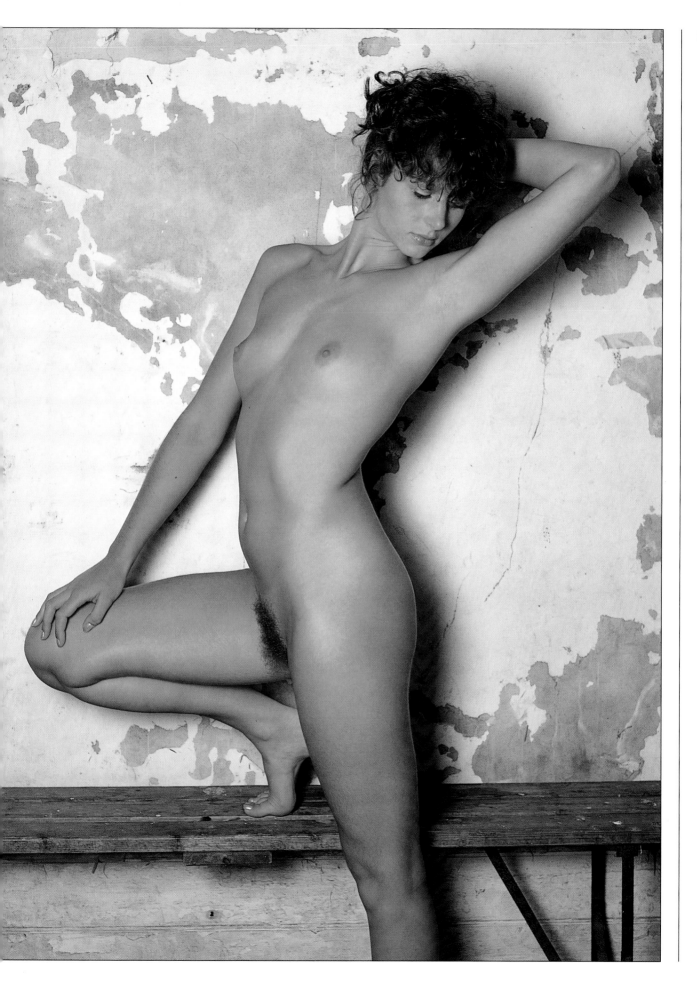

Previous page I placed a flash gun fitted with a small soft box about six feet from the model and just to the left of the camera. I shot a polaroid to check the lighting and the flashmeter reading, which was f8 on Kodak's EPR Ektachrome using a Rolleiflex SLX with a 150mm lens

The two photographs (**above**) show the effect of an undiffused flash placed just to the right of the model and slightly above his eye-level and the effect created when he moves his head more into profile

The pair of pictures – **opposite top** – show the effect of an undiffused and diffused light placed at an angle of about 45° to the camera and slightly above the model's eye-level. Those **opposite below** show the effect of an undiffused and diffused light placed a foot or so from the floor and slightly to the right of the camera position

preferable to use a reduced power setting for the flash gun, enabling you to use a wider aperture and a faster shutter speed.

A potential problem when photographing people or animals with flash-on-camera lighting is that of red eye, the effect of flash-light reflecting from the back of the retina. It usually only occurs in low-light levels when the pupil is dilated, causing a red-tinted unnatural glow. Some of the latest built-in flashes use a low-powered pre-flash which is fired fractionally before the main flash exposure. This causes the pupil to contract, reducing or eliminating the reflection from the back of the eye.

For those with a separate flash gun, another solution to this problem, and one which can also improve the lighting quality, is to hold or support the flash gun a short distance from the camera. Placing it a couple of feet to one side of the camera and slightly above the subject's head, eliminates the risk of red eye and also creates more modelling, revealing more detail within the subject.

A further improvement is to use bounced flash. This is simply the technique of aiming the flash gun at a convenient wall or ceiling so that its light is reflected back on to the subject. This causes a considerable degree of diffusion and also produces a softer, more pleasing quality of light with a higher degree of modelling.

The technique is ideal for those occasions when people or objects within the picture area are at different distances from the flash. This is because the light is much more evenly distributed than it is with direct flash. When shooting in colour it is important that the surface from which the flash light is bounced is white, or at least fairly neutral, or a colour cast will result.

The exposure required is significantly more than that for direct flash because the light travels further, from the gun to the wall and then to the subject; furthermore, the reflective surface absorbs some

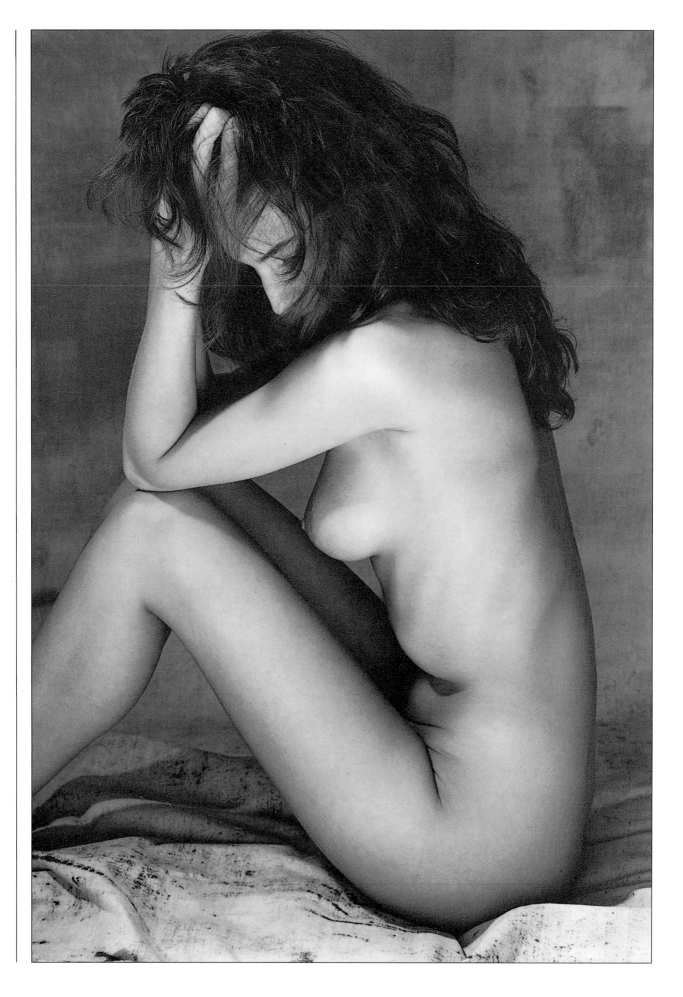

of the light. A dedicated flash gun, or one with a detachable sensor, still enables you to use the automatic exposure control. It is in such circumstances that a more powerful flash gun is a distinct advantage, since the technique can reduce the light received by the subject by three stops or more.

It is also possible to buy small soft boxes to fit portable flash guns, achieving a softer, more flattering light than direct flash. If held to one side of the camera, and slightly above, it also creates more modelling, making it a useful accessory for portraits. Remember, however, that the further the soft box is from the subject the harder the light quality. Such devices are only really effective when used from relatively close lighting positions.

Portrait Lighting

The human face is a subtle and intricate complex of contours and shapes, and the art of creating an interesting and revealing image by the means of lighting techniques has been the core of many great photographers' skills. The approach, method and style of portrait lighting can be immensely diverse. You only have to compare the work of photographers like Richard Avedon, Brian Griffin and Lord Snowdon to realise that lighting a portrait is a very individual and perceptive process, and by no means simply a matter of placing lights in standardised positions.

The development of a personal style is easier to achieve if you have a full understanding of the basic techniques and the ways in which the direction and quality of a light can affect the character, mood and impact of a portrait.

The Key Light

The key to understanding portrait lighting is, appropriately, the key light. This is the term used to describe the light which establishes the main highlights and shadows, revealing both the shape and form of the model's features and the texture of his or her skin. The decision as to where this light is placed, and the degree to which it should be diffused, is crucial to the final outcome.

The easiest way to appreciate the effects the key light can have is to employ the help of a patient friend and set them in front of a plain dark-toned background. With your model facing the camera, passport-style, take a single light in an ordinary reflector and place it immediately above the camera, which should be level with the model's eyes. You will see that very few shadows are created within the face's outline, just a small shadow under chin and nose and down the sides of the model's face, which will appear quite flat and formless with little impression of its contours.

By moving the lamp progressively higher above the camera the nose shadow will increase in size, and contours will be revealed around the mouth and cheekbones. At the same time, shadows will develop in the eye sockets. With the lamp moved lower than the model's eyeline, contours will again begin to be revealed but in a rather unfamiliar way, giving the sinister appearance of a horror-movie character. This is because we do not usually see the human face lit from below; the sun, after all, is usually above our heads.

Now continue moving the lamp to each side of the model's face, and higher and lower than the eyeline. Observing the effect this has on the formation of facial contours, the quality of skin

Opposite I used a partially diffused halogen light from well above the model and slightly to the left of the camera position for this nude shot, with a second light bounced from a large white reflector on the opposite side to lower the brightness range. The shot was taken on a Mamiya 645 with a 150mm lens at an exposure of 1/30 sec at f8 using Ilford's XP2 film

Overleaf A halogen light fitted with a fresnal lens was used to produce the spotlit effect on this Hollywood-style portrait. A second light placed behind the model to her right was used to create the highlights on her hair. Ilford's XP2 was used in a Nikon FE2 fitted with a 150mm zoom and an exposure of 1/60 sec at f8 was measured through the camera's meter

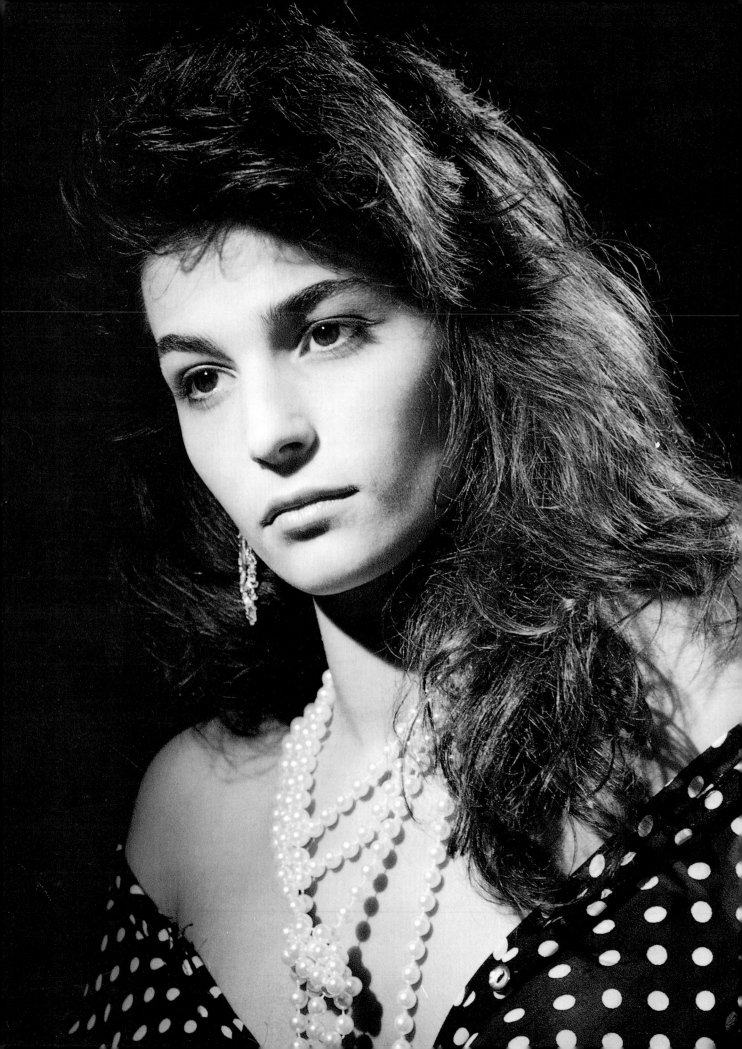

Overleaf Publicity shots like this can afford to be over the top but the lighting is, in fact, quite simple. A single flash fired through a large diffusing screen was placed to the right of the camera at an angle of about 45° and a large white reflector positioned close to the model on the opposite side. The background was a roll of white cartridge paper

Opposite This location portrait of the late painter, John Bratby, was lit by a single flash fired at the ceiling of his studio almost directly above his head. I used a Nikon F2 with a wide-angle lens at an aperture of f5.6 together with a shutter speed of 1/15 sec to record some ambient light using Ilford's FP4 film

texture and the changes in character and mood which this imparts is the first step towards developing a lighting technique. Explore too the variations which are caused when the model alters his or her expression, and when the head position is changed from full-face to profile, and with the head tilted down and chin lifted up. It will soon be apparent that the interplay of lighting and face can lead to an infinite variety of effects.

The light from a bare bulb, or flash tube, in an ordinary silvered or matt reflector is essentially hard, causing clearly defined shadows, fairly harsh modelling and pronounced skin texture with an abrupt transition from highlight to shadow.

The next stage is to explore the changes with can be made by introducing varying degrees of diffusion to the light source. This is done most easily by the use of a wooden frame covered with diffusion material such as tracing paper or translucent plastic. By altering the distances between the light source, the screen and the model, the light can be diffused to the point at which the shadows are barely defined and much weaker, introducing a more subtle graduation between highlight and shadow, with facial contours more rounded and skin texture less pronounced.

The shadows can be made even less dense by using a reflector to bounce light into them from the key light. With a highly diffused key light, and a reflector placed very close to the model on the opposite side, it is possible to achieve a virtually shadowless lighting with little modelling or skin texture.

Many of the greatest portraits have been taken using just a single light source and a variety of diffusers and reflectors, from the soft, flattering images of beauty photographers like Barry Lategan to the hard, uncompromising images of people like Richard Avedon and David Bailey.

Secondary Lights

A good rule-of-thumb for any type of studio photography, and especially for portraiture, is never to use more light sources than are strictly necessary. There are two main reasons for using a second light source. One is simply to lower the brightness range created by the keylight, making the shadows lighter and revealing more detail. With quite-close-up portraits this can usually be achieved by placing a reflector close to the model. With full-length and group shots, however, it might not be possible to move the reflector close enough to have the desired effect, and a second fill-in light is needed. In order to avoid the effect of secondary shadows and cross lighting it is important that the fill-in light is diffused and its power carefully balanced so that the keylight remains dominant.

The second reason for using an additional light source is to establish highlights. Placing a light slightly behind and to one side of a model's face, for example, can result in a pleasing rim of light around the profile. This helps to add form to the image, creating a stronger impression of depth and at the same time making the face stand out more boldly from the background.

In a similar way, a light above the model's head brings out flattering highlights on the hair, adding sparkle to the image. In both these cases, it is important to regulate the power of the second light so that the highlights it creates are not too strong; this would cause loss of detail and unattractive burned-out tones and colours. It is also

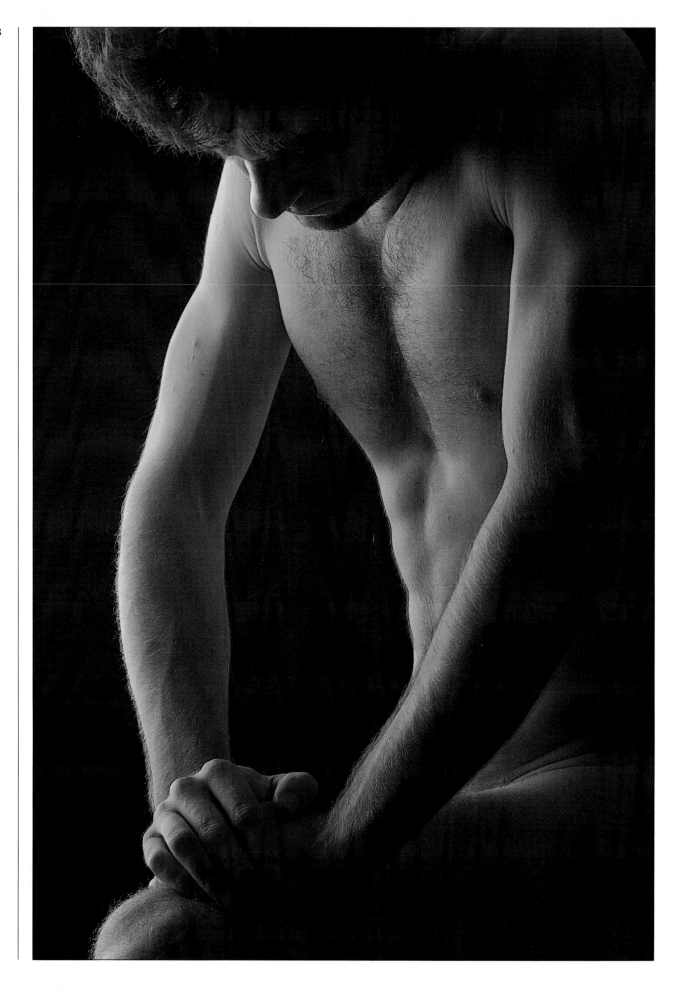

vital to ensure that a hair or rim light is positioned and angled carefully so it does not throw unwanted highlights on the face; a hair light can easily spill on to the model's nose, for instance. A second light also frequently causes too much reflected and scattered light, especially in a small light-toned studio. It is then necessary to use some means of controlling light spill, like a snoot or honeycombe grid, for example.

A third light enables a rim light and a hair light to be used together, or it can be employed to illuminate the background. With a plain paper background a light fitted with a snoot, spotlight or honeycombe creates a pool of light, adding more interest and introducing a range of tones into the background. It also helps to strengthen the composition by introducing a lighter tone around the model's face, establishing a frame effect and helping to focus the viewer's attention.

If a broader flood of light is needed to lighten the entire background expanse, two lights might be called upon – one each side. This is often the case when a pure white background is required. Care must be taken that the background lights do not spill on to the model or cause scattered light to dilute the effect of the keylight. Barn doors can be fitted to the reflectors to prevent this.

Opposite The lighting for this abstract male nude was very simple: a single flash bounced from a large white reflector placed slightly behind the model to his right. No other lighting or reflector was used in order to retain a dark moody effect. I used a Rolleiflex SLX with a 150mm lens and Fuji's ISO 100 film

Below A flash fitted with a large soft box was suspended about 5ft above the model on a boom stand for this abstract nude. No other lighting or reflector was used and the photograph was taken on Polaroid's black-and-white peel-apart negative film using a Rolleiflex SLX and a 150mm lens at an aperture of F8

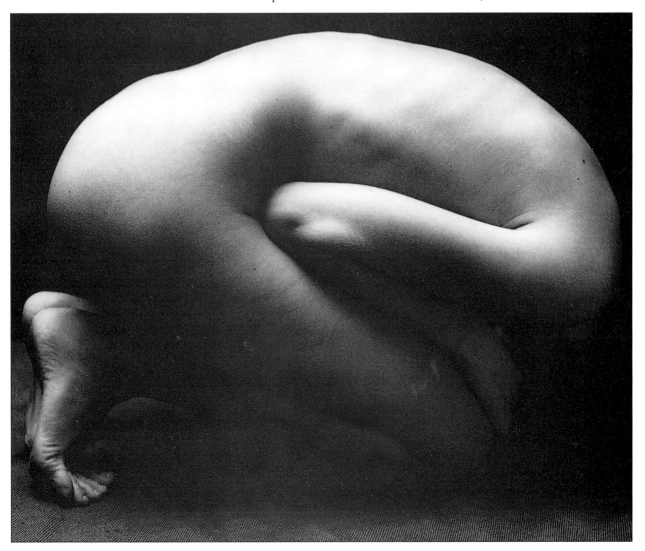

Lighting and Style

Lighting styles and techniques are often influenced by fashion, and it helps to study the work of earlier photographers in order to gain a fuller understanding of what can be achieved. It's also the case that such trends tend to repeat themselves and what might have appeared dated, say, ten years ago may easily become the current vogue.

The Hollywood portrait style, for instance, in which spotlights are used as key lights to form small, hard, dense shadows and sharply contoured features is often revived. Another classical style of portrait lighting which has returned to favour a number of times is the technique which was made a trademark by the famous Canadian photographer, Karsh. He often achieved a quite striking degree of modelling by the use of two rim lights and a fill-in instead of a dominant key light. This technique establishes a particularly rich moody quality and, like the Hollywood style, it is enhanced by the use of black-and-white materials.

The way in which a subject is lit, and the purpose of the photograph, must also be considered. Portraits fall into a number of categories, the most common probably being the social portrait in which a photographer is commissioned to produce a likeness of a subject for their own use. The main consideration in this case is usually, but not exclusively, a degree of flattery, or at least an intention to hide the sitter's less attractive features.

The outcome is often rather bland and characterless, the photographer drawing heavily on techniques such as strongly diffused lighting, soft focus and canvas-bonded prints to lessen the harsh realism of which photography is only too capable. Lighting for such pictures should be arranged so that the subject's face is shown at its most pleasing angle, emphasising the best aspects of bone structure and features, and minimising skin texture. At the same time the lighting should be fairly unobtrusive, free of obvious signs of artifice. Dramatic effects are usually out of place.

The publicity, or advertising, portrait – commissioned in order to promote a person or a product – usually needs a touch of glamour. Thus more obviously contrived lighting is often used with theatrical effects and larger-than-life expressions and gestures. The magazines contain a wealth of this type of image and much can be learned from studying the techniques used by photographers like Annie Liebowitz and Herb Ritts.

Then there is the art or editorial portrait where the photographer is allowed to indulge his own tastes to a much larger extent, either with the cooperation and knowledge of the sitter or without. These pictures aim to reveal the character of the model and, at the same time, act as a vehicle for the photographer's own opinions, style and taste. It is in this field that portrait photography tends to become both more interesting and truly creative. There are numerous examples of the genre in which one can sense that the sitters must have been greatly disturbed by the aspects of their character revealed in the portraits. They were, presumably, unaware of the photographer's intentions. Richard Avedon's group portrait of the Daughters of the American Revolution and Arnold Newman's photograph of Alfred Krupps spring to mind. One of the skills of a good portrait photographer is the ability to provoke or encourage interesting and revealing expressions.

Opposite I used an undiffused halogen studio light fitted with a fresnel lens to create a spotlight effect for this portrait of a young man. No reflector was used as I wanted the shadows to remain black. The position of the light, and the subject's head, was quite critical in order to control the modelling in the face and the light on the eyes

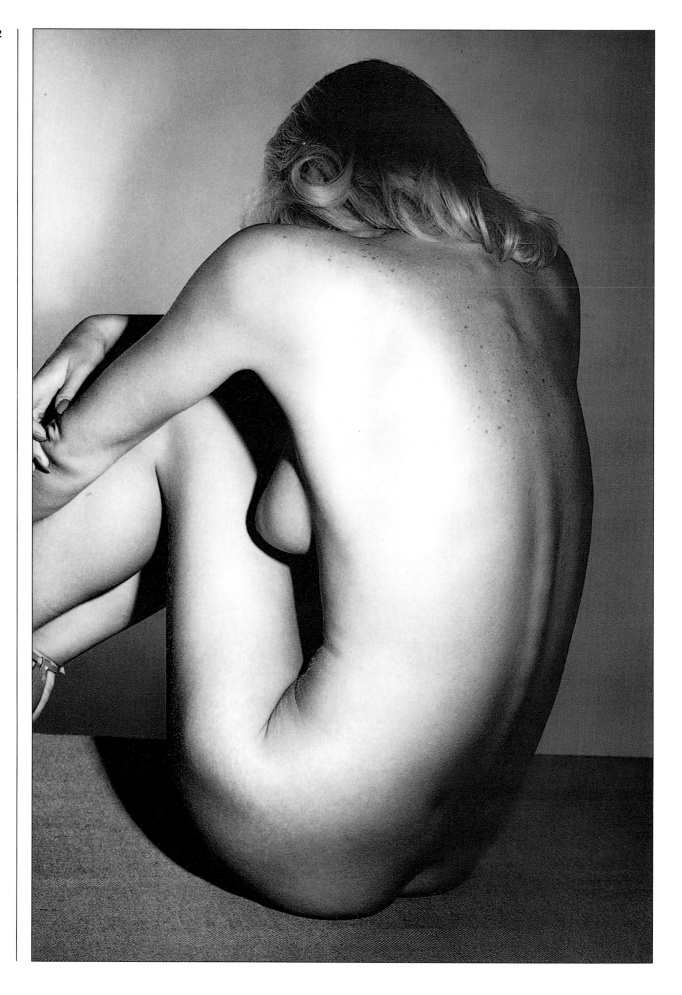

Lighting the Nude

The human body has been a source of inspiration to photographers ever since the medium was born over 150 years ago. One reason is that all the subtleties and possibilities of lighting effects associated with portrait photography can be extended even further with the greater complexities of form, shape and movement which the body provides.

Like portraits, nude photography invites a wide variety of approaches and styles, and the lighting techniques employed tend to vary accordingly. The methods used, for instance, by glamour photographers shooting for men's magazines vary enormously from the lighting style employed by a photographer like Bob Carlos Clarke, whose images are intended for gallery walls and art collectors rather than bookstall magazine racks.

Nude photography has often been described in terms similar to that of landscape work and the comparisons are not as far-fetched as they may first appear. The contours of the body, and the shapes and forms created by the movement of limbs and torso, evince strong similarities to the light, shade, tone and texture of the hills and dales of a rural landscape.

The main concerns of nude photography, in the abstract sense, are the visual elements of line, form and texture, and these are controlled to a large extent by the lighting. Line is emphasised by lighting which clearly defines the body's outline against the background. This can be emphasised by the choice of background, selecting a colour or tone which forms a bold contrast to that of the

Opposite A single undiffused flash fired from just above the camera and slightly to its right was the sole source of illumination for this nude. I used a long-focus lens on a Nikon F3 and the aperture was f11 using Ilford's FP4 film

Below Two flash heads fired at a white ceiling directly above the model provided a very soft, high key light for this nude. I placed a large white reflector on the floor just in front of her and angled it to throw some light back into the shadows. It was shot on a Nikon F3 with a 50mm lens at f11 using Kodak's Tri X film

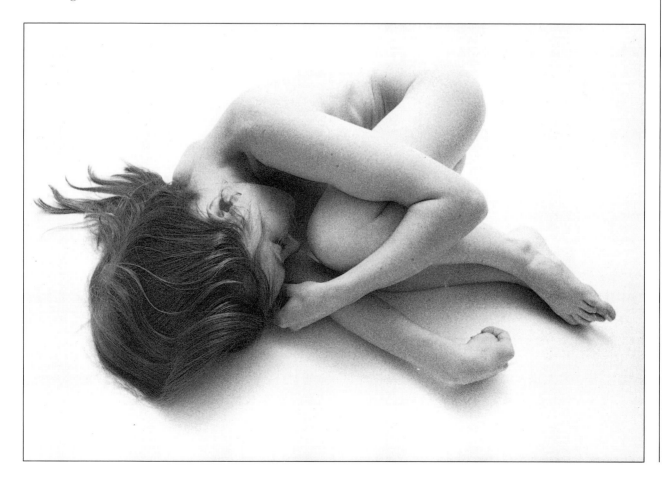

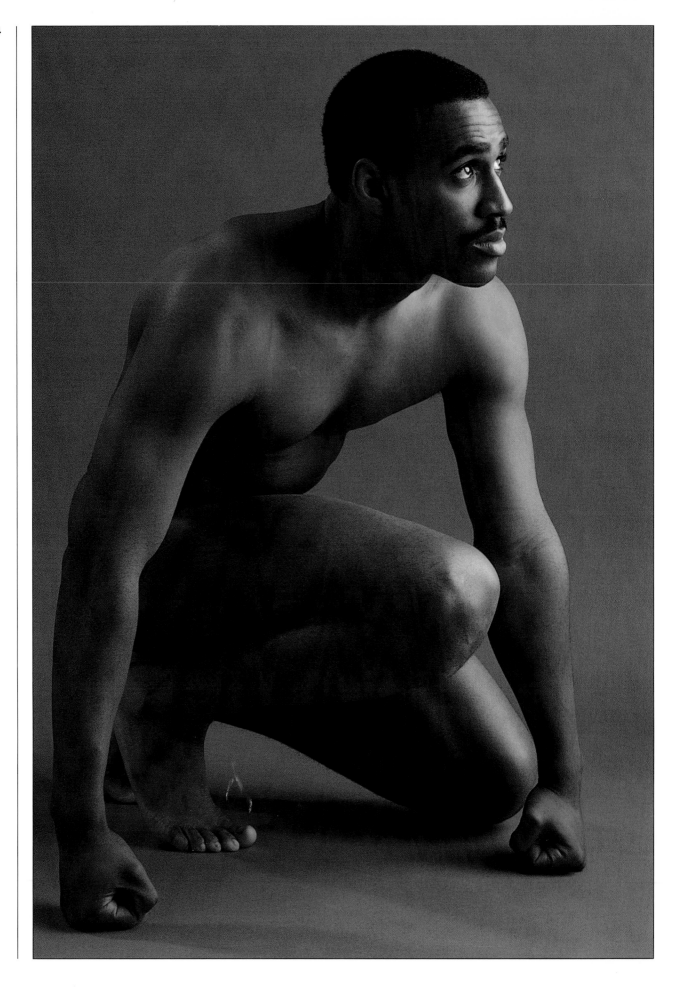

body. A black background, for instance, provides strong emphasis for a light-skinned body, and needs little help from the lighting to achieve it.

However, where the body tone, or colour, is closer to that of the background the lighting must be arranged to create a degree of separation. This may be done by lighting the body so that highlights are introduced around its outline, separating it from a darker background tone. Rim lighting affords a very striking way of achieving this. The background can also be illuminated to create a lighter tone against a partly silhouetted outline. This too has considerable impact, especially when the model's pose makes for strong and interesting shapes. Hard directional lighting throws up bold shadows along part of the body's profile, forming a darker line against a contrasting lighter-toned background.

Shape is seldom interesting enough to constitute the sole basis of a photograph, and the lighting must also reveal a sense of form and depth. This is achieved by a directional light which establishes highlights, shadows and graduations of tone between them. Such qualities are more readily obtained from a diffused light source, which produces shadows of softly defined edges and gentle graduation of tones, rather than a hard source in which the transition from highlight to shadow is abrupt.

The direction of the light is largely dependent upon the model's pose. With a model in a standing position, for example, the lighting will probably be most effective when directed horizontally, but with a reclining figure an overhead light might create better modelling. In practice, even slight changes in the model's position can have a radical effect on the nature of the shadows and quality of the image, and this is one of the reasons why nude photography is so challenging.

The third important visual element which contributes to the quality of nude photography is that of texture. The tactile qualities of skin, hair, clothes and accessories can be greatly enhanced by lighting. However, it is necessary to be quite careful when lighting for texture. Emphasised unduly it can easily introduce an unattractive skin quality, making pores and blemishes too prominent and the skin appear excessively coarse.

Indeed, photographers shooting nudes for glamour or beauty magazines try to minimise the effects of skin texture by using very soft frontal lighting and soft-focus in order to make the pictures rather more idealistic than realistic. However, even when the aim is to make the skin soft and appealing it sometimes helps to juxtapose other textures like hair, silk or fur by way of contrast. In practice, lighting for texture needs to be reconciled with that required for revealing the other elements of form and shape.

In many aspects of nude photography – glamour, advertising, beauty and health, for example – there is usually a desire to create an idealised and flattering quality, and this has a considerable influence over the way the subject is lit. Where less commercial considerations prevail – in fine-art or personal, expressive work – the approach to lighting can be far less inhibited.

In many such pictures the body is treated in a far more abstract, de-personalised way, the model becoming the vehicle for making a photographic image and much less a subject being photographed for his or her own sake. Although female models are more widely

Opposite A single flash head fired through a large diffusing screen placed at almost right angles to the model created strong modelling in this male nude. I placed a large white reflector near him on the opposite side to reduce the brightness range. It was taken using Fuji's ISO 100 film at an aperture of f8 on a 150mm lens with a Rolleiflex SLX

used in nude photography, the male nude has become increasingly favoured in recent years, and here too the lighting approach tends to be bolder and less restrained. Qualities like skin texture, sinew and muscle tone tend to be more acceptable when given bold emphasis than is the case with a female body.

Lighting for Still Life

Still-life photography is the backbone of the professional photographer's business, but has tended to be less widely used as a medium for creative and personal photography. This is odd in a way since it is the one area of photography in which the photographer has the ability to control the content and quality of his images in a manner which approaches that of a painter. It's interesting to note, however, that in recent years greater interest has been shown in still life as a theme among fine-art photographers and some innovative work is now being produced by photographers such as John Blakemore and Don McCullin, who had established their reputations in other fields.

The most basic form of still-life photography, and probably the one which accounts for the greatest output of professional studios, is the pack or product shot. This can be anything from a single item, such as a can of beans on a plain paper background, to an elaborate arrangement of objects of varying shapes, sizes and materials on polished laminate or specially constructed backgrounds.

The prime concern in lighting a pack shot is to show it as clearly as possible, using lighting which reveals its shape and form and which accurately records the colour and texture of its surface. The objects photographed are often quite dull, and the challenge is to produce a pleasing image solely from the lighting quality. This is usually quite straightforward using a large diffused source like a soft box or fish fryer to produce a subtle graduation of tone and colour with soft shadows and muted highlights.

When the objects have matt surfaces, such as printed-card packaging, the lighting can be positioned in a way which creates the most effective modelling. The keynote is simplicity. If you study still-life photography in magazine ads and good catalogues, you will see that the lighting is invariably quite simple, often with a single source creating bold shapes, colours and tones against a well-chosen background. A harder, undiffused light, or even a spot light, might be necessary for textured surfaces which need emphasising.

Since still-life set-ups of this type are often quite small, shadow control can usually be obtained by the use of reflectors. Small pieces of white card, cut to size and strategically placed, are generally all that is needed. Mirrors and crumpled aluminium foil are also handy and can be used to establish small accents and areas of highlight. Where a stronger highlight is needed a spotlight, or light fitted with a honeycombe grid or snoot, can be used. A tightly controlled beam of light like this is also very helpful for illuminating background areas, throwing a pool of light, for example, behind the object, or projecting a shadow pattern. For lighting very small areas a fibre-optic attachment can be fitted to studio flash units.

A recent development is the 'light-hose' in which a continuously pulsing flash is chanelled through a fibre optic device allowing the subject to be sprayed with light. In a darkened room with the camera shutter left open, the photographer can walk completely around a set-up adding highlights at will creating effects not normally possible.

Opposite The hard lighting for this abstract nude was achieved by placing an undiffused flash head at an angle of about 45° to the left of the camera. I used a black-painted reflector close to her on the opposite side to ensure the shadows remained black and a separate light shielded with a snoot to illuminate the background

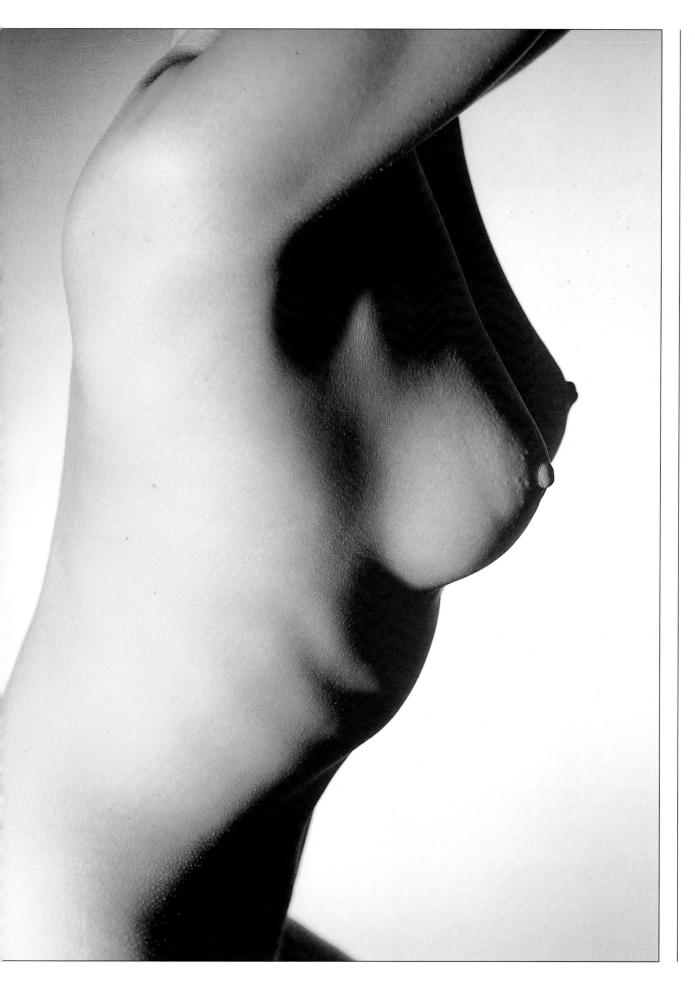

Previous page This elegant product shot by Simon Wheeler was lit by a 2K tungsten light which was diffused through a tracing-paper screen placed at right-angles to the camera. Simon used several large black screens to shade the set-up selectively and a white reflector on the opposite side to throw some light back into the shadows. It was shot on a 10x8 Sinar with a 360mm lens and needed an exposure of 180 seconds at f45 on Kodak's 6118 artificial-light film

Right The perfume bottle in this pack shot was placed on a curved piece of opal perspex and lit from below with a flash head which was screened with black card to create the graduation at the top of the picture. A small amount of fill-in was provided in a soft box from above the set-up

If the surface of the object being photographed is shiny or reflective, however, a different set of problems arises. In these cases the position of the lights must be partly governed by the reflections they create. One or more large soft sources used in conjunction with reflectors must be placed close to the arrangement, their positions and angles being adjusted until the desired effect is achieved.

Even when the lighting and reflectors are arranged very carefully it is not always possible to eliminate all of the unwanted reflections, and other techniques must be employed. With metallic surfaces, aerosol cans of dulling spray are sometimes used to create a matt surface which does not alter the metallic appearance of the object. With glass and other non-metallic surfaces, a polarising filter is often effective, in some cases in combination with another polarising filter over the light source.

When multi-faceted objects with mirror-like surfaces are to be photographed it is sometimes necessary to use a tent. This is a construction of white translucent fabric erected on a framework that completely envelops the object, leaving only a small aperture

through which the camera lens is introduced. The lighting is created by aiming diffused lamps at the tent until the desired balance on each of the various facets of the object's surface is obtained. Some tonal variations will be necessary, however, to convey the impression of a reflective surface. These can be introduced by the careful placement of grey or black reflectors to make darker tones, and by spotlighting strategically placed white reflectors to add highlights.

Glassware

The photography of glass objects requires a rather different approach to that of most other still-life subjects because glass can both reflect light and transmit it. Nicely lit glassware is capable of producing very rich and satisfying images for this reason, and the ways in which the lighting is arranged can alter quite dramatically both the appearance of the object and the quality of the photograph.

The translucent quality of glass is most readily exploited by using a light-toned or backlit background. A glass object placed in front of an evenly lit white background, for example, will appear as a

Below This pack shot was lit in a similar way to the picture opposite but the subject was placed on a piece of glass separated by about two feet from the perspex below. Pieces of coloured acetate laid on the perspex provided the patterned effect. It was shot on an Arca Swiss 5x4 camera with a 180mm lens at f22 with an aperture of f32 on Kodak's Professional Ektachrome

Above The lighting for this still life of cutlery was achieved by bouncing the light from a flash from a large white reflector placed behind and above the set-up and angled so that it leant over it. Two small additional reflectors were placed in front of the arrangement and angled to reflect light into the vertical facets

Opposite This food shot by Simon Wheeler has made use of a light box. The plate was rested on a sheet of glass which was supported a couple of feet above a piece of backlit perspex. In this way shadows from the plate have been avoided giving a floating feel to the subject. The food was lit by a large soft box and shot on a Sinar 5x4 camera with a 210mm lens at an aperture of f45 on Kodak's Ektachrome Professional film stock

uniformly white tone except where the surface of the glass is cut, curved or moulded. A very plain glass object, such as a wine glass, would have just the shape of its bowl and stem defined as a slightly darker tone, which can be made stronger by placing pieces of black or grey card close to the sides of the glass. With some objects it can be effective to place them on a translucent surface, such as a sheet of opal plastic, to be lit from underneath.

In addition to an evenly lit background, the effect may also be varied using a spotlight or honeycombe grid to form a small pool of light immediately behind the object, and allowing the background tone to darken towards the corners of the image area. This will introduce a graduation of tones within the surface of the glass according to the curve or angle of its surface. Very subtle changes to the quality of the image can be made by fine adjustments to both the intensity and the area covered by the background light. With patterned-glass objects, like a cut-glass decanter, for instance, back-lighting alone creates quite well-defined detail in its surface, but both white and toned reflectors can be used for additional control.

The reflective quality of glass must also be taken into account. When photographing objects with different-angled surfaces, like cut glass, it can be sufficient to show only its reflective qualities, enabling it to be placed on a darker-toned background and lit only from the front with large diffused lights. In most cases, however, it is preferable to use a combination of both back and frontal lighting to exploit both the reflective and translucent qualities of the object.

If you want to photograph glassware on a dark-toned background, cut small reflectors to the right size and shape, and hide them behind the object to reflect light back through the glass from a frontal light. If the glass is tinted, or contains a coloured liquid, it helps to use small mirrors hidden behind to create a more intensive reflection. This technique is often used in beer ads, for instance.

Lighting for Food Photography

Like glassware, food photography also requires a rather different approach to other types of still-life work. A food shot can combine all the visual elements of a powerful image – shape, form, colour, texture and pattern – as well as being an inherently appealing subject capable of evoking an emotive response. Food photography is one of the more specialised fields of professional work, and one in which there is great demand for high-quality photographs.

The majority of food photographs are shot on large-format cameras using 5x4 or 10x8in sheet film. This helps to produce images with a high degree of sharpness, colour saturation and detail. The lenses for large-format cameras, however, have significantly less-effective depth of field than the shorter focal lengths used with medium format and 35mm, and must be used at small apertures even when camera movements are used. Consequently, when using flash a powerful unit is needed: 5,000- or 10,000-joule generators are commonly used. Tungsten lighting can be a sensible alternative, since long exposures allow the use of very small apertures.

A great deal of the skill in this type of photography lies in the preparation of food, the styling of shots and the selection of props and backgrounds. However, ultimately it is the quality of the lighting which determines how successful a shot will be.

It's probably true to say that the majority of food shots, certainly those of prepared food, are taken from a fairly high viewpoint, and overhead lighting is one of the most effective ways of dealing with this. A large diffused source, like a soft box or a fish-fryer, is often used, since it introduces a soft even flood of light with smoothly graduated tones and luminous shadows. When used directionally, from one side or slightly from the back, such a light reveals form most effectively. The use of low-angled spotlights which skate across the surface of the set-up, accentuating both form and texture, is another popular and vogueish lighting style in this genre.

Form and texture are dependent upon lighting which creates a full range of tones, with a brightness range between highlight and shadow, and which is within the tolerance of the film. If this is exceeded, detail will be lost in either, or both, the highlight and shadow areas. It's also important to appreciate that highlights dilute colours and shadows degrade them. The most effective lighting is that which successfully balances these various elements. Although for large set-ups a fill-in light might be needed to lower the brightness range and to reveal more detail in the shadows, reflectors will usually suffice for smaller arrangements.

Texture is also an important element of food photography, enhancing the realism of the image and inviting a tactile response to it. The subtle variations in the texture of different foods, and the props and backgrounds used in the shots, contribute enormously to the effect. In many cases, a soft directional light gives enough emphasis to the textural elements of the image, but where a particu-

larly rich quality is wanted, or where the textures are very fine, then a harder light, like a spotlight, is preferable. This can either be used as the key light or as an additional light used to accent an area.

The strongest effect of a texture light arises when it is set at an acute angle to the illuminated surface so that the light virtually skims across it. This might be necessary with fine textures like that, say, of fruit or bread, but when the surface has a deeply indented, pronounced texture such a light creates excessive contrast and strong shadows and a softer, less directional light is preferable. It is important to appreciate that such effects tend to be significantly stronger on the film than appears visually, so it is best to err on the side of subtlety, or to make a polaroid test exposure before shooting.

When using spotlights in this way it sometimes helps to bring about an element of atmosphere and a more pleasing quality by using an orange-tinted acetate filter over the light. It gives the highlights in selective areas of the image a warm inviting glow. This is often done to enhance the colour quality of roasted meats like chicken, for instance, or to add a richness to dishes in sauces.

There are many forms of cheating used to aid lighting effects in food photography. Food is seldom cooked fully, and this helps to preserve its shape and texture and prevents its colour from being degraded. Surfaces are often brushed with oil or glycerine to impart

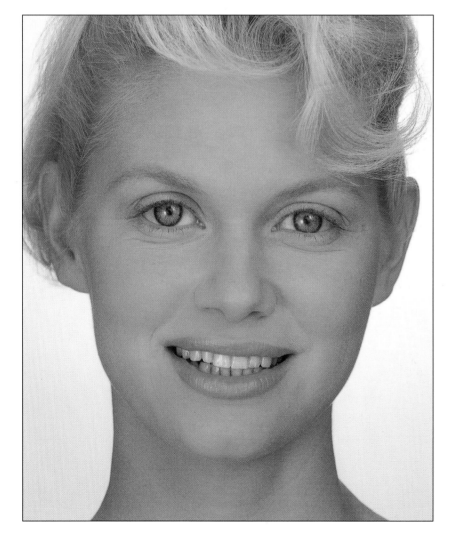

Left The fresh natural look of this beauty shot was the result of an hour or so's extensive make-up work. Two heavily diffused flash heads close to the camera position on each side, together with a white reflector under the model's chin, were used to create a soft, almost shadowless effect. The shot was taken on a Rolleiflex SLX with a 150mm lens at f11 using Kodak's EPR Ektachrome

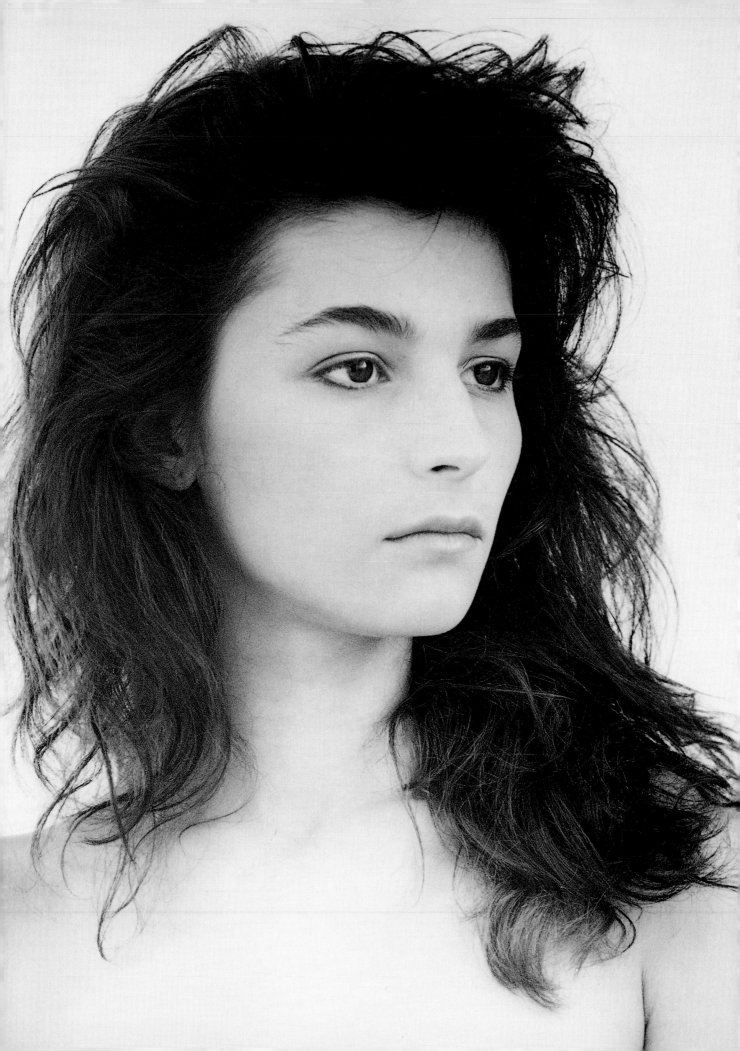

a gloss, and a fine water spray used to apply droplets of moisture. Pats of butter are often placed strategically and then melted with a small blowtorch immediately before the exposure is made.

Lighting for Fashion and Beauty

Beauty photography is simply a specialised form of portraiture, in which the aim is usually to create a smooth and flawless skin tone. As a general rule a large diffused light source close to the camera is used as the key light. This establishes a subtle degree of modelling, defining the model's features but minimising texture. The shadows are reduced, or eliminated, by surrounding the model with large white reflectors. One placed as close as possible below the face is designed to throw light back into the shadows formed in the eye sockets and under the chin.

Even with very soft lighting, make-up is invariably an essential part of beauty photography, sometimes with several hours spent preparing a model's face and hair for a single shot which takes only a few minutes to expose. In some cases the make-up is designed to give an impression of modelling, which allows the lighting to be completely frontal and shadowless. Shading on cheek bones and under the eyebrows, for instance, lends definition to the features which the lighting does not. And when a harder, more directional light is used, even the most perfect skin needs help from the make-up artist's box of tricks.

With many beauty shots the aim is also to create a very low

Opposite The high key lighting for this female portrait was achieved by bouncing two halogen lights from large white reflectors placed close to the model on each side. The shot was taken on a Nikon FE2 with a 150mm lens using Ilford's XP2 with an exposure of 1/30 sec at f8

Below Red-and-blue-tinted acetates were placed over the flash heads for this female portrait. One undiffused light was placed at right-angles to the camera and slightly above the model's eye level and the other, diffused by an umbrella, placed on the opposite side. Daylight-type film was used for the shot

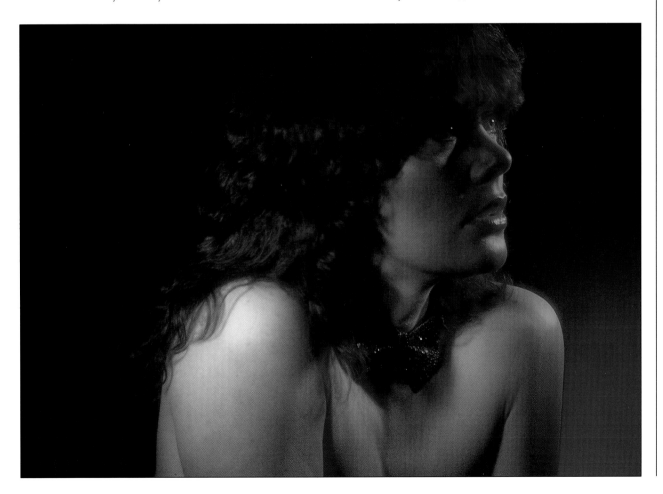

brightness range by almost eliminating both shadows and highlights. This allows the film to be overexposed, by as much as a stop or more, further reducing skin texture and making the skin a pale luminous colour. For this reason, stronger tints than would normally be worn are often used for lip colour, blusher and eye shadow to compensate for the loss of colour in overexposure.

While it is possible to identify well-defined lighting styles in beauty photography, fashion work is altogether different. This is partly because a fashion photograph can have such a wide variety of purposes. In a mail-order catalogue, for example, the main brief for the photographer is usually that the garments must be seen clearly, the seams, pleats and fashion features to be readily identifiable and the colour and texture of the fabric recorded accurately. On the other hand, in a style magazine like *Vogue*, for instance, the brief is more likely to be focused on creating a mood or general look rather than a faithful representation of the clothes.

The lighting itself is a slave to fashion and an approach which might be all the rage one month can be passé and dated the next. In the Fifties the trend was towards white backgrounds and a broad, soft flood of light creating a shadowless pencil-sketch effect. In those days fashion models were often rather aloof young ladies from titled families and the aim was to achieve a remote and unattainable quality in the images.

In the Sixties a new approach was heralded by photographers like David Bailey and the emergence of model girls like Twiggy and Jean Shrimpton. Here, the emphasis was placed more on femininity, sensuality and mood, and the lighting became less predictable and much more interesting. This more unbridled approach has carried through into the Nineties, and good editorial fashion photography is constantly undergoing changes. The top fashion magazines are a good source of ideas for ways in which lighting can be used to create a wide range of effects and moods, not only for fashion photographs but also for portraits, nudes and still lifes.

Lighting for Close-up and Copy Work

When the camera is very close to the subject the way in which it can be lit is much more limited. When using a macro lens, bellows attachment or extension tubes the distance between the lens and the subject may be as little as a few centimetres and this can make the positioning of lights rather difficult. A single light placed to one side of the camera gives an extremely directional effect in these circumstances, and even if it is well diffused it tends to create excessively large areas of shadow if the subject has an indented or strongly textured surface.

With a fairly flat, smooth subject this type of lighting can be quite satisfactory. Where excessive shadow areas are formed, one solution is to use a fill-in light of similar strength on the opposite side of the camera to reduce the density of the shadows and to lower the brightness range.

With static subjects this method works well, but it is too cumbersome in those situations – nature photography, for instance, or medical work – where a more mobile camera is needed. A ring flash is very useful for photographs of this type. This is an electronic flash tube formed into a circle which fits around the front of the lens mount. Because the light source completely surrounds the subject,

the result is virtually shadowless and its quality remains constant, regardless of the relative positions of the camera and subject.

In those circumstances where a more frontal light is needed – perhaps to reveal the sheen of a metal surface, like a coin – it is possible to use a piece of optical-quality glass to direct a beam of light along the camera's optical axis. By placing a light source at right-angles to the subject the glass is positioned at an angle of 45° directly in front of the camera lens. In this way the camera 'sees' through the glass but the light is deflected from its angled surface towards the subject.

Just as the brightness level of a light source diminishes in power the further it is moved from the subject, so too does the brightness of the image as the lens is moved further from the film plane. When a lens is focused on a very close subject it is moved significantly further from the film than when it is focused at infinity. At an image-to-subject ratio of 1 to 1 (life size) the lens will be twice as far from the film than when it is focused on a distant subject. This is known as double extension; a 50mm lens will, for example, be moved to distance of 100mm. In this way the brightness of the image will be reduced to 1/4 requiring an increase in exposure of two stops.

When using a camera with TTL metering this decrease in image brightness will be measured, but when using other types of camera – a view camera, for example – it is necessary to calculate the increase required. A useful tip is to use the dial on your exposure meter as a slide rule. Set the 1-sec mark on the exposure scale against the f number equal to the focal length of the lens in use. The required increase is indicated by reading the exposure opposite the f number, which is equal to the distance to which the lens has been extended.

When making a flat copy, from a photographic print or a painting, for instance, the main concern is to ensure that the lighting is perfectly even across the area being photographed. The usual method of making a copy is to use studio lighting, with two lamps in normal reflectors placed at equal distances at an angle of about 45° on each side of the original. If the surface of the copy subject is not perfectly matt it may be necessary to juggle with the lighting angles a little to remove any slight reflections. In practice, it is often helpful to use the edge of the light beam instead of aiming the lamps directly at the original; in this way the lights would be almost pointed towards each other. An effective way of gauging the evenness of the lighting is to hold a pencil at right-angles to the surface in the centre of the artwork, adjusting the distance and angle of each of the lights until the shadows cast from the pencil are of equal density.

Where a very critical and accurate copy is required from an original with a glossy or textured surface, like a painting, for instance, the clarity and fidelity of the colours can be improved by the use of polarising filters. By placing polarisers over both of the light sources and the camera lens, and adjusting their polarity, it is possible to eliminate all of the reflections from the surface, allowing the full depth of colour and hue to be recorded.

Where small originals are concerned, and colour accuracy is not too critical (and with black-and-white copies), the light obtained in open shade or on an overcast day can be ideally soft and even.

Interiors

An area of professional photography which requires a quite

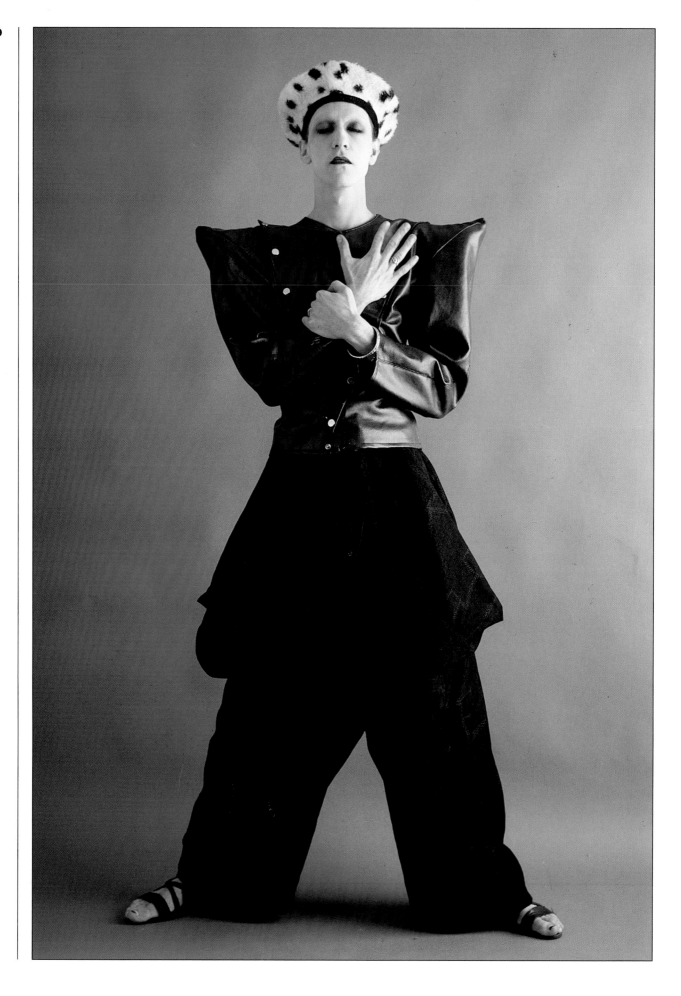

Opposite The lighting for this fashion photograph was achieved by placing a 6ftx4ft diffusion screen close to the model at an angle of about 45° to the camera on the right-hand side. It was lit by two flash heads placed about six feet from the screen. A large white reflector was placed on the opposite side to lighten the shadows

Above A single flash fired into an umbrella was positioned immediately to the model's left in this male portrait to create a strong side lighting. I placed a large white reflector on the opposite side to reduce the density of the shadows. I used a Pentax 6x7 with a 150mm lens at f8 on Ilford's FP4

Right A single undiffused photoflood lamp was used in this male portrait and placed directly in front of the model's face with another bounced from a white reflector on the opposite side to introduce some highlights to the darker tones. I used a Rolleicord VA with Ilford's FP3 – it's a very old shot and I don't remember the exposure

Opposite This high key portrait of a girl was lit by bouncing two flash heads from two large white reflectors placed each side of her with a third placed under her chin. The grainy effect was the result of shooting on Kodak's 2475 Recording film. I took the shot on a Nikon F2 with a 150mm lens at an aperture of f16

specialised approach is the production of photographs for publications like home and life-style magazines and books. The photography of room interiors presents a quite different set of problems to those generally encountered in studio lighting.

It is one thing to flood a room evenly with artificial light and to take a photograph, and quite another to light it in such a way that its character and atmosphere are preserved or enhanced. A further problem in this type of work is that the places in which lights can be positioned are often limited, either by walls and ceilings or because they will encroach on the picture area.

To overcome these problems, interiors in which the decor and atmosphere are important aspects of the image are seldom lit exclusively by studio lighting. In locations like domestic interiors, restaurants, and even offices, the lighting is an inherent part of the room's design and mood and drowning it with additional lighting will completely alter its appearance and destroy its atmosphere. Where possible, most photographers shooting interiors prefer to work in daylight so that any existing window light can also be employed. Indeed, with many rooms window light is often a significant aspect of their character.

For this reason the photographer's own lighting is used mainly as a supplement to the ambient lighting and carefully balanced so

that its effect is preserved. This usually means a soft diffused light which does not cast defined shadows. Lights can often be reflected from white ceilings and light-toned walls to achieve this, or diffused with umbrella reflectors or soft boxes. In many cases the position of these lights is determined by the shape of the room and the selected viewpoint, rather than the ideal place for them to be.

Reflections are another factor which limit both the position of lights and the camera viewpoint. Pictures on walls, windows, mirrors, ornaments, and even highly polished furniture, can all create distracting highlights and the ideal lighting arrangement is frequently compromised by the need to avoid them. Thus, an important part of interior photography is 'reflection spotting', usually with the aid of a polaroid.

A polaroid is frequently necessary to help judge the balance between studio and ambient lighting, since this can be difficult to assess unaided, particularly when flash is used. Flash has the advantage that its colour quality matches that of daylight, so that it can be combined readily with window light and daylight-type film can be used. Windows are a potential problem because they are significantly brighter than studio lighting, and can become overexposed and create flare.

Sometimes the view from a window is an important part of the image, when shooting a hotel bedroom, for instance, or a lounge with a patio window. In these cases flash effectively balances the exposures required for both the exterior and interior lighting. The aperture is used to establish the correct exposure for the flash, and the shutter speed is then selected to give the correct daylight exposure. It is an advantage to have a camera with a between-lens shutter for this type of work, as such cameras will synchronise with the fastest shutter speeds whereas focal-plane shutters can only be used on slower speeds with flash.

Even when a room has no daylight a combination of flash and daylight-type film remains a useful option because the room lighting will be recorded with a warm colour cast, which can produce a particularly pleasing quality in room interiors. Mixed lighting is often difficult to avoid but variations in colour in localised areas will usually add to the atmosphere. On occasions, photographers use coloured acetates over small light sources, like table or wall lamps, to add colour where required. Photoflood bulbs are sometimes used to replace ordinary domestic bulbs to increase the intensity.

In a similar way, small battery-powered flash units fitted with slave cells can be hidden at strategic points in a room to create pools of light and colour in order to add interest and atmosphere when the ambient lighting is rather flat.

An exception to the desirability of mixed light sources is when fluorescent tubes are present as they can create a most unattractive green cast. It can be largely countered by the use of colour-balancing filters. Tests are advised, but as a starting point with daylight matching-tubes filtration in the order of 20-30 magenta is suggested. The problem arises when fluorescent tubes have to be combined with other light sources, like flash. In these cases it is necessary to cover some of the sources with colour-balancing filters. Large sheets of tinted acetate can be obtained from professional dealers for this purpose. Where flash and fluorescent light has to be mixed, for instance, it is possible to fit a magenta filter over the camera lens to

correct the green cast, and then to place green filters of the same strength over the flash tubes to eliminate the potential magenta cast in areas where the flash lighting predominates.

Some interiors, such as those of cathedrals, are so large that they are impossible to illuminate in this way with anything less than a location-lighting unit. In these cases the most practical approach is to use a combination of daylight, existing artificial light, long exposures and a careful choice of viewpoint and framing.

An alternative method for large interiors is a technique known as painting with light. This involves using a single light source, a flash or tungsten light, and during a long exposure directing it in turn to each section of the picture area. With the camera on a long time exposure it is possible to move to different positions around the picture area firing flashes at selected areas or, with a tungsten light, moving the light source over the field of view in a continuous 'painting' motion. Both the exposure determination and the final effect of this technique are difficult to predict, and the method is best used in conjunction with a polaroid.

Lighting for Special Effects

Although a good general rule-of-thumb for photographic lighting is that it should be largely unobtrusive – like the Victorian child, seen but not heard – there are occasions when the way a subject is lit can become a dominant feature of an image.

Increasing the brightness range is perhaps the most obvious way in which lighting can be so used. Extreme contrast is one method of creating a dramatic and striking image. It is a lighting technique which is very effective for subjects like abstract nudes, theatrical portraits and some still lifes, especially in black-and-white photography.

A single undiffused light source placed to create a strongly directional modelling with no fill-in can easily create a brightness range greater than the film can accommodate. When the exposure is calculated to record detail in, say, the light tones of the subject the shadow areas will be left as rich black tones. If the correct exposure is given to record detail in the darker tones the highlights will be starkly white. These effects are striking with subjects which have bold shapes or outlines, and can also enhance the effects of texture and pattern in a subject.

To achieve this in a small light-toned studio or room it is necessary to use black reflectors to prevent scattered light being reflected back on to the subject, reducing the brightness range. Black curtains can be draped around the subject and large sheets of polystyrene painted matt black are very convenient and effective to use. Although an undiffused light source gives the highest degree of contrast, a degree of diffusion will introduce a more subtle quality and in black-and-white photography the contrast can be further increased by the use of harder grades of bromide paper. The uncompromising black-and-white portraits made by photographers like Richard Avedon and David Bailey are good examples of this.

In addition to using a main light to create a contrasty image, techniques like backlighting and rim lighting can also be used in a similar way. Often a spot light, or a light fitted with a snoot or grid, introduces strong highlights and sharply defined, dense shadows to selected areas of the image.

Lighting techniques can also control the tonal range of an

Above This interior by Simon Wheeler was lit by a single flash fitted with a soft box. A slow shutter speed of one second was used to allow the ambient daylight to record and to avoid the details through the window becoming visible. A 28mm lens on a Nikon F3 was used at an aperture of f5.6 on Kodak's ISO 64 Ektachrome

image, and this too affects its mood and atmosphere. The majority of photographs have a full range of graduated tones from highlight to shadow. When an image consists primarily of dark or light tones it can have a striking effect on both the quality and mood of a picture. A photograph which consists mainly of dark tones is said to be low key. It creates a sombre and subdued atmosphere, adding an element of mystery and intrigue. A picture in which the tonal range is predominantly at the lighter end of the scale is said to be high key, and evokes a more delicate and romantic atmosphere.

Low-key lighting is designed to create small controlled areas of highlight with the greatest mass of the image formed from well-graduated tones at the darker end of the scale. It is a particularly effective technique with subjects which have a rich and interesting texture. Character portraits, like those of Yusef Karsh, are a good example of this technique, and it can also add a striking quality to nudes and still lifes, especially food. Low-key effects are not dependent entirely upon lighting since the tones inherent in the subject also have a marked influence. A subject containing large areas of both light and dark tones makes it difficult to create a true low-key effect. It works best when the subject has a fairly limited range of tones and the lighting can be used to make shadows and small areas of highlight .

Exposure, too, is an important factor since it must be calculated in order to achieve good graduation in the darker areas of the image without losing detail in the highlights. In black-and-white photography, and with colour-negative film, the final quality of the image may be controlled when the print is made, but with colour-transparency film the exposure is critical. As a general rule, a degree of

underexposure is desirable and with a static subject, like a still life, it is a good idea to bracket exposures especially when shooting on transparency film.

High-key effects also depend to a large degree upon the inherent tonal range of the subject. Since a high-key photograph requires most of the image to be formed from the lightest tones in the scale, only very small areas of darker tone are acceptable. A portrait of a woman with dark hair, for instance, would not produce a true high-key picture. It is necessary to light the subject in a way which achieves an almost shadowless effect, such as a very soft, diffused light from close to the camera position. A degree of overexposure is usually helpful as long as it is not enough to lose detail in the very lightest tones. The technique suits subjects where you want to minimise qualities like texture and to create soft pastel colours. Much of the photography for beauty and cosmetic advertising is essentially high key in nature.

When shooting in colour it is also possible to influence the mood and atmosphere of a photograph by using coloured acetates over one or more of the light sources. Back or rim lighting, for instance, can create pleasing highlights on a portrait or still life, adding sparkle and an up-beat feel to an image. When, say, a yellow- or orange-tinted filter is placed over this light it helps to add a warm and inviting quality to the image. This technique is often used in food photography. In the same way, if a key light or fill-in light is given a degree of blue filtration if helps to create a quieter mood.

Projection

In most studio shots the background is either a paper roll, fabric or a construction of some sort, lit in a similar way to the subject. Projection is a method of introducing a much greater range of effects.

The simplest technique, and one which requires no specialised equipment, is back projection. The principle is to set up the subject in front of a translucent screen upon which an image is projected from behind. It is possible to buy special back-projection screens, but both tracing paper and frosted acetate can be used quite successfully.

The method is best suited to static subjects like a still-life arrangement. Although it can be used with a model, it is not ideal because, in order to light the model in such a way that the projected image is not degraded, there must be a considerable distance between the screen and the subject, and the lighting on the latter must be very carefully controlled so that it does not spill on to the screen.

With a static subject, however, this is not a problem as the screen may be placed close behind the subject and separate exposures used for each. The method is to arrange the subject as close to the screen as possible and to determine the ideal size and position of the projected image. The next step is to light the subject in the most effective way. If you wish to produce a picture in which the background appears to be real – a food shot with a landscape behind it, for example – it is necessary to ensure that the lighting on the subject is compatible with the lighting used for the projected image. A backlit landscape, for example, would not look very convincing behind a strongly side-lit still life.

When the lighting and composition are satisfactory, measure the exposure needed for both the subject and the projected image independently. With the room lights and still-life illumination

switched off make an exposure of the projected image. Make sure that the camera is not moved from this point until the procedure is complete and do not wind on the film. The next step is to switch off the projector and cover the screen with a piece of black velvet; then, with the subject illuminated, make another exposure to complete the image.

Front projection is a technique used quite widely in studio photography to enable outdoor or abstract backgrounds to be combined with a model. It requires a special projector and screen. The projector is set to one side of the camera and a piece of semi-silvered glass used in front of the camera lens to reflect the projected image directly along the camera's optical axis. A special directional screen is placed behind the model. It produces a very bright image from light directed at right-angles to its surface, ie the projector, and sends it straight back into the camera. Scattered light falling on the screen from other directions is largely deflected and absorbed. In this way the projected image seen through the camera is protected from degradation by the presence of other lighting, and a single simultaneous exposure can be made to record both projected image and the subject. The subject lighting, however, must be arranged so that as little light as possible is spilt on to the screen.

This technique allows quite convincing outdoor backgrounds to be used in the comfort and convenience of a studio, provided the lighting of the projected slide and the subject are similar in direction and quality. The equipment needs to be set up accurately in order to avoid a potential rim of shadow between the subject and projected background. The method lends itself equally well to the creation of bizarre and abstract backgrounds, as well as offering a wider range of possibilities to the portrait photographer.

Movement

One of the intriguing aspects of photography is that it can reveal things invisible to the naked eye. Movement, for instance, is seen by the camera as either a blur or as a frozen image. Slow shutter speeds can create the most subtle and fascinating images of a moving subject. Very fast shutter speeds can reveal fleeting aspects of movement in a way of which we are normally completely unaware. The photographs of people and animals taken by Eadweard Muybridge spring to mind.

However, some of the most dramatic qualities of movement have been captured by lighting and the use of the very-brief-duration high-speed flash. Harold Edgerton took a series of historic images revealing movements – like a bullet piercing a sheet of glass – by using flash exposures of 1/10,000sec, and contemporary photographs of birds and insects taken by photographers like Stephen Dalton are images of quite extraordinary beauty.

Effective frozen-action shots can be taken with quite basic flash equipment; low-power settings produce the briefest flash. Triggering devices are needed to capture such moments and there are a variety available from specialist suppliers. Subjects like bird and insect flight actions are usually recorded by an infra-red beam. In this way the camera can be set and focused at a predetermined spot between the receiver and transmitter: when the subject reaches the spot and breaks the beam the flash is fired. The set-up must be prepared in a darkened room so that the camera may be left with the shutter open.

Opposite Back projection was used to provide the background for this still-life shot. A slide of the interior of the casino at Baden Baden provided the background scene and the dice and green baize were set up on a bench in front of the tracing-paper screen at a distance which ensured the background was slightly out of focus. The foreground was lit by tungsten light to match the projected image and I shot it on a 5x4 Arca Swiss with a 150mm lens using artificial-light film

Different triggering devices can be used for other subjects. A contact trigger could be used to record a glass breaking as it hits the floor, for instance, or an audio trigger used to photograph a light bulb fractured by an air-gun pellet.

The strobe technique of using a pulse of high-speed flash to record a sequence of frozen images on the same piece of film has also led to some memorable photographs. Gjon Mili used it to produce very unusual and creative editorial images for *Life* magazine in the Forties and Fifties, and the method is used widely to analyse the actions of athletes and sportsmen.

It is possible to hire strobe lights from disco and theatrical suppliers, but the individual flashes are of relatively low power and the lights need to be used quite close to the subject or used with a fast film. An effective pseudo-strobe effect can, however, be produced by firing an ordinary flash in rapid sequence, either in conjunction with a motor drive or manually. The film must not, of course, be wound on until the sequence is completed.

If a movement is made in slow motion, and the flash fired manually at selected moments during the sequence, a quite convincing strobe effect can result. It is necessary to shoot this type of picture in a darkened room so that the camera shutter can be left open while the movement is complete.

Such images must be photographed against a black background so that the cumulative effect of the exposures does not build up in this part of the image. In order to obtain a clearly defined sequence of movement it is generally best to use rim lighting, with the flash placed to one side and slightly behind the subject. In this way the outline of the moving element of the subject is separated quite boldly from the rest of the image.

The effect of movement can be enhanced by combining a frozen image with a blurred action. It requires the use of both flash and tungsten light, and again the technique works best with a black, or very dark, background. The method is to make the flash exposure, using a slow shutter speed, with the subject at the end position of the movement – at the downward swing of an arm and tennis racquet, for instance. At the moment the flash fires the model must move his or her arm back to the starting point of the movement to record the blur. The trick is to gauge the length of the shutter speed to coincide with the duration of the movement.

Ultra-violet Light

Just as the invisible infra-red radiation can be used to take photographs, so too can the ultra-violet rays beyond the opposite end of the visible spectrum. However, unlike infra-red, ultra-violet does not need a special film, although it does require a special light source.

The most convenient form of ultra-violet radiation for photography comes from what are commonly known as black-light lamps, so called because they emit a minimal amount of visible light (unlike sun lamps, which are not suitable). Black-light lamps are obtainable from electrical stores as either fluorescent tubes or as filament bulbs; both are suitable. They can also be hired from disco and theatrical suppliers.

The ultra-violet effect works on the principle that certain elements absorb the energy from the ultra-violet radiation, and in

Opposite A flash set on low power was placed immediately behind the model in order to backlight and freeze the water droplets, which were provided by an assistant on a step ladder with a watering can. A flash fired into an umbrella from close to the camera position provided the frontal light for the model. I used a 150mm lens on a Nikon F3 with an aperture of f11 using Ilford's FP4 film

Above I did not take this shot of a martial-arts expert – he did. He felt that I was missing the crucial moment each time I tried so I gave him a remote release which he concealed in his right hand allowing him to fire the flashes himself when he had reached the right position

Opposite The pseudo-strobe effect of this nude shot was achieved by making a sequence of four exposures on the same frame of film as the model moved slowly forward in an arc. In order to keep the image as simple as possible I placed a single undiffused flash slightly behind the model to create a rim light, leaving the rest of her body in deep shadow

doing so become 'excited' and release brilliant colours. This is called fluorescence and it is used sometimes in shop windows, discos and for theatre lighting effects.

The most dramatic effects come from those objects which contain a high proportion of these elements. The easiest way to discover what will work best is to simply aim a black-light source at potential items to see the reaction; many everyday objects will respond in this way. If you wish to shoot something which is not fluorescent you can introduce fluorescent paint or dye by painting opaque objects or filling transparent ones. A wide range of suitable paints and dyes can be obtained from art and craft shops.

The pictures need to be taken in a room which can be darkened as the fluorescence is relatively dim and ambient light will degrade or destroy the effect. Exposures will be correspondingly long, but a sensitive exposure meter will give a quite accurate reading. As a general guide, with an averagely fluorescent subject and a light source about a yard or so away, the exposure using an ISO 200 film will require about one second at f5.6, but it is advisable to make a test or bracket exposures. The use of an ultra-violet filter such as a Kodak 2A is recommended to prevent scattered UV light degrading the effect.

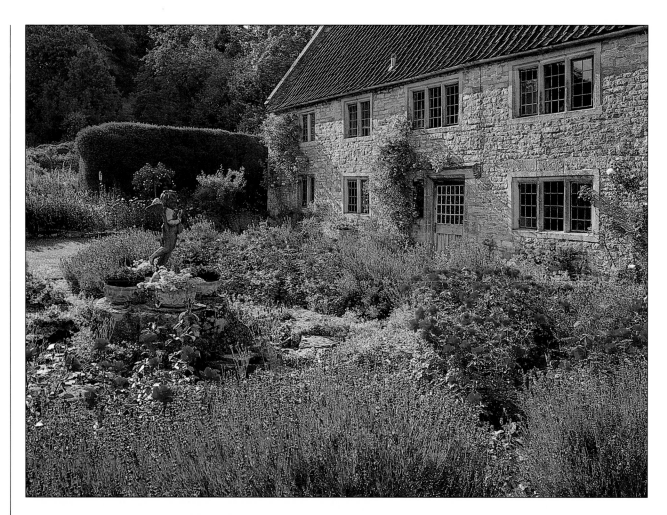

4 Natural Light

Shooting in Sunlight

When photography was invented it was completely dependent upon sunlight to make the exposures, since the sensitive materials of those early times were very slow and unresponsive. Even a dull day could make photography difficult, if not impossible. Now photographs can be taken successfully in lighting conditions in which reading would be difficult.

Nevertheless old habits die hard and there is, even now, a general belief that sunlight is the best form of illumination. There is, in fact, good reason for continuing to hold this view as pictures taken outdoors do tend to have a greater clarity, sparkle and superior colour quality when the sun is shining than when it is dull and overcast.

There are situations and subjects, however, where direct sunlight can be undesirable. The quality of richly coloured subjects, like flowers for instance, is lost to some extent when illuminated by direct sunlight because the highlights and shadows created affect the purity of the colours. Areas of highlight make colours appear weak and desaturated, and shadow tones degrade them. As a general rule, very brightly coloured subjects can be photographed more successfully with a soft diffused light. A good example of this is car photography, where the light of dusk or dawn is often used; in effect, the sky itself becomes a kind of large soft-light source which illuminates the car.

Direct sunlight also makes photography in such places as city streets and markets very difficult, since large areas of deep shadow are often juxtaposed with brilliantly lit details. Such situations restrict viewpoints and composition considerably, and the softer light of an overcast day can be far more satisfactory.

You might well imagine that direct sunlight is pretty much the same the world over since it travels millions of miles from its source to illuminate the relatively minute planet we live on. The opposite is true, however. Such are the subtleties and nuances of lighting that two photographs of the same scene taken at the same time on two consecutive sunny days can be quite different from one another.

The quality of sunlight is affected significantly by many things: the time of year, the hour of the day, atmospheric conditions, clouds and mist and so on. Even very local conditions and topography can affect the lighting quality of the sun; some regions, like Provence and Cumbria, for example, are known for the special quality of the light.

Sunlight and Contrast

When the sun is directly overhead, at midday in high summer, the shadows it casts are at their smallest and densest and the sunlight is least affected by the atmosphere. As the sun moves away from its zenith the shadows lengthen and change direction. Early and late in the day, in autumn and winter, near or far from the equator – these are all factors which affect the quality of sunlight.

Opposite, above Although the sunlight has perhaps lost some of the subtlety and colour quality of the flowers, it has given this shot of the garden of Fitz House in Wiltshire a distinct sparkle. I shot it on Fuji's Velvia film using a Mamiya 645 with an 80mm lens stopped down to f16. An 81C filter was used to add warmth to the image

Opposite, below The colour and detail in this shot of graffiti in a San Francisco alleyway were lit by the soft light of open shade. Direct sunlight would, I feel, have had a less-pleasing effect and had a negative effect upon its colour quality. It was shot on Kodak's ISO 64 Ektachrome on a Nikon F3 with a 75-150mm zoom lens at the shorter end of the range

Above This Copenhagen street scene was shot using the soft light of an overcast day. As the scene itself contained a good range of tones and a considerable amount of detail it made a more pleasing black-and-white shot than would have been possible when lit by sunlight. I used a 105mm lens on a Nikon F2 using Ilford's FP4 film

The direct light of the sun on a clear cloudless day sometimes emphasises unattractive qualities unless used in a careful and considered way. A high brightness range and excessive contrast is the greatest potential problem. Shadows cast by bright unobscured sunlight can be very dense indeed, and at the same time very bright highlights are created. The difference between the brightness levels of the lightest and darkest areas of a subject lit by sunlight is often far greater than can be recorded successfully on film.

For this reason, exposure calculations need to be made with some care and thought when photographing high-contrast subjects. An averaging reading taken in the normal way ensures that the mid-tones will be correctly exposed, but this can result in highlight areas being seriously overexposed and shadow tones underexposed.

For many subjects of this type, the only practical way to control the contrast is by choosing a viewpoint and framing the image in such a way that it does not contain large areas of both highlight and shadow. If, for instance, the image consists mainly of mid-tones and shadow areas the exposure can be calculated to give the optimum results in these areas and any small, lighter details allowed to become overexposed.

The difficulty of calculating exposure for high-contrast subjects is compounded because the human eye has the ability to adjust to different brightness levels so swiftly that we are largely unaware of it, resulting in a scene appearing to be far less contrasty than it actually is. A good way of judging the potential contrast of a photograph is to view the subject through half-closed eyes. Alternatively, with an SLR camera you can view the image with the lens stopped down.

Early advice to photographers, which still influences people today, was to keep the sun behind your shoulder when taking photographs. Like most rules-of-thumb it's based on sound principles; keeping the sun close behind the camera ensures that the shadows are at their smallest and any dark, detailless areas will be very restricted. However, observing this rule seriously limits the style and effect of your photograph. With experience photographs can be taken successfully with the sun at every conceivable angle to the subject, providing the image is composed in a way which limits the extremes of the brightness range.

The greatest contrast is likely to be produced when the sky is clear blue and cloudless. These conditions are often those which lead to the least-pleasing light for photography: the brightness range is at its highest, and the shadows are dense and sharp-edged with limited gradation between the lightest and darkest tones.

With static subjects, like landscapes and buildings for instance, the only controls available over the direction and quality of sunlight lies in the choice of viewpoint and the time of day at which you take your photographs. You can think of the sun as a huge spotlight which moves slowly in an arc over the subject you are photographing. By waiting you allow it to move, casting shadows in a different direction. Even a relatively short space of time can make a significant difference to an architectural subject. Just a few minutes allows a glancing light revealing rich texture along one face of a building to change into deep shadow, with little detail and tonal variation.

Observing the effect of sunlight throughout the day on a

Below The special quality of the light in Cumbria has contributed to this landscape shot on Kirkstone Pass on an evening in the early spring. I used my Mamiya 645 with a 50mm lens stopped down to f16 using Fuji's Velvia film. An 81C filter and a neutral graduate were fitted to add warmth and to retain density in the sky

Opposite Evening sunlight slanting through the mist which often swirls around San Francisco created the effect in this shot of a high-rise building. I used a 200mm lens on a Nikon F3 using Kodak's ISO 64 Ektachrome with an exposure of 1/250 at f8. I added an 81B filter to add a little warmth to the image and gave half a stop less exposure than indicated

familiar building – your house perhaps – helps enormously in increasing your awareness of the ways in which it affects the nature and quality of a subject. It helps to remember that in the northern hemisphere if you are facing the sun it will move to the right, and the shadows it casts will shift to the left. In the southern hemisphere this phenomenon is reversed – something which can be confusing the first time you take photographs on the other side of the equator.

By changing your viewpoint you also alter the direction of sunlight relative to the subject. Facing your subject with the sun at right-angles to your left, for instance, produces acutely angled lighting with large areas of shadow. By moving to your left the lighting becomes progressively more frontal in relation to the subject, and the shadows become smaller and less dominant. By moving to your right the subject begins to be backlit with, eventually, the sun directly behind it.

While changing the viewpoint on a building can be a quite practical way of altering the lighting angle, it can be difficult, or impossible, with more distant subjects like a landscape. Furthermore, in many other cases the viewpoint cannot be changed without altering the nature and composition of the picture in an unacceptable or undesirable way. In these instances, the only solution is to wait (or return) for when the sun has moved to a position where the shadows create a more pleasing effect.

With moveable subjects, like people, the lighting angle can be altered much more readily, as their positions can be changed as well as the camera's. With smaller mobile subjects, and with those which

Below Bright Caribbean sunlight directly overhead at midday provided the lighting for this shot of passengers relaxing on a cruise ship. I used a 150mm lens on my Nikon F3 with an 81C filter and shot on Fuji's Velvia film with an exposure of 1/60 at f11

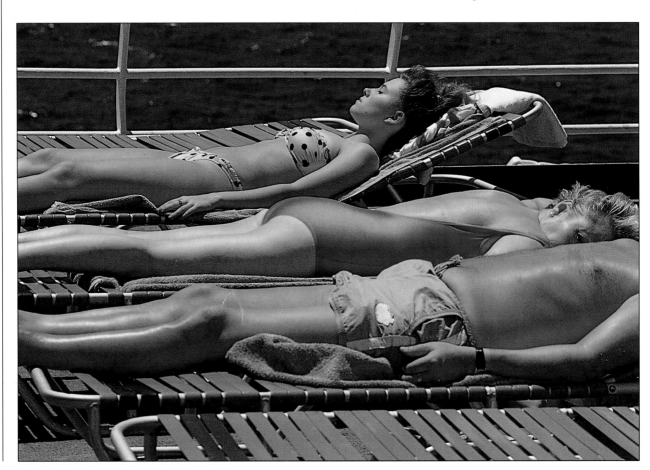

are quite close to the camera, the problems of excessive contrast can also be dealt with more easily by the use of reflectors and fill-in flash.

In practice, excessive contrast in landscapes is not frequently a problem in normal sunlight. Indeed, when the sun is at its strongest in summer the prevailing atmospheric conditions often cause haze and wishy-washy skies. This can result in the lighting for many subjects being insufficiently contrasty; distant views, in particular, can be disappointing in such conditions.

The dominant green and uniformity of texture which characterises the British countryside in summer does not help in this respect. A clear autumn or winter day usually creates a far more pleasing light for landscape work. This is partly because the maximum intensity of the sun is reached when it is still at a fairly low angle creating a more directional light with longer, larger shadows.

The difficulty of insufficient contrast can often be overcome by shooting late in the day, when the angle of sunlight is more acute forming longer shadows with more pronounced texture. This is the main reason why landscape photographers often favour the first and last couple of hours of the day. A polarising filter, that eliminates much of the scattered and reflected light, can often be used effectively to increase contrast on slightly hazy days.

Clouds as well as haze have an enormous effect on the lighting quality of sunshine. When the sky is cloudless and is a deep clear blue, the contrast can be very high indeed. This is because the sun acts like a spotlight, casting dense hard-edged shadows with little scattered and reflected light to relieve them. When sunlight is mixed with a good cover of white clouds the brightness range established can be significantly lower, since the clouds act like massive reflectors. However, when clouds are dense and dark with gaps which allow the sun to pierce through, the contrast can be considerable, with small areas of a scene lit brilliantly and others in deep shadow.

Shooting into the Light

The old rule-of-thumb advice of keeping the sun over your left shoulder has resulted in the general belief that shooting into the light is rather hazardous and ill-advised. There was good cause for this in the early days of photography because in those times lenses were of quite simple design and the glass surfaces uncoated. Any bright light, let alone sunlight, falling on to the lens could seriously degrade the image.

Shooting with the sun behind the subject can, however, result in striking and dramatic images, often with a quality that lifts them above the ordinary. It's a technique which can be effective with a variety of subjects, from landscapes to portraits and close-ups, but it does need certain conditions for it to work well and care still needs to be taken to avoid the hazards of flare.

The use of a lens hood is the standard advice for the avoidance of flare but, as a rule, the normal type of lens hood offers only minimal protection and is of little help when the sun is close to the image area – which is often the case with the most effective shots against the light. For most types of camera used by professionals it is possible to buy a compendium, which is far more satisfactory. It is a lens shade which can be extended by bellows to just clip the edge of the image area, regardless of the focal length of lens in use.

I've made a useful gadget for my into-the-light shots, which

Opposite This picture of the French village of Balazuc perched above the River Ardèche was taken in the evening light just before sunset when the sky had recently cleared after a cloudy, rainy day. In the middle of the day the sun was behind the village and I had tried the same viewpoint in the early morning but this produced the most pleasing result. I used my Mamiya 645 with a 150mm lens fitted with an 81C filter for extra warmth and a neutral graduate to increase the density in the sky; the film was Fuji's Velvia

Above Weak winter sunshine in the late afternoon lit this landscape of the Valley of the Rocks near Lynmouth in North Devon. I used a polarising filter to increase the definition and colour in the sky together with an 81EF for extra warmth and a neutral graduate to increase the density of the sky. It was shot on my Mamiya 645 using an 80mm lens stopped down to f16 with Fuji's Velvia

consists of a piece of bendy cable, as used on angle-poise lamps, about 18in long with a heavyweight bulldog clip fixed to each end. One clip is attached to the camera or tripod top and the other holds a piece of black card which can be bent down to shade the lens very precisely.

The use of an SLR camera makes the control of lens flare and the positioning of a shade much easier; with a viewfinder camera it is a rather more hit-and-miss affair.

On occasions it is desired to include the sun itself in the shot and here, of course, a lens shade cannot help. If the sun is weak, perhaps in mist or just before it goes down, it may well not cause flare. It's worth remembering, however, that some lenses are more prone than others. As a general rule you are likely to avoid flare more readily with wide-angle lenses and those with small front elements, and are more at risk with zooms, long-focus and lenses which have large front elements. The presence of filters, especially of the resin type, is also likely to increase the risk of flare. In some cases it is possible to find some foreground detail, like the overhanging branches of a tree, to partly mask the sun and to weaken its effect.

The other problem associated with shooting into the light is that of exposure calculation. The danger is that a normal averaging reading will usually give a misleadingly high figure and result in a degree of underexposure. This is partly because backlighting can cause bright highlights and also because the sun itself can influence the reading.

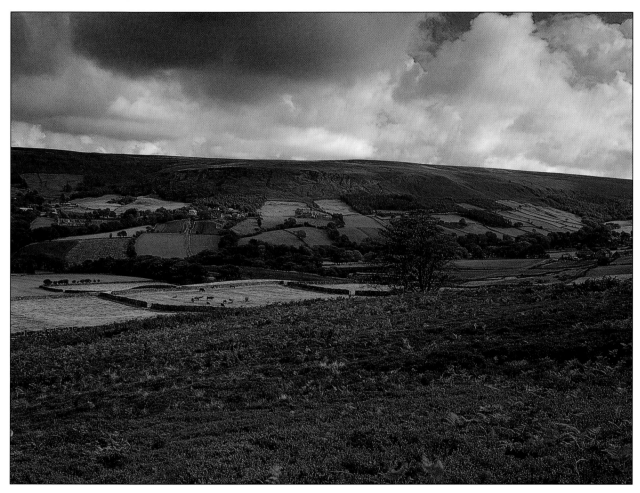

With some quite close-up subjects, like a portrait for instance, underexposure can create a very unattractive semi-silhouetted effect. It is necessary to take a close-up exposure reading from a mid-tone within the subject, and to ensure that the direct light of the sun and areas of highlight do not affect the reading.

Some automatic compact cameras have a backlight button which is intended to give, usually, one-and-a-half stops extra exposure for subjects lit in this way. In practice, both more and less exposure adjustment than this may be needed and it is best to assess each picture on its merits.

With subjects like landscapes, for example, a degree of underexposure is often desirable and full exposure would lose the dramatic effect brought out by the lighting. In these instances there is a good case for bracketing exposures, since it is not always possible to predict the precise effect of the exposure and sometimes equally interesting, but quite different, effects are achieved over a fairly wide range of exposures. A sunset photograph, which is in essence shooting into the light, is a good example of this.

Another reason why exposure calculation can be problematic with backlit subjects is because they usually have a higher-than-average brightness range which exceeds the latitude of the film. In these cases it is necessary to decide which range of tones are the most important in order to decide upon the best exposure.

With a backlit portrait, for instance, the skin tones are likely to be the most critical aspect of the picture, and if highlights in the

Above This picture of Farndale taken in the early spring was shot on a day when the gaps in large dense clouds created small pools of sunlight. I used a combination of a polarising filter, an 81EF and a neutral graduate to darken the sky using Fuji's Velvia in my Mamiya 645 fitted with a 150mm lens

background, or on the model's hair or profile, become overexposed it will not matter too much. On the other hand, in a backlit landscape with rich textures the highlights would be most important. The exposure in this case would be calculated to give a good range of tones in this part of the image, even if it resulted in detail being lost in the darker areas of the subject.

With close-up subjects, like portraits or flower photography, excessive contrast can be reduced by the use of reflectors or fill-in flash. With more distant subjects it is necessary to control the contrast by the choice of viewpoint and the way the image is framed.

In some cases a neutral graduated filter is effective in lowering the contrast by reducing the brightness of sky or highlighting details at the top or bottom of the image. With a sunset, for instance, such a filter reduces the brightness of the sky area, allowing more exposure to be given to darker foreground details.

A polarising filter can also sometimes be used to reduce contrast by eliminating reflections from the surface of objects within the picture area. A good example of this is with backlit water: when sparkling highlights are far too bright, a polarising filter often reduces them significantly.

Shooting in Dull Light

The direct light of the sun is a point source, forming dense hard-edged shadows similar in character and quality to a studio spotlight. The light of a dull overcast day, however, is more akin to that obtained by a vast soft box with very weak, soft-edged shadows. Indeed, on a very dull day in the open outdoors the shadows may be non-existent, because the sky constitutes an all-enveloping blanket of soft, even light.

The brightness range on a day like this can be very low. Unless the subject has an inherently wide range of tones and colours, photographs taken in such conditions can be too soft and lacking in sparkle, with no strong highlights or full blacks in the image to give shape and definition. This lighting can be simply too soft for many subjects like landscapes, particularly distant views, making satisfactory photographs impossible. In these cases waiting for better conditions becomes the only practical option.

In some circumstances it is possible to overcome the problem of poor contrast by choosing viewpoints and framing pictures in such a way that details and areas of tone are introduced into the image which increase the brightness range to a more satisfactory level. With a landscape, for instance, it might be possible to include a silhouetted tree or a dry-stone wall in the foreground, which would add much darker tones to the image. Alternatively, light areas could be included, like an expanse of water, or a foreground of light grasses or flowers. The use of a wide-angle lens, in preference to a standard or long-focus, often adds a significant degree of contrast to the image. With portraits it is possible to introduce clothes or accessories which add an element of contrast and brightness to an image.

It's worth remembering that a polarising filter often effectively increases contrast. Graduated filters, too, can sometimes work in this way by darkening foreground tones. A portable flash gun, used to illuminate specific areas of some subjects, increases contrast by adding a range of lighter tones to the image. This technique is often used by magazine photographers when shooting location portraits,

Opposite Shooting into the light has helped to create a plain contrasting background in this San Francisco street scene. I used a zoom lens on my Nikon F3 and took the reading with it fully extended to avoid including the brightly lit background then pulling it back to take the shot. The film was Ilford's FP4 at 1/125 at f5.6

Above Backlighting has produced the quality of this shot taken in Brittany on a 200mm long-focus lens. I used Ilford's FP4 film and, although it was backlit, used the indicated exposure of 1/250 at 5.6 in order to obtain a low-key effect

Opposite This picture of a silhouetted tower near Jaffa in Israel was taken as the sun began to weaken as it sank into mist. The exposure was calculated by taking a reading from the sky just above the tower, excluding the sun. I bracketed in small increments about a stop each side but the central exposure proved to be best. It was shot on a Hasselblad with a 250mm lens and Kodak's EPR Ektachrome

for instance. As well as overcoming the lack of contrast caused by dull light, such techniques also help to create more dramatic and atmospheric images. The technique can sometimes be used effectively to illuminate the foreground details of more distant subjects, like landscapes, for instance.

Although on dull overcast days the temptation might be to use a fast film, it can be preferable to use a slow film since such emulsions tend to have higher contrast and greater colour saturation. With static subjects, like a landscape, this does not present a problem, but where a moving subject is involved a compromise must be reached in order to be able to use shutter speeds fast enough to freeze the motion.

Because the sky itself becomes the light source on a dull day, the exposure necessary to record foreground details usually causes the sky to be considerably overexposed. In these situations a neutral graduated filter is very useful indeed, as it helps to add tone and detail to the sky and, by reducing flare, it sometimes improves the contrast of the foreground. This method is particularly effective when there is some tonal gradation in the sky, and the shapes of individual clouds can be seen. But even when the sky is a flat even tone a neutral graduated filter still improves the overall quality of a picture by making the sky a shade or two darker.

The colour quality of the light on dull days is also unsatisfactory, with a high colour temperature and an excess of ultra-violet creating images with a pronounced blue cast. For landscape photographs the use of the 81-series filters is invaluable. I often use the 81C or 81 EF for pictures of this type as, although it can result in the image being warmer than the subject, it is not readily noticeable when landscape colours like green and brown predominate in the

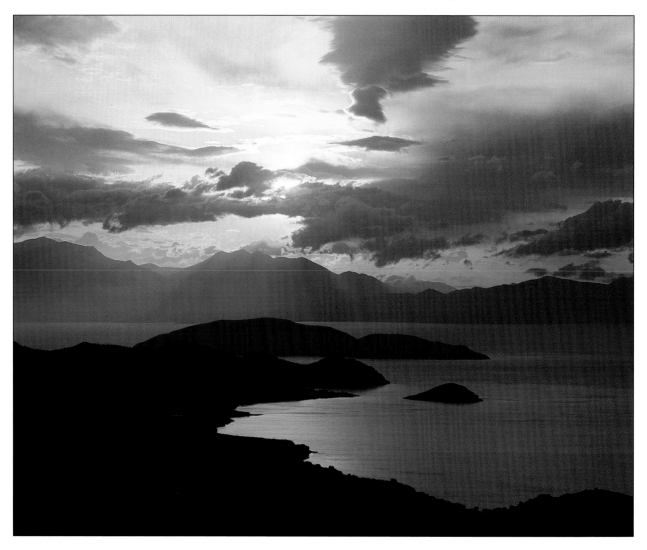

Above Photographed in late summer on the southern coast of Crete the soft colours of this sunset have been created by quite heavy cloud cover allowing the sunlight to only pass through in limited areas. I used a neutral graduated filter to retain the maximum amount of colour and tone in the sky

Opposite In this shot of the river Lot in France I've used a polarising filter to subdue the very bright highlights on the water created by the backlighting. I also added an 81C to add warmth to the image. It was shot on my Mamiya 645 using a 50mm lens stopped well down and Fuji's ISO 50 film

image. The excess warmth often creates an almost sunny impression, and when a neutral graduated filter is used to make the sky a darker richer tone the result can be quite striking.

In some situations the blue cast caused by dull light is attractive, and it is advantageous on occasions to accentuate it by using a filter of the same hue to strengthen the cast. This is especially effective with pictures taken at dusk or dawn.

Of course there is a positive side to photography on dull days. As a professional photographer, away sometimes for weeks at a time on assignments, it is essential to seek subjects which can be photographed successfully on dull days, as otherwise it would be easy to lapse into a state of resigned depression.

Black-and-white photography is one field where the softer light of cloudy skies can be a positive advantage. I suggest that a study of creative outdoor photography used in books and magazines would reveal that the majority of colour photographs are taken when the sun is visible in the sky, and most black-and-white images when it is not. The potential manipulation of tone and contrast is far greater with the black-and-white process than it is with colour, and as a general rule the rich tones which help to create strong black-and-white photographs are often more readily achieved when the subject is lit softly.

However, some colour photography can also benefit from softer lighting and lower contrast. Subjects with very bright saturated colours, like flowers for instance, are usually more effectively

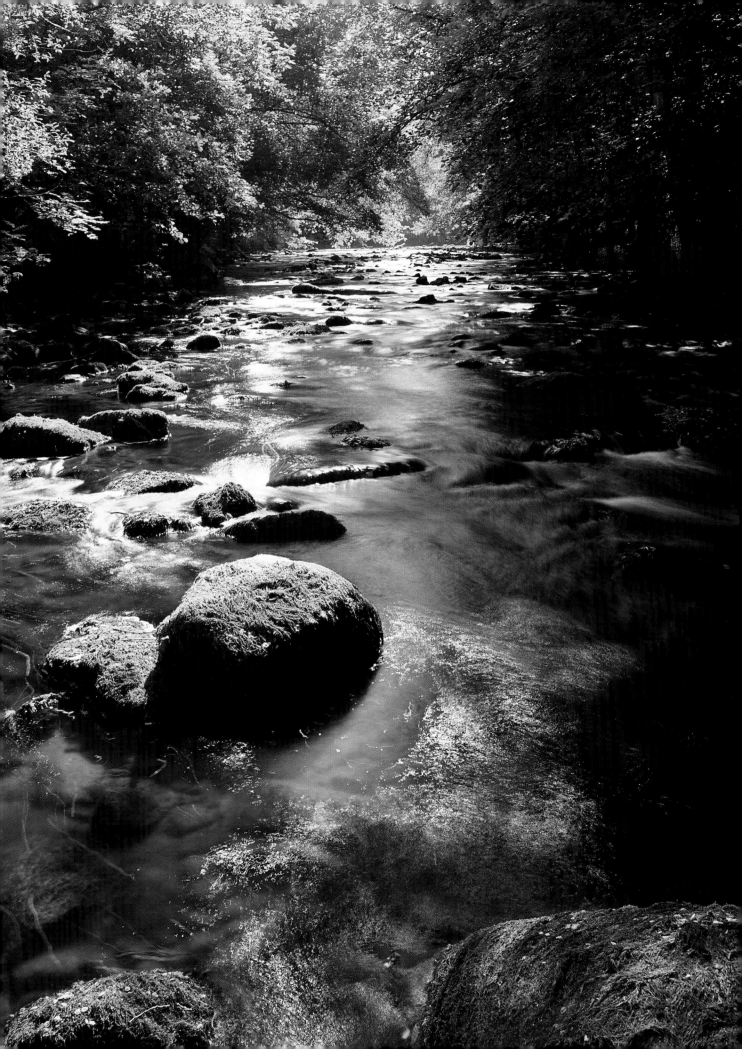

photographed on a dull day than in bright sunshine, because of the absence of bright highlights and strong shadows. In addition, a soft light and low subject contrast makes possible a degree of underexposure, and this too increases colour saturation.

Action subjects are, in some respects, easier to photograph in dull light, unless the brightness level is very low. This is because soft lighting and the lack of dense strongly defined shadows allow much more freedom in the choice of camera viewpoint and in the position of the subject. In a similar way, subjects which contain lots of detail, and which have an inherently high brightness range, can be difficult to photograph in sunlight as the choice of viewpoint is severely restricted by the direction of the light and the shadows it casts.

The dramatic or atmospheric context of a photograph is also influenced considerably by the lighting. The impact of serious documentary subjects – like war or social deprivation, for instance – can be lessened if the photographs are taken on sunny days, and the sense of concern heightened by soft lighting and subdued tones.

Using Daylight Indoors

In spite of the development of modern lighting equipment, and the ingenious methods of controlling the quality of artificial light, daylight remains one of the most attractive and appealing forms of illumination when shooting indoors. Indeed, some of the most expensive items of studio lighting equipment are those designed to simulate the effect of daylight. Many top photographers prefer the effect of the real thing and have studios designed to make use of window light.

Window light is particularly effective for subjects like portraits and nudes. It has the added benefit of having the potential to use the room interior as a setting or background for a shot. This possibility is equally useful for still-life arrangements, like food photography for instance. Many of the evocative food photographs of Robert Freson are shot in indoor locations using predominantly window light.

The drawbacks of using daylight indoors compared to studio lighting are the relatively low intensity and the more limited degree of control over its direction. With static subjects, like still lifes, the brightness level is not a problem and with relatively static ones, like portraits, it is not an insurmountable problem when a tripod-mounted camera is used and a reasonably fast film is loaded. If a model is placed close to a large window on a bright day, even fast-moving fashion poses can be captured successfully.

Lighting direction is rather more of a difficulty since the light source is fixed, and the subject, camera and background must be moved in relation to it in order to vary the angle of the lighting. A large north-facing window is best since it will not be subjected to direct sunlight and its illumination will tend to be more constant. The larger the window the softer and more even are the effects obtainable. Diffusing material, like frosted plastic sheeting, tracing paper or fine-mesh net curtains, can be used to make the window light softer still if required.

The softest lighting quality will be obtained when the subject is facing the camera with the window behind it. In this position the shadows will be minimal. As the subject and camera are rotated away from this position the lighting will become progressively more direc-

Opposite, top A dark murky morning with a low mist lying on the fells created the quality in this landscape taken on Hardknott pass in Cumbria. I used a 28mm wide-angle lens on a Nikon F3 fitted with an 81C filter to add warmth to the image and a neutral graduate to retain some tone in the sky. The film was Fuji's ISO 50 and the exposure bracketed in the region of 1/4 sec at an aperture of f11 for sufficient depth of field; the camera was mounted on a tripod

Opposite, below I used a pale-blue filter in this lake landscape to accentuate the blue cast created at dusk on an overcast day. It was shot on a Nikon F2 with a 105mm lens using Kodak's ISO 64 Ektachrome

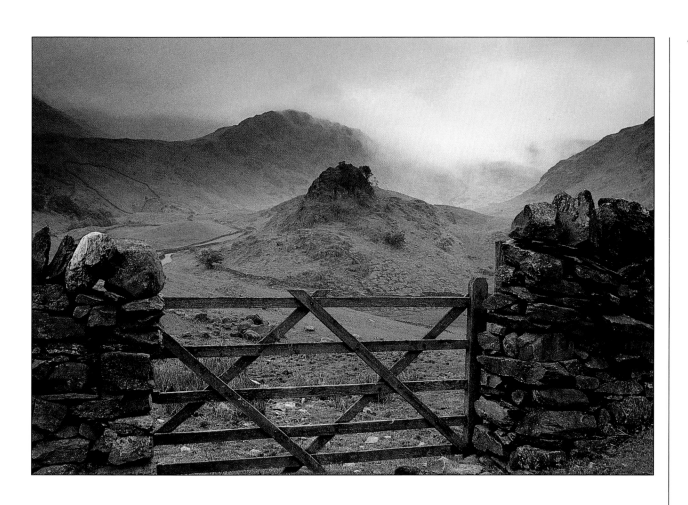

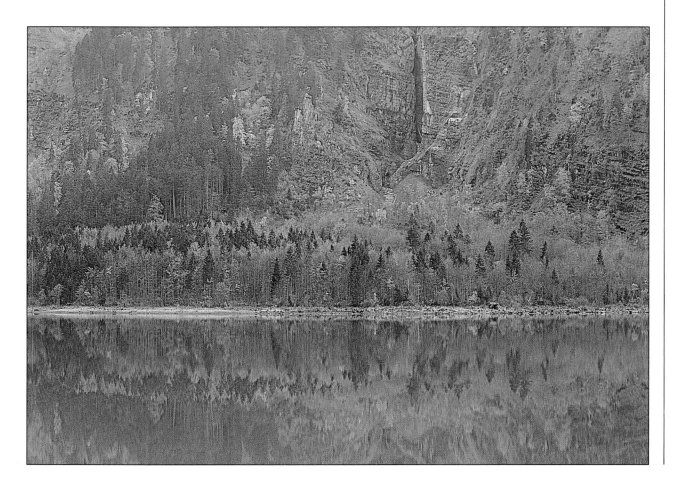

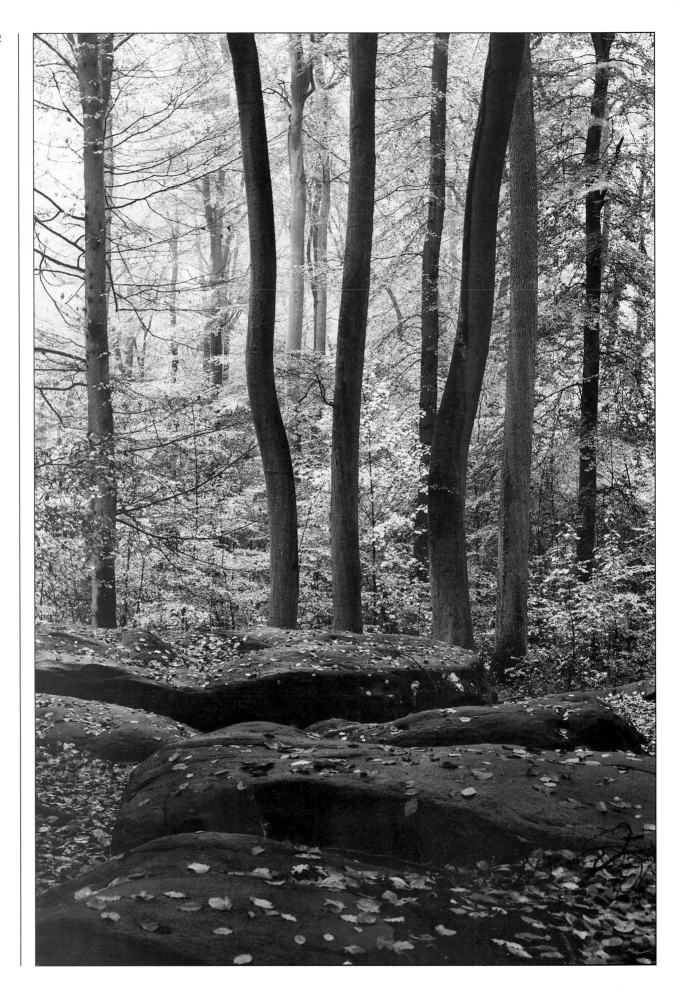

tional, with denser and more strongly defined shadows, until the window is at right angles to the line between subject and camera. As the subject is moved further away from the window the light will become harder with more defined and denser shadows.

Although it is a rather more cumbersome process than using, say, a large soft box with studio lighting equipment, it is possible to exercise a considerable degree of control over the quality and direction of window light. The shadows can be controlled by using white reflectors to bounce light back and reduce their density, or if higher contrast is wanted, a black-painted board can be used to make the shadows darker by excluding reflected light. If greater reduction of shadow density is needed than can be achieved by using reflectors, it is possible to use fill-in flash.

For small subjects, like still lifes and close-ups, an easily moved table-top surface is ideal, and it helps to have one which can be adjusted for height. With portraits or figure shots it is important to have a reasonably large area of moveable background which can be placed behind the model wherever he or she is needed in relation to the window. The most convenient types of background are cartridge-paper rolls which can be bought in a variety of colours up to 12ft wide and supported on tripod-base stands or spring-loaded poles in any position required.

Shooting in Low Light

Some of the more interesting and subtle images are created when the light level is very low, especially with colour photography. I remember driving through a valley in Lancashire on a dark dull day in winter when it was raining hard. The place seemed almost magical; the red-tinted dead bracken had an extraordinary intensity, and although I took some shots in the rain I decided to return when the weather had cleared. On the following day, in sunlight, the valley seemed quite ordinary and all the qualities which had been so appealing had disappeared.

One of the best reasons for using a tripod habitually is that very-low-light levels need not be an inhibiting factor provided the subject is static, as in landscapes and architecture. I often shoot pictures in conditions in which I need the light of a torch in order to see the camera settings.

If the light level is so low that the meter will not register a reading, the simplest solution is to set the film speed to a much higher number and then to adjust the exposure indicated by that factor. With a film of ISO 100, for instance, you could reset the meter to ISO 1000 and then simply give ten times the indicated exposure. Don't forget, however, to reset the film speed correctly after you have completed your low-light pictures.

At dawn and dusk the colour quality can be quite unusual, revealing shades of purple, lilac and magenta which are often not visible to the eye. Lighting conditions like these underline the need to be familiar with the characteristics of the film you are using, since there can often be quite marked differences in the way various brands and speeds of film react to such subtle hues.

These differences are compounded by the fact that films suffer from reciprocity failure when given significantly longer exposures than a second or two. With long exposures, film becomes effectively slower than its indicated speed and its response to the primary

Opposite The wide range of tones in this landscape, taken in the forest of Compiegne, was the result of a very soft light created on an overcast day in mist and rain. Bright sunlight would have created excessive contrast and destroyed the atmosphere of the picture. The negative was shot on Ilford XP2 which affords a good degree of control over the tonal range of subjects like this

Overleaf The lighting for this still life of the ingredients for the Calissons of Aix-en-Provence in France was provided by the window behind the arrangement. A white reflector was placed in front of the set-up to bounce some light back into the shadows. I used an 80mm lens on my Mamiya 645 with an exposure of 2 seconds at f16 on Fuji's ISO 100 film

Previous page This picture of a Sri Lankan craft worker was lit by a large window facing her and behind the camera. I used Kodak's High Speed Ektachrome in a Nikon FE2 with an exposure of 1/30 sec at f8 on a 50mm lens

Below The pale light just before sunrise created the colour quality in this picture of a mosque in Delhi. I used a 28mm perspective-control lens on my Nikon FE2 and bracketed around an exposure of 1/8 sec at f8 on Fuji's ISO 100 film. About one-third of a stop less than indicated proved to be the best

colours less balanced, thus creating a colour bias.

Recommended adjustments to exposure, and the filtration for long exposures, are provided with professional materials to aid accurate exposure and colour balance. With pictorial and creative photography, however, it is usually a question of simply knowing, and liking, how a particular type of film responds to low light levels and long exposures, and this is only achieved through regular use. In any event, the subtle effects created in these conditions mean that bracketing exposures is vital when using colour-transparency film. Even variations of just a third or a quarter of a stop can make significant differences to the quality and colour of an image.

When using shutter speeds of 30 seconds or more I find the easiest way to bracket exposures is to leave the aperture set at the selected f number and simply to vary the exposure time. With a reading of 30 seconds at f8, for instance, I would usually give exposures of 10, 15, 20, 30, 45 and 60 seconds.

When shooting pictures at times like dawn and dusk the sky is often the brightest part of the subject. It is important to ensure that it does not influence the exposure reading, since this would cause darker foreground details to be underexposed. In many cases a neutral graduated filter helps to retain detail and colour in the sky and allows more exposure to be given to record foreground details.

With moving subjects long exposures are not feasible and it becomes necessary to use a faster film in order to allow a shutter speed to be set which is fast enough to freeze the motion. Fast film has noticeably coarser grain structure, and the image quality and

definition is inferior to slow fine-grained films. However, with the right type of subject these factors often enhance the mood and quality of a photograph.

There is now a wide range of very fast films of ISO 1000 and more, available in 120 and 35mm formats for both colour negatives and transparencies. The latter can be push-processed to increase their stated speed by two stops or more if required.

Bracketing exposures is not an ideal option when shooting a moving subject, since Sod's Law dictates that the best composed shot is invariably either lighter or darker than you would have liked. The best solution in these circumstances is to shoot an entire roll of film on the subject at the same exposure and to make a clip test from the end frame or two. The processing time for the remainder of the roll can then be adjusted to give the precise density and colour quality required.

Daylight and the Time of Day

The quality of daylight varies enormously according to the time of day. This variation is most marked when the sun is not obscured by clouds, but even on a cloudy day both the colour quality and direction of light will be influenced by the sun's position in the day.

Perhaps the most significant change is that of the colour quality of sunlight in early morning and late afternoon, when the angle is at its most acute and the colour temperature is at its lowest. In landscape photography these times of day are valued for both effects. The low angle can create bold contours and textures, and the colour quality has a unique warmth and richness.

When I'm travelling on assignments I try to take maximum advantage of these times by placing myself in locations where the effects can be exploited fully. During the day, when I'm visiting loca-

Above The saturated colour of this strawberry was produced by the soft light of open shade and the use of Fuji's Velvia film. The background was a piece of slate covered in a sheen of water and I shot the picture on my Mamiya 645 with a 150mm lens and an extension tube; the exposure was 1/8 sec at f16

Above This landscape shot shows Mont Granier in France's Savoie Alps at about mid-afternoon in February. I used an 80mm lens on my Mamiya 645 with a polarising filter to increase the colour saturation of the sky and an 81 EF to add warmth to the image. I used Fuji's Velvia with an exposure of 1/30 at f8

tions, I try to visualise where the sun will be as it goes down and rises, and attempt to anticipate the effect it will create. Very often a subject or scene which appears dull or ordinary during the middle of the day is transformed into an exciting and atmospheric image just by waiting a few hours.

On those occasions where a subject is very important, and I want to produce as strong a picture as possible, I will spend the night close to the location so that I have the chance of two shots, late evening and early morning. Sometimes both times of day can work well, and on other occasions only one shot will work, but at least I have two bites of the cherry.

It might be thought that the warm cast of low-angled sunlight could be obtained just as effectively with a filter, but this is not so. Only those parts of the scene which are lit by the sun will have the warm cast, leaving the remainder neutral, or in some cases with a bluish cast. This can be far more interesting and atmospheric than the effect of a warm filter which throws the same colour cast over the whole of the image. The hard truth is that there is no real substitute for staying out late or getting up early.

Of course, the time of year also affects sunlight and the position at which the sun rises and sets is markedly different in the winter months from those of the summer months. The sun also remains at a much lower angle for all of the day during the winter months and, to a degree, the effects of early and late sunlight are extended at this time of the year. This is one reason why landscape photography in

Above The same scene about two hours later, just before the sun set. This shot needed an exposure of 1/15 sec at f8 without filters

particular can be more satisfying from late autumn through to early spring, with the added advantage that you don't have to get up nearly as early to shoot the sunrise!

My experience is that the warmth of early-morning light is usually less marked and lasts for less time than that at sunset; maybe there is a scientific explanation for this. For this reason, if I want to shoot at sunrise I like to be on the spot well before it is due to rise. There is a bonus in that the pre-dawn light can also be very atmospheric and interesting.

The effects of the time of day on sunlight are not just confined to landscape photography. The varying angle of light can, for instance, be crucial in architectural work where a particular viewpoint is only feasible at a certain time. Low-angled sunlight is also very effective in revealing the texture of stone work and, with old buildings especially, the warm cast of early or late sunlight can enhance the quality of mellow weathered walls.

Portrait, fashion and nude photographs are also influenced by the lighting quality at different times of the day. The overhead light of midday can produce a strong top-light effect, even with clouds, which causes unattractive shadows on faces and bodies. Location photographers shooting fashion or glamour photographs, for instance, will often plan their schedules so that models can take a break in the middle of the day, and work longer in the mornings and evenings. The warm colour quality of late and early sunlight can also be a bonus with subjects like nudes, swimwear and holiday-brochure

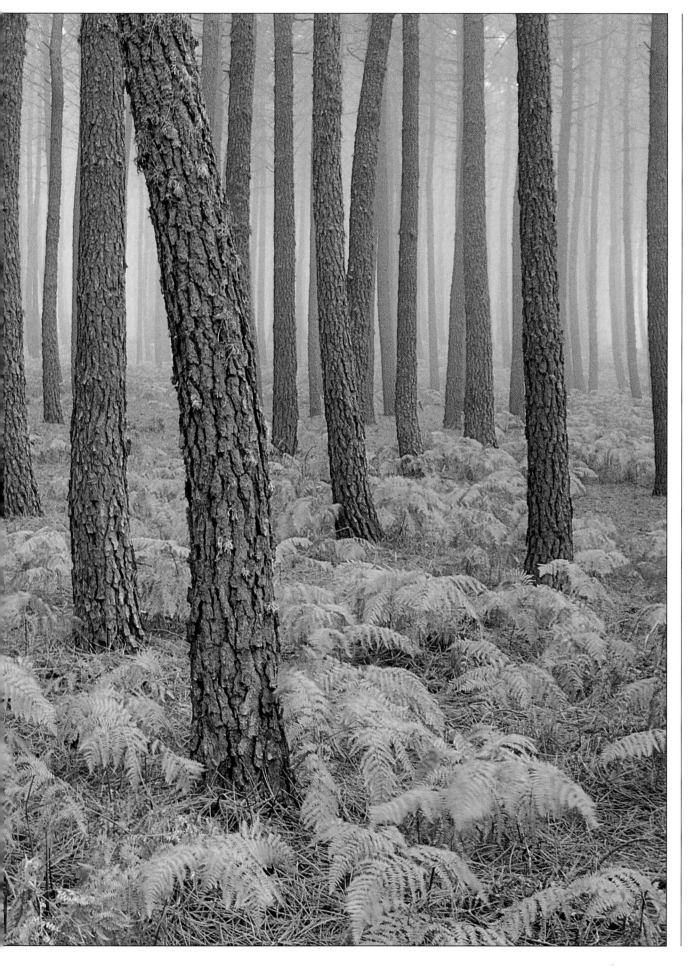

Previous page This shot, in Spain's Sierra de Gredos, was taken on a morning which looked hopeless, dense fog which made the car headlights necessary. I used a 35mm lens stopped down to f16 on my Nikon FE2 with an 81C filter and a tripod to allow the use of a slow shutter speed

pictures, since the effect of tanned bodies is greatly enhanced by these lighting conditions.

Daylight and the Weather

The complexities and nuances of daylight are also influenced considerably by aspects of the weather, in addition to those caused by clouds. Fog and mist are the most dramatic from a photographer's point of view, and are capable of creating images of exceptional beauty.

The borderline between the conditions in which photography is impossible, and those where interesting effects are created, is very subtle and unpredictable. I remember once driving into the Sierra de Gredos near Madrid when I could see little more than a car's length with my headlights full on, convinced that I would take no photographs until I could escape from the fog. A few minutes later, however, I took a great shot in the pine trees by the roadside which has since been reproduced numerous times. It was a picture entirely created by the fog, transforming a rather ordinary woodland scene into a subtle arrangement of shapes and colours.

One great advantage of mist is that it has the ability to simplify an image, removing or subduing background details and giving foreground objects more clarity in spite of the fact that the light is invariably very soft. Providing the foreground interest is quite close to the camera, pictures of this type can be taken successfully in a quite dense fog, especially if a wide-angle lens is used.

Mist can be very localised and it sometimes moves with surprising speed. Consequently it pays to allow time for pictures to develop and, if a potential subject is seen, waiting can be productive. The shots of woodland scenes, for instance, where sunshine filters through the branches of trees as shafts of light through the mist, are often taken during the fleeting moment before it clears completely.

Photographs taken in mist and fog generally have a much lower brightness range than normal, and this often means that a wider range of exposures can be used. A degree of overexposure, for instance, can create very soft high-key images in which all the tones and colours are at the lighter end of the scale; underexposure will produce pictures with a richer, more brooding quality.

In winter the effect of fog combined with a hard frost can be stunning. I drove through northern France one February while on a photographic trip, and for several mornings the landscape was covered in hoar frost with every single branch of entire forests covered with ice crystals.

Another very pleasing effect of mist is when you are able to climb above it and find a high viewpoint from which a distant view is partially shrouded. These effects are often best in the early morning or late evening, when a range of very subtle colours can be seen as well as the atmospheric effect of the lighting. Certain locations are often more prone to mist, and if you can find a good viewpoint overlooking one of these areas, a suitable weather forecast can make early rising well worthwhile.

Snow, of course, is well known for its pictorial potential, but here too light plays a crucial part. Bright sunshine with a blue sky, immediately after a heavy snowfall, often looks very beautiful but it sometimes looks almost too pretty. Remember as well that the brightness range on such days is very high indeed and, unless care is

Opposite The warm glow in this nude shot, taken in Ibiza, was the result of shooting just before the sun set. I used a 150mm lens on a rolleiflex SLX and the exposure was in the region of 1/60 at f11 on Kodak's EPR Ektachrome. I made a clip test from a complete roll shot on the same subject and pushed the remainder of the roll by about a third of a stop to obtain the desired density

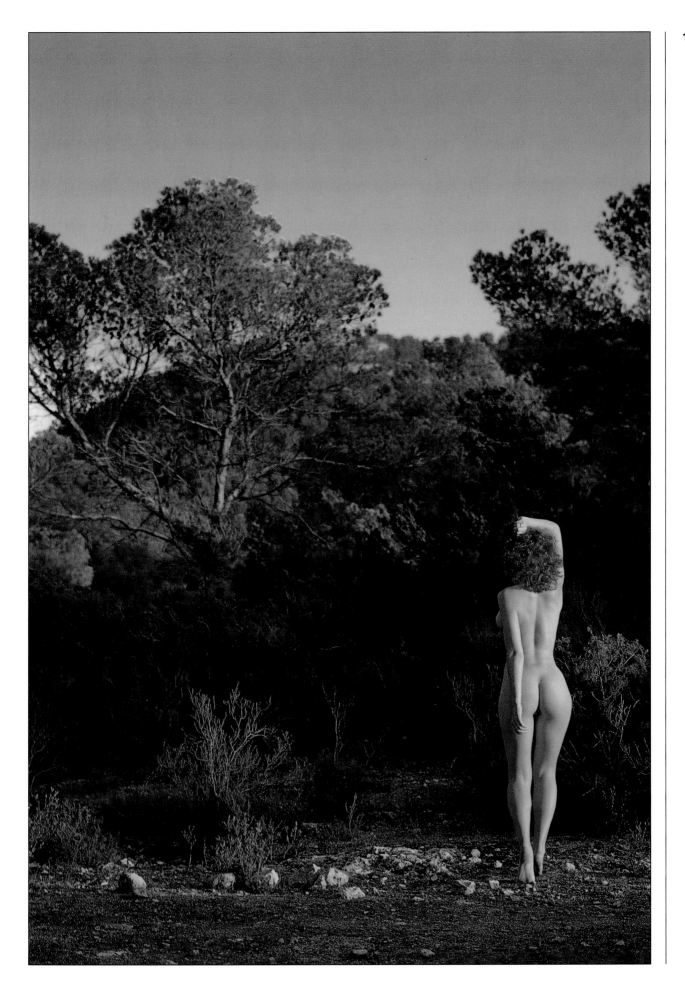

Above The harbour of New Orleans photographed just after sunset when the sky and water were still quite light and showed the shapes of the buildings and boats clearly. It was dark enough, however, for the lights to record quite brightly. An exposure of a second at f8 using Fuji ISO 100 film was needed with the camera mounted on a tripod

taken, normal exposures can result in extreme loss of detail.

The best solution lies in choosing a viewpoint which limits the area of highlight; shooting into the light can be very effective. Photographing early and late in the day, when the sun is at a lower angle, also helps to overcome this problem, as well as establishing an interesting colour quality when the warm light of low sun is combined with the blueish quality of a snowy landscape.

Snow on a dull overcast day, perhaps while it is still snowing, can often create bolder, more graphic images, transforming quite ordinary scenes into striking arrangements of patterns and shapes. Such conditions can be very effective in black-and-white photography, but for the colour photographer they also offer the intriguing potential of colour images which are *almost* pure black and white.

The question of filtration has to be addressed with colour photography in snow, since these conditions can give rise to a positive blue cast, especially in shadow areas on a sunny day with a blue sky. The standard advice is to use a warm filter in the 81 range. An 81C, for instance, will usually make blue shadows quite neutral, but in some instances a blue cast contributes to the cold mood of a subject and also produces a more striking colour image. I've sometimes shot pictures of this type both with and without filters, and often, although quite different, it's hard to decide which effect I like best.

Rain, too, can contribute to lighting effects. On a dull day, wet surfaces add contrast and sparkle to what might otherwise be a rather flat image. This can be exploited best in urban locations, where wet roads can make for bold reflections, especially at dusk when street lights and shop windows are illuminated.

Infra-red

While the photographic effects of ultra-violet light can only be exploited with artificial light in the studio, infra-red offers an interesting means of producing unusual and striking effects in outdoor photography.

Although infra-red wavelengths are not visible to the naked eye, they can be recorded on a special type of film. Many surfaces reflect the IR wavelengths, which are present in flash and tungsten as well as daylight, in ways which are quite different to those of visible light. Consequently, the results can be unpredictable: human skin, for instance, reflects IR light very strongly; so too does foliage.

Infra-red film was developed for use in aerial, medical and forensic photography, but it has very useful creative applications and is available from Kodak in both black and white and colour versions, and Konica in black and white only. Because the films are sensitive to visible light as well as IR, it is necessary to use filters to allow only the latter to pass. The correct IR filter for black-and-white film is opaque, so the image cannot be seen on the screen of an SLR when the filter is in place.

In practice, a deep-red filter has a very similar effect, and is easier and more convenient to use. The most striking effects of black-and-white IR film are that the green chlorophyll in foliage records as near-white, and blue skies as almost black.

The effective speed of the film depends very much upon the IR

Below Taken at the end of the afternoon in the early spring on the North Devon coast near Lynmouth, I used a polarising filter to increase the colour in the sea and sky and an 81C to add warmth to the image. The exposure was made on a Mamiya 645 camera with a 50mm lens stopped down to f16 to ensure adequate depth of field; the film was Fuji's Velvia

content of the light and the nature of the surface which reflects it, so it is necessary to bracket quite widely around the exposure indicated by using the nominal film speed. Quite often a rather dense negative will produce the most interesting results. The film tends to be quite grainy, and this can also add to the dramatic quality of the images. It is particularly vulnerable to fogging, and it is advisable to load and unload the camera in a darkroom.

Infra-red colour film can be quite spectacular since it responds to both visible light and IR wavelengths, and the colour sensitivity of each of the layers is quite different to that of ordinary colour-transparency film. A deep-yellow filter is necessary with this film, to counter its excessive sensitivity to blue and ultra-violet. Unfiltered exposures will produce a pronounced blue cast.

The most predictable qualities of the film are that foliage will record as red or magenta, reds as yellow and non-IR-reflecting surfaces as blue or purple. In landscape photography, these effects will vary widely according to the nature of the light, the time of year and the type of foliage. Further variations can be introduced by using different tints of filters in the yellow band of the spectrum. I've found the Cokin tobacco filter to have some especially interesting effects. Fairly wide bracketing is advisable and, as IR wavelengths have a slightly different point of focus to visible light, it is best to use a small aperture.

5 Daylight Techniques

Lighting for Portraits, Fashion and Glamour

Although a studio is considered to be an essential requirement for most professional photographers, a surprisingly high proportion of work for magazines, brochures, books and advertising is done on location.

There are sound reasons for this. One is that the studio environment is rather sterile, and creating atmosphere and interest in studio shots tends to be a time-consuming and expensive affair. Another is that both photographer and model usually find it easier to produce convincingly natural and relaxed photographs when working out of doors in an appropriate setting. Although, in principle, many shots taken outdoors could, in some ways, be more conveniently set up in a studio the results invariably have more atmosphere and spontaneity.

Backgrounds and Settings

Model photography in outdoor locations requires a considerable degree of planning and organisation if things are to run smoothly and the session is to be productive. Even with a simple head-and-shoulder portrait the setting, lighting and background need to be considered carefully to ensure a satisfying result.

Below These backlit rocks were photographed on the North Devon coastline using a Nikon F2 and a 35mm lens stopped down to f16 to obtain good depth of field. The film was Kodachrome 25 and I used an 81A filter to add a little warmth to the image. I used a close-up reading from a mid-tone in the rocks to calculate the exposure which was bracketed around 1/15 sec at f8

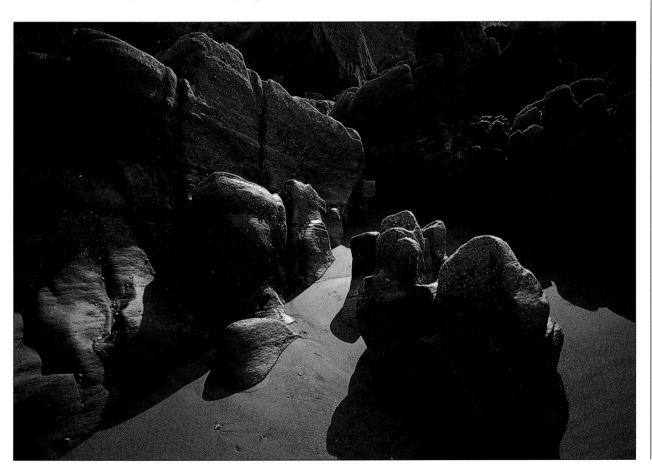

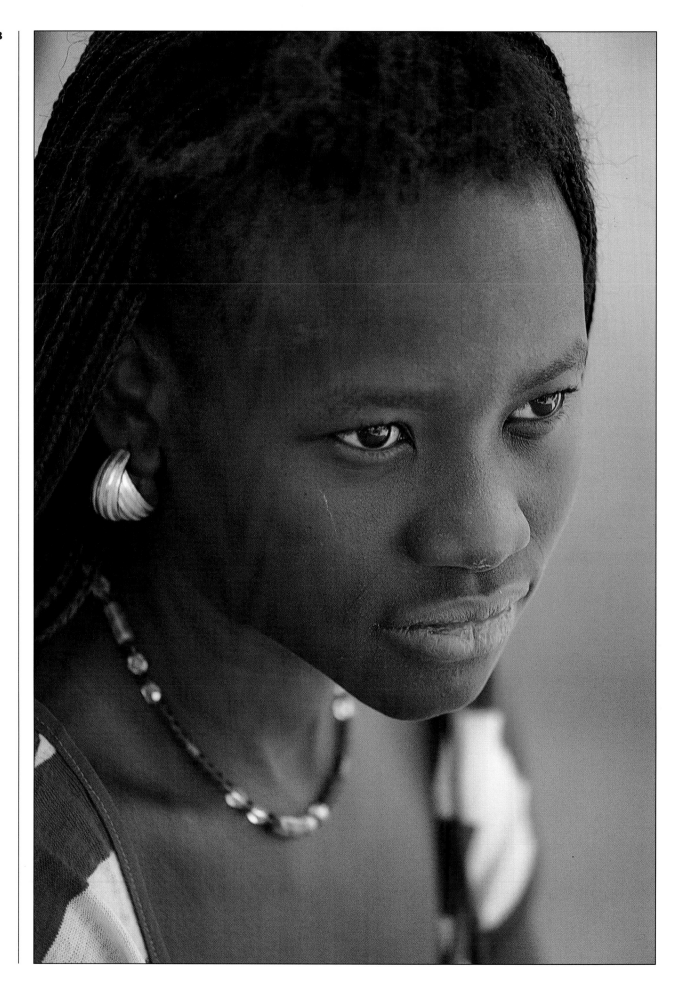

For anything other than a casual, informal portrait some form of reconnaissance is recommended to find a suitable location in which the background, lighting and surroundings can be chosen in advance of the session. Portrait photography depends a great deal upon a good rapport between model and photographer, and this can easily be disrupted by hesitancy, uncertainty or delays in getting the photography started. Even with the reportage style of portrait taken of strangers encountered while travelling, it is far better to consider the question of backgrounds and lighting before approaching a potential subject.

The setting is an important factor, because portraits taken outdoors can easily be spoiled by an inappropriate or fussy background. With quite-close-up head-and-shoulder portraits it is usually best if the background is unobtrusive, providing a degree of colour or tonal contrast with the subject. Lighting helps in this respect, since a light-toned background can be formed if the background area is lit more strongly than the subject. Conversely, a dark-toned background can be obtained by placing an area of shadow behind the model.

If it is difficult to avoid a potentially fussy or distracting background area, it is usually possible to subdue unwanted details by throwing them out of focus. Using a long-focus lens with a wideish aperture limits the depth of field and, providing there is sufficient distance between subject and background, such details will be recorded as a soft homogeneous blur. This effect can be a pleasing aspect of a photograph, and details like backlit foliage with strong highlights can make very effective backgrounds when kept well out of focus.

It is not always desirable, however, to have unobtrusive and indeterminate backgrounds. Sometimes the setting is an important part of the picture, adding an element of atmosphere, interest or meaning to the shot. Where such areas contain lots of detail, soft lighting is usually required since a profusion of shadows and highlights easily becomes a distracting element in a composition. So too can areas of colour. Even a small object, or detail of a strong contrasting colour in the background area, can set up a division of interest, drawing the viewer's attention away from the subject. For such pictures the choice of camera viewpoint, the model's position and the way the picture is framed, must be designed to ensure that background details create an harmonious and balanced composition in a way which allows the model to remain the focus of interest.

When choosing a location it is also necessary to consider the way in which the model will be positioned, since standing upright and unsupported can make it virtually impossible for the subject to be relaxed and to vary his, or her, pose to any degree.

For close-up, head-and-shoulder portraits it is most convenient for the model to be seated. This will allow them to use arms and hands, both as supports and compositional aids, and help them to feel more comfortable and relaxed. A seated model is also at a convenient height for the normal camera viewpoint, which, in most circumstances, needs to be just above the subject's eye level.

You can simply seat the model on the ground, or on a camera case, for instance, but it is worth taking along a suitable stool or chair if a lengthy or important session is planned. For three-quarter or full-length portraits it is usually necessary to choose the location

Opposite The soft light of open shade was used for this portrait of a young woman taken in a Gambian village. I used a 150mm lens on a Nikon FE2 using Fuji's ISO 100 film without a filter. I gave half a stop less than the meter indicated to avoid overexposing the dark skin and the exposure was 1/30 sec at f8 with the camera mounted on a tripod

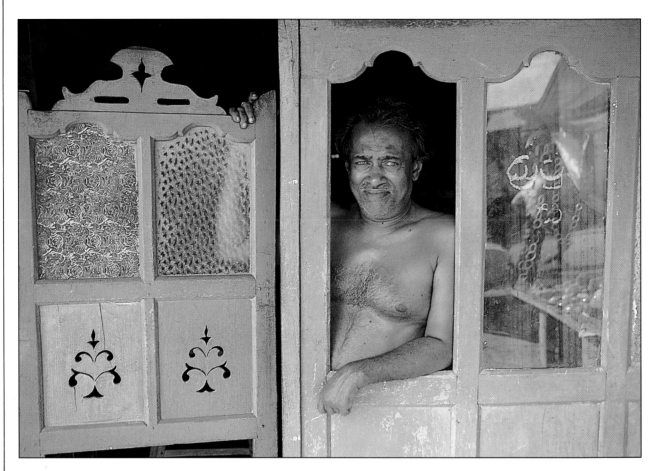

Above The Sri Lankan gentleman in this portrait was very willing to be photographed but I simply couldn't get him to adopt a more enthusiastic expression. However, I liked the setting and the colour quality so much I shot it anyway. I used a 75-150mm zoom on my Nikon FE2 somewhere in the middle of its range, and the film was Kodak's ISO 64 Ektachrome without a filter

Opposite I used a 250mm lens at a fairly wide aperture to obtain an out-of-focus background for this portrait. The model was backlit on a hazy day and I used a large white fabric reflector placed quite close to her to fill in the shadows. I took a close-up reading from her face to calculate the exposure using Kodak's EPR Ektachrome

with this consideration in mind, ensuring that some natural feature of the setting, like a wall or tree, can be used in this way.

Lighting

The lighting is also an important aspect of choosing a location since you must consider its direction and quality in relation to the background area and the model's position. Direct sunlight needs to be treated with the greatest caution since it can have very undesirable effects. With the sun behind the camera the model will often find it extremely uncomfortable to look into it, and will either resort to squinting or will make it necessary to take shots in short, sharp bursts.

Direct sunlight too can be very unflattering, creating dense shadows, limited modelling, poor tonal graduation and unattractive skin texture. Some subjects can, however, benefit from this type of lighting. Dark-skinned people, for instance, with weathered and lined features often produce striking photographs when lit quite harshly.

Glamour and swimwear photography at beach and pool-side locations are also subjects in which the quality of direct sunlight often contributes to the effect of a picture. Sunlight on tanned bodies produces very strong images, and in these cases techniques are often used to accentuate the skin texture. A light coating of oil, well rubbed in, often enhances the effect and helps to create a strong tactile quality, which is often accentuated further by spraying droplets of water on to the skin.

The richness of skin colour can also be effectively increased by the use of warm filters in the 81 range, and on occasions a polarising

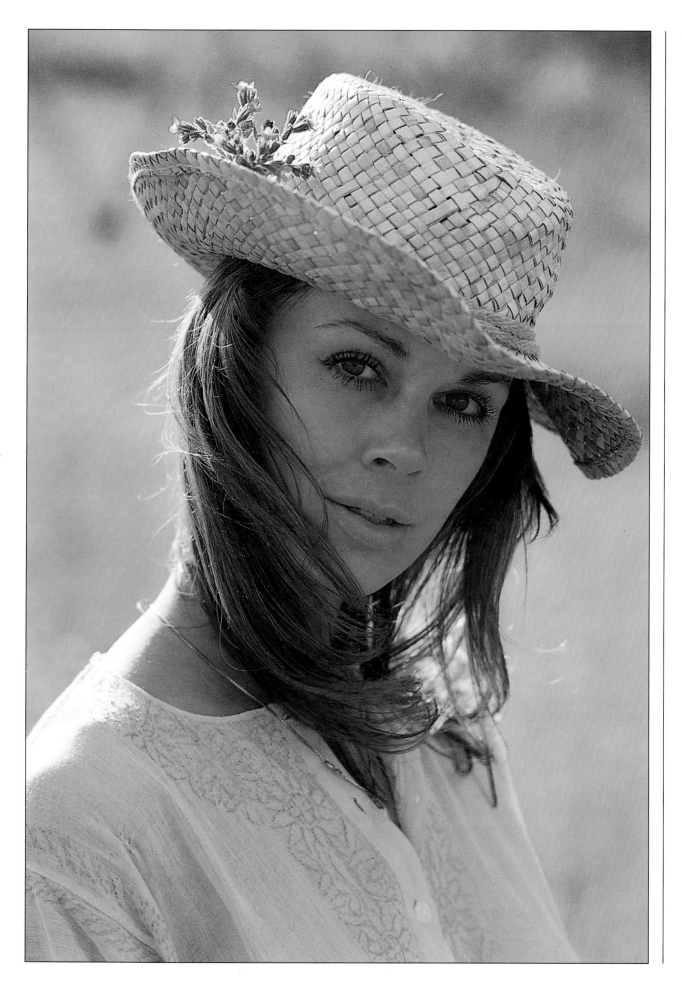

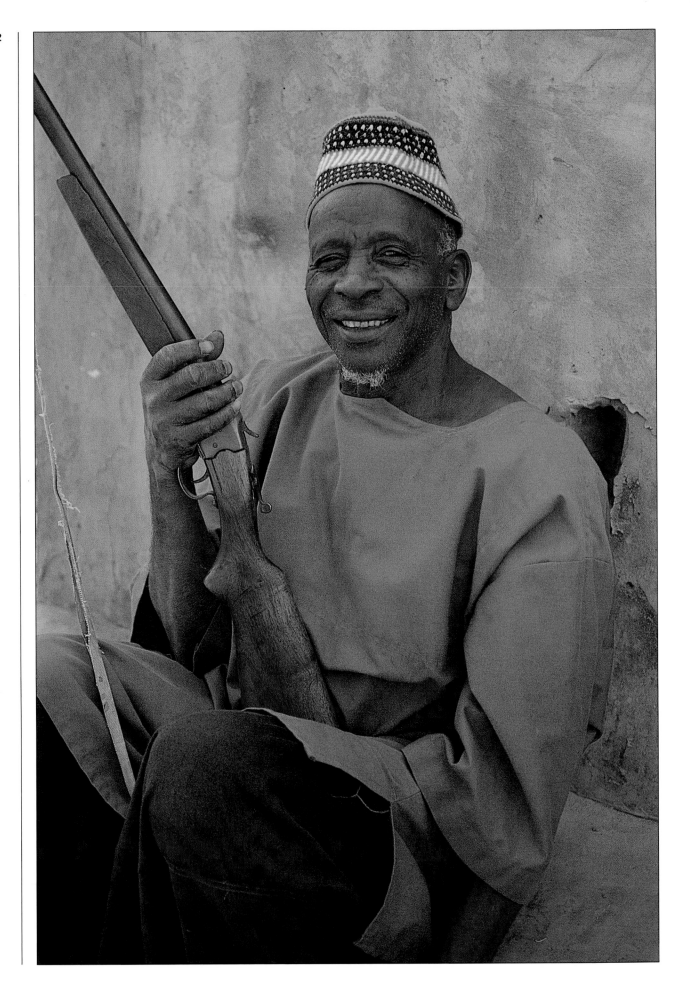

filter can be used to increase colour saturation. The natural warmth of early-morning and, especially, late-evening sunlight is particularly desirable for such photographs. The effect of skin texture and colour can be given even more emphasis by a degree of underexposure; sometimes a stop or less than indicated produces dramatically rich images.

Such lighting, however, means that both the camera viewpoint and the position of the model's head must be carefully controlled to ensure that the shadows formed do not produce unpleasant effects. Direct sunlight often produces a brightness range well in excess of the film's tolerance, and this means that exposures must be calculated to give detail in the most important areas.

With this type of portrait the lighter tones are usually the most crucial, since they will reveal the skin texture. The optimum exposure to record particulars will result in the shadow areas being very dark and lacking in detail, making their size and position even more important. Quite often the considerations of viewpoint and background mean that the model's pose and head position must be arranged to achieve the most pleasing effect of the shadows.

With light-skinned people, the contrast and shadows of direct sunlight are even more of a problem. The simple answer is not to use such lighting for portraits, but sometimes it is unavoidable. On other occasions the effect or atmosphere of a sunlit face is actually wanted, like an advertising shot for sun glasses, for example.

In these instances reflectors can be used to bounce light back into the shadows to reduce their density and to lower the image contrast. For fairly close-up shots, a strong-enough effect is possible by using a quite small reflector. Lastolite, for example, make a small circular white-nylon reflector which can be compacted to fit into a camera bag. In some cases natural features, like a white table top, a newspaper or a white wall, can be used effectively.

With photography used in advertising for cosmetics and beauty products the aim is often, as far as possible, to eliminate both shadows and skin texture. Reflectors are used on each side of the face and from underneath to counter shadows below the chin and in the eye sockets.

Where a longer shot is lit by direct sunlight, as in a full-length portrait, even a large reflector may be inadequate, simply because it may not be possible to place it close enough to the model without encroaching upon the picture area. Sometimes a large reflector is simply impractical. On many occasions, I've given up attempting to control a large fabric reflector when working in windy locations like a beach. In these cases, fill-in flash is necessary.

Fill-in Flash

For casual, informal portraits the small flashes built into many 35mm cameras have a fill-in flash programme which balances the light from the flash with that of the ambient light to give an acceptable result. Although flash on camera can provide a satisfactory image, it is not ideal. The effect cannot be controlled with such systems, and sometimes the fill-in is stronger or weaker than needed. In addition, direct flash creates a rather unnatural effect, and a more pleasing and less noticeable quality is obtained when the light is diffused by using a soft box or an umbrella reflector. It can also be an advantage to use the fill-in light from just to one side of the model, creating a

Opposite The rifle is a symbol of status for this headman of a Gambian village and a prized possession rather than an offensive weapon; having it in the shot helped him to relax and feel good. I used a 75-150mm zoom on a Nikon F3 at the wide end of the range and the film was Fuji's ISO 100 film with the camera mounted on a tripod for an exposure of 1/30 at f8 in open shade

Overleaf A lowish viewpoint enabled me to use the sky as a background for this portrait of a Rajasthani tribesman. I felt the harsh direct sunlight enhanced the weathered quality of his skin but had to be careful over choice of viewpoint and his head position to avoid unmanageable shadows. It was shot on a Nikon F3 with a 70-150mm zoom at the long end using Fuji's ISO 100 film with the camera mounted on a tripod

Previous page Light reflected from the sand provided a degree of fill-in for this spontaneous backlit beach portrait which was shot on a Nikon F2 with 105mm lens. I had no time for a close-up reading so gave one-and-a-half stops more than indicated by the meter using Kodachrome 64

Below The rich skin tones of this pool-side nude were partly the result of the model's good tan which was accentuated by the use of a polarising filter combined with a Wratten 81C. The skin texture was enhanced by a coating of oil with a scattering of water droplets and the blue pool background has increased the colour contrast

degree of modelling in preference to the flat effect of a frontal light.

Exposure calculation for fill-in flash should be designed simply to reduce the density of the shadows to an acceptable level, but not to eliminate them completely. The easiest method is to take a reading in the normal way to obtain an exposure for the daylight; let us say this is 1/60sec at f16.

The flash exposure is dependent upon its power, the aperture used and its distance from the subject. To avoid eliminating the shadows completely you will need to create a degree of underexposure by one or two stops, depending upon the effect required. This could be done in the above example by placing the flash gun at a distance where an aperture of f22 or f32 was needed for a correct exposure.

In practice, it is best to place the flash in the most convenient position and then to vary its output, or reduce its intensity with diffusers, until the required degree of underexposure is obtained. If the aperture required for the flash exposure is different to that of the original reading, the shutter speed must be adjusted accordingly to maintain the correct daylight exposure.

A Softer Light

On a sunny day a more pleasing quality of light can be obtained by placing the model in open shade. This method is often used for fashion photography, where the subtle textures and colours of

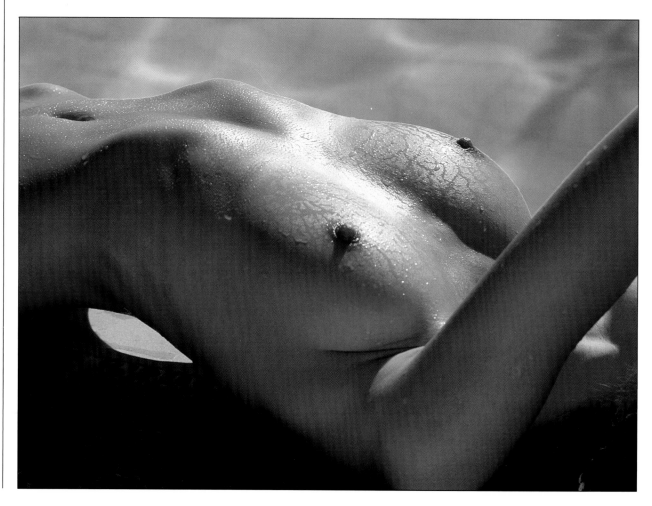

Previous page The soft frontal light and dark background for this model picture was obtained by placing her in an open doorway which provided open shade on a sunny day and eliminated excessive top light. I used a 150mm lens on a Pentax 6x7 camera and Kodak's EPR Ektachrome with an 81A filter to offset a potential blue cast. The camera was tripod-mounted to give an exposure of 1/30 at f8 from a close-up reading taken from the model's face

Opposite A Norman portable flash fitted with a soft box and placed almost at right-angles to the camera was used for this nude shot. I used a flash meter to calculate the correct aperture and set a faster shutter speed than the camera's meter indicated to create about two-and-a-half stops underexposure for the ambient light – which was quite bright daylight. I used a 150mm lens on a Rolleiflex SLX and shot a polaroid first to check both the lighting balance and exposure

fabrics can be lost in the harshness of direct sunlight. It might seem odd that photographers shooting for magazines and mail-order catalogues will often choose exotic sunny locations like the Caribbean for their assignments, and then shoot most of the pictures in the shade. But even in the shade sunlight tends to have a pleasing and quite distinctive quality, especially when it is reflected from white-washed Mediterranean walls and shaded by palm trees.

In cases where the required background and camera viewpoint make direct sunlight unavoidable, diffusers are often used to introduce a pool of local shade for the model. It is possible to buy large white 'location' umbrellas which create a large-enough area of shade to encompass a full-length figure.

Shooting into the light is another satisfactory way of dealing with the sunlight, and it can lead to very pleasing effects. However, this too can create excessive contrast, and either reflectors or fill-in flash might be necessary to reduce the brightness range. In addition, the use of soft-focus devices or diffusion or fog filters helps to reduce contrast, and they can give a particularly attractive atmosphere with backlighting.

A certain amount of cloud often improves the quality of sunlight. A clear blue sky, for example, can make for an unrelentingly harsh light, but the presence of a few white clouds can soften it significantly. Perhaps the most pleasing light for figure and portrait photography is that produced on a hazy day when cloud partly obscures the sun, but it may still be seen. In these conditions the light is directional with defined, but not excessively dense, shadows, creating a brightness range which is within the tolerance of the film.

An overcast sky, on the other hand, is not generally very satisfactory for figure photography. The main reason is that the light on such days is usually directed predominantly from above, the sky becoming effectively the light source. With both portraits and figure shots this can result in unattractive modelling, with shadows under the eyes and chin. Reflectors overcome this to a degree, as does a small amount of fill-in flash. One very effective solution is to position the model so that some, or all, of the top light is excluded: under a tree, for example, or in a doorway. Alternatively, a location umbrella or an opaque reflector can be positioned above the model's head.

Key-light Flash

There might also be low contrast and general lack of sparkle in the lighting on a cloudy or overcast day, especially when shooting in colour. Flash can be used in these situations, and not just simply as a fill-in. One technique in location portraiture which has been employed quite widely in recent years is the use of the flash as the key light, allowing the daylight to become the fill-in. Photographers like Terry O'Neil and Annie Liebowitz have made a trade mark of this technique.

The basic procedure is to set up the flash using a soft box or umbrella at an angle to the subject which ensures good modelling, and to calculate the aperture required for the correct flash exposure. The exposure for the daylight is then reduced by using a faster shutter speed than the exposure meter indicates. By setting the shutter speed to 1/125sec instead of 1/60, for instance, the daylight exposure would be reduced by one stop.

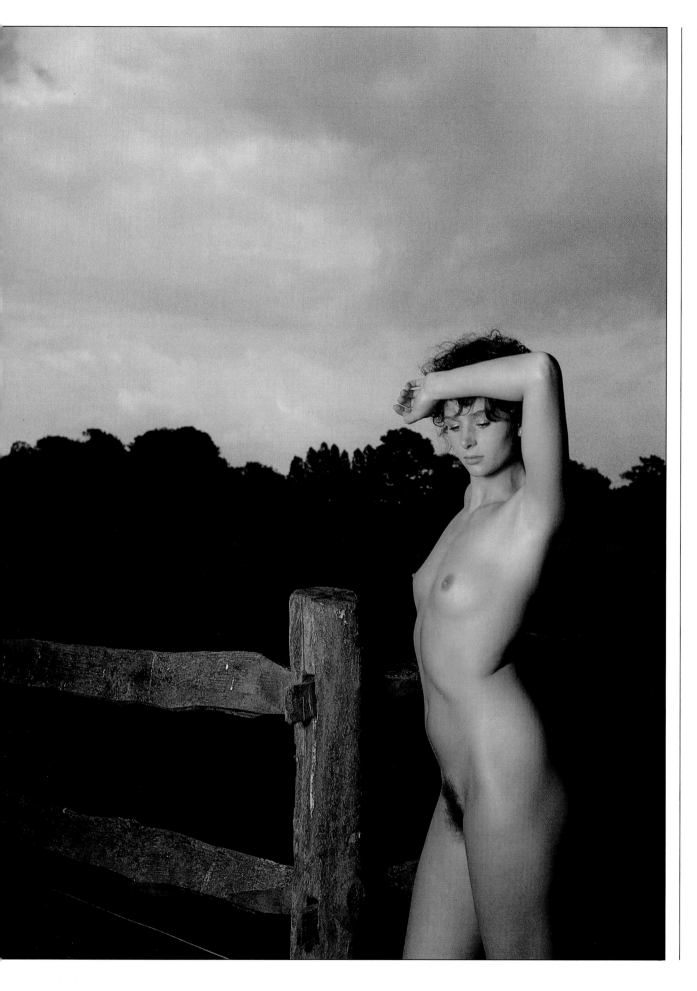

In practice, daylight exposure reductions of two or three stops are often used to create quite dramatic effects with darkened backgrounds and richly toned skies. This technique is easier to control if you use a camera with a between-lens shutter, like a Hasselblad 500C, since the flash will synchronise with all the shutter speeds. With many focal-plane shutters it is not possible to use shutter speeds faster than 1/60 or 1/125sec when using flash.

The dramatic impact of this type of lighting is further enhanced by using a second flash as back or rim lighting. There is also the possibility of using coloured filters over one or more flash units for further effect when shooting in colour. Flash can also sometimes be used fruitfully to illuminate the background, either to make it lighter or to create a colour cast through the use of filters.

Lighting for Landscape

There are two basic approaches to photography. One is that of the visualiser, a photographer who pre-plans his pictures, arranging the subject and the lighting in order to create an image he has in his mind, or has sketched on a layout pad. The second approach is that

Right For this portrait I used a white reflector placed close to the left of the little girl to throw light back into her shaded face, which was backlit on a hazy day. I increased the indicated reading by one stop for an exposure of 1/30 sec at f5.6 on 105mm lens fitted to my Nikon F2. The film was Kodak's ISO 64 Ektachrome

Opposite, top Taken in the evening sunlight, I liked the contrast between the shadowed parts of the building and the sunlit facade of Leeds Castle in Kent which this viewpoint provided. From the opposite side the building was fully lit but I felt this shot had more atmosphere

Opposite, below The viewpoint for this picture of St Cirq Lapopie in France is not hard to find as the shot was taken from the road which leads up to the village. I had to return, however, as on my visit earlier in the day the lighting was not very pleasing. This shot was taken in the late afternoon at the end of winter

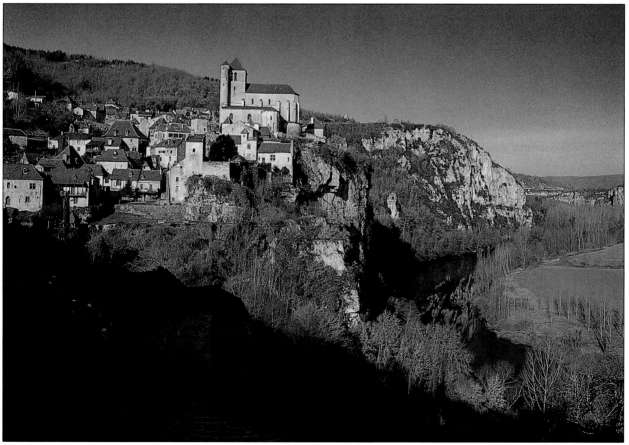

Above I used a 150mm lens fitted with a neutral graduate on my Mamiya 645 for this shot of the Dentelles de Montmirail in Provence. I found the viewpoint a day or so previously and thought that it might prove to be a good location for a sunset. Taken shortly after sunset in February, it also looked nice with the sun still in the sky but I preferred the softer effect of this shot. The film was Fuji's Velvia

of the seeker of pictures, one who looks for images and relies upon a combination of observation and good old plain luck for his results.

The first method of working is obligatory for many of the assignments undertaken by professional photographers for advertising, magazines and brochures. In many cases the initial idea for a picture emanates from an art director or a picture editor, and the photographer's main contribution is to use his skills to construct the photograph according to a detailed visual or brief.

In the high-budget world of advertising and glossy-magazine editorials the photographer often has considerable support from specialists like location searchers, home economists and stylists. With the basic composition already mapped out by the art director, the photographer's role becomes more akin to that of the cinema industry's lighting cameraman. Indeed, it is no coincidence that many top advertising photographers like David Bailey and Terence Donovan have extended their careers into making TV commercials.

While this approach is more commonly applied to subjects like food, fashion and product photography, it is also used where landscape subjects are needed for an illustration. Where an idealised or stylised image is needed to promote a product or an idea an advertising agency is unlikely to leave the outcome to chance. Often weeks are spent searching for a location which fulfils the requirements of a magic-marker visual, and sometimes a place is partially reconstructed if it doesn't quite fit.

A colleague told me of an assignment he once had where, having spent eight days looking for a suitable landscape in which to photograph a new car, a farm track had to be altered to look like a road by adding a section of tarmac, road-marking and bollards. The

existing road did not have the right outlook, and the lighting and background were unsatisfactory.

It is not possible to control lighting in landscape photography other than by choice of viewpoint and the time at which a shot is taken, although sometimes techniques like supplementary lighting, retouching and photo-montage can be used to alter an image. I was once victim to such a deception when a publisher showed me an advertising photograph of a Spanish castle which he thought would be an ideal subject for the jacket of a book he was publishing. It was a stunning picture, shot in the half-light, the castle was perched on a sombre grey-brown mountain with a rich-toned sky of similar colour and just the castle walls flooded with rose-pink light.

I imagined that it must have been shot either at very first light within minutes of the sunrise or at sunset. I found the viewpoint easily enough and set out at dawn on the following day. The sun rose well behind the castle leaving it completely silhouetted; it must be sunset I reasoned. But no, at this time of day the sun was behind the castle on the other side, leaving only a sliver of light down one edge.

I returned the next day at noon when I could see that the positions of the shadows were very close to the picture in the ad. However, at this time of day both the mountain and the castle were a flat khaki tone and the sky just plain blue, a very dull drab image. On looking again at the ad I was convinced that the photograph must have been taken around the middle of the day as I was now seeing it. The only way in which the quality of the photograph could be explained was that it had been shot in black and white, a print then made with extensive and heavy shading which was subsequently toned and the rose-pink light of sunrise applied with an air brush.

Above The landscape close to Puy Mary in France's Auvergne region was the location for this winter landscape taken towards the end of the day. I used a 150mm lens on my Mamiya 645 with a polarising filter to increase the colour saturation in the sky and hillside together with an 81C to add warmth to the image. The film was Fuji's ISO 50 and the exposure was bracketed around 1/15 sec at f11. This frame was about half-a-stop darker than the indicated exposure

Above Taken in the Darent valley in Kent near my home, this shot of poppies growing at the end of a wheatfield was one of many I've taken in the same valley through all the seasons and at all times of the day. I used a 55mm lens on my Mamiya 645 in conjunction with a polarising filter and an 81EF to increase the warmth and colour saturation of the image

Opposite Shot for an equestrian fashion feature, this picture was taken in the soft light of an overcast day. I used a 75-150mm zoom lens on my Nikon F3 at the shorter end of the range, the film was Ilford's FP4 and the exposure 1/60 sec at f8 with a tripod-mounted camera

Observing Light

As already mentioned, the other basic approach to photography is that adopted by the photographer who scans his surroundings for pictures, keeps his eyes peeled and tips his hat to Lady Luck for the best images. These are the circumstances under which most landscape photographs are taken, particularly those which are shot for personal satisfaction.

It's often occurred to me that many of my best pictures are those in which the element of luck has played a large role; a few minutes earlier or later and the picture would not have been there. Of course, good luck is vital in any venture but it's certainly something upon which you would be unwise to depend completely, especially if your livelihood depends upon it. It has been said that luck favours those who are well prepared, and the thought has particular pertinence in landscape photography.

The quality of the light and the nature of the countryside are inextricable elements of a good photograph. The most beautiful location will not produce a striking photograph if the light is not suitable, and the most dramatic light will not create a meaningful image if the subject it illuminates is not interesting. The skill which is most telling in landscape photography is the ability to see the relationship between the two and to be able to anticipate how one might best be used to exploit the other.

Like most landscape photographers I work very hard at ensuring that I have as much good luck as possible. I use maps, guide books, extensive research and a great deal of time and petrol to try to ensure that I'm at the right place at the right time for as many pictorial opportunities as possible.

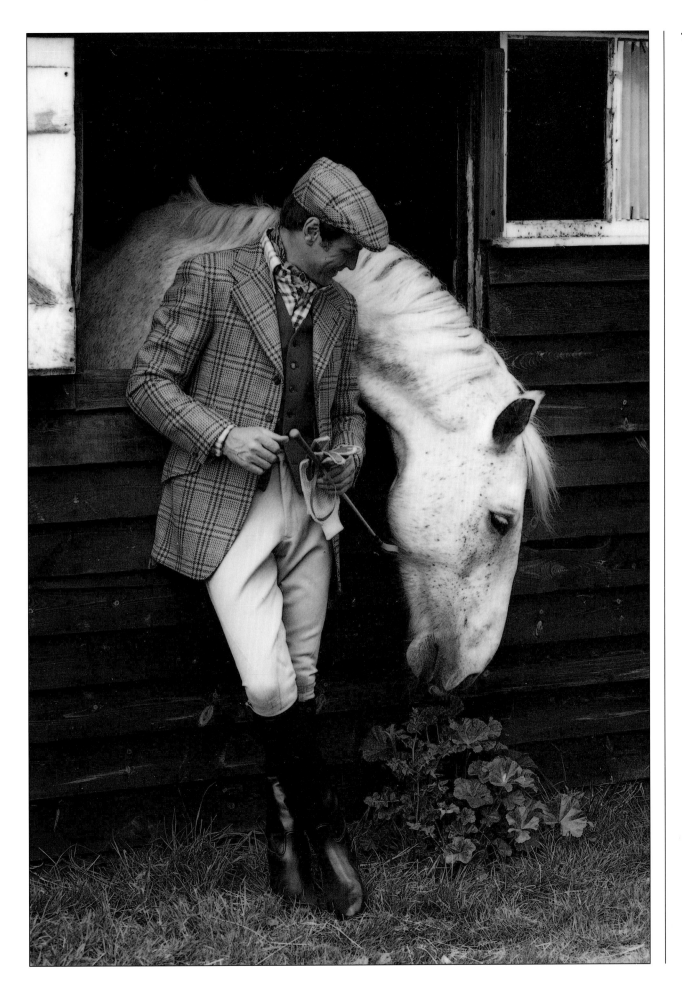

Opposite, top I used a polarising filter together with a neutral graduate to keep the bright sky within the range of the film and to ensure it retained tone and colour. I also used an 81EF for added warmth. The film was Fuji's Velvia in a Mamiya 645 fitted with a 150mm lens using exposures bracketed around 1/15 set at f11 on a tripod-mounted camera

Opposite, below It's odd in a way that this picture has proved to be popular with magazine editors since the famous mosaic roof of the Hospice de Beaune in Burgundy is obscured by snow. It goes to prove, I guess, that an unfamiliar view of a well-known place will always find a market somewhere. It was shot on a 24mm wide-angle lens on a Nikon F3 poked through the bars of a gate as the building was closed at the time

It helps a great deal to be familiar with the countryside you are photographing. At times when the light is poor I will carry out extensive reconnaissance trips looking for viewpoints and interesting features so that when the light improves I know exactly where to be.

I mark my map with highlight pens to indicate viewpoints and stretches of interesting countryside, trying to anticipate when the best time of day might be for a photograph. A lake facing to the west or an interestingly shaped tree silhouetted on a hill top, for instance, might provide an effective foreground if there is the possibility of sunset. A high viewpoint overlooking a furrowed field that could look striking when lit by early-morning sunlight, for example, or a vivid crop of sunflowers might look more interesting when the light was softer or at dusk.

In the same way, a particular type of light or change in the weather might suggest a location I've noted. A foggy morning might perhaps send me hurrying off to a viewpoint overlooking a river valley or to a forest. A stormy sky could remind me of a dramatic rocky landscape that didn't look right when the sky was blue. On a day when the sky is pale and hazy I would go to some high viewpoints I'd located so that I might shoot down and exclude the horizon.

Although on many occasions a potential picture is revealed because of a particular circumstance of the lighting, I find that locations seen in this way often turn out to have an inherent photogenic quality and can be returned to successfully on other occasions when the light is quite different, or at a different time of the year.

I have places to which I will return again and again over long periods of time. The resulting pictures are invariably quite different from each other, and often not recognisably of the same place. A while back I took a series of photographs over the period of a year to illustrate a book on the English landscape through the seasons. Although the photographs included most regions of the country, I evolved what I called my milk round, a circuit through the countryside around my home around which I would travel once a week to see how the landscape was changing. Many of the pictures used in the book were taken in this small pocket of countryside, and yet I doubt that anyone would know but for the captions.

Having a familiar landscape to which you can return at frequent intervals is an ideal way of developing the knack of recognising how a certain type of lighting must best be exploited, and when might be the most suitable time to visit a particular location.

The sky is a very important aspect of landscape photography, not least because it is a key to the lighting quality and can suggest the best basic approach to a day's shooting. A deep-blue sky, for instance, indicates good air quality and atmospheric clarity, making distant views and the use of long-focus lenses feasible. It also suggests that the lighting quality in the early morning and late afternoon may be especially effective.

A hazy or milky sky would make these possibilities less probable, and hint that closer subjects and those which contain bold elements of colour, shape and design would be more fruitful. A bright sky with large dark clouds is likely to create more dramatic and sombre images with pools of sunlight selectively illuminating the landscape, whereas a clear blue sky with white clouds is an ideal situation for shooting the type of pictures used in holiday brochures, calendars and postcards.

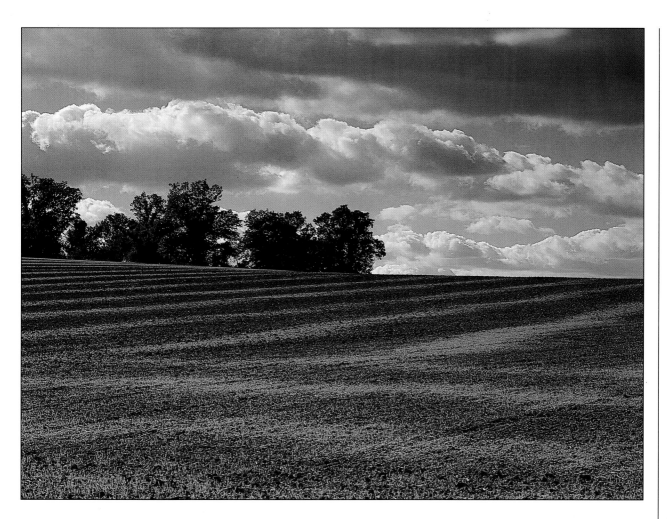

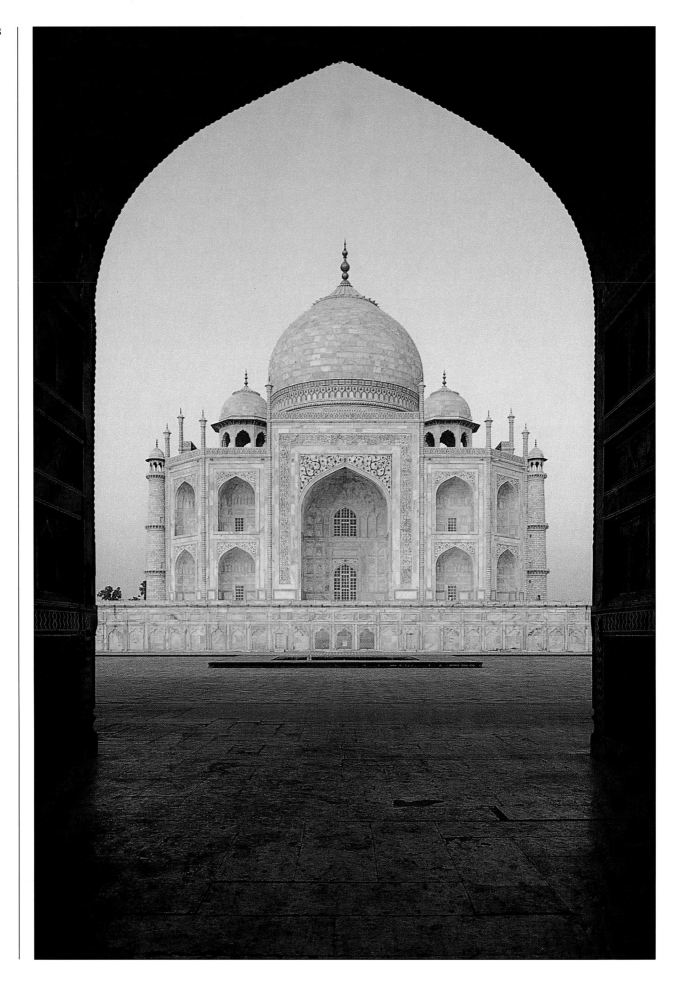

The Sky and Filters

The sky can also be a crucial element of composition, and can play an important role in conveying mood and atmosphere in a picture. In many cases its effect can be given more emphasis and quality by the introduction of filters. The colour saturation of a blue sky can often be increased and given a deeper tone when a polarising filter is used, although being neutral it will not alter the overall colour balance of the image. It requires an increase in exposure of between one-and-a-half and two stops but this can be measured in the normal way with a TTL metering system.

The effect of a polarising filter depends on the direction of the sun in relation to the area of sky included in the picture. In some cases it will have a very striking effect and in others none at all. There is a danger when using wide-angle lenses that a polariser will cause the sky to darken unevenly, and in these cases it is preferable to use a neutral graduated filter to produce a richer tone.

Although neutral in quality, in practice a polarising filter some-times makes an image appear rather cooler, and a more pleasing effect is often achieved by using a warm 81-series filter in conjunction with it. I frequently use a polariser in combination with an 81EF when shooting summer landscapes in the middle of the day to obtain more warmth and richness.

White clouds in a blue sky can be given much stronger relief by a polarising filter. An even more dramatic effect comes from using a neutral graduated filter in conjunction with a polariser, especially when the clouds are strongly illuminated. This technique is particu-

Opposite Famous landmarks are frequently difficult to photograph successfully because there are often so many people around to get in the way. One solution is to shoot early or late in the day when the crowds have disappeared. The added bonus is that the lighting quality can be more interesting, like this sunrise shot of the Taj Mahal. This viewpoint also is less familiar than that commonly used

Below Shooting at dusk is another way of dealing with untidy pictures caused by people and parked cars. This picture of the square in Lille was taken just after sunset on a winter's evening using a 35mm lens on a Nikon FE2 and tripod-supported exposures bracketed around 1/8 sec at f8 on Fuji's ISO 100 film

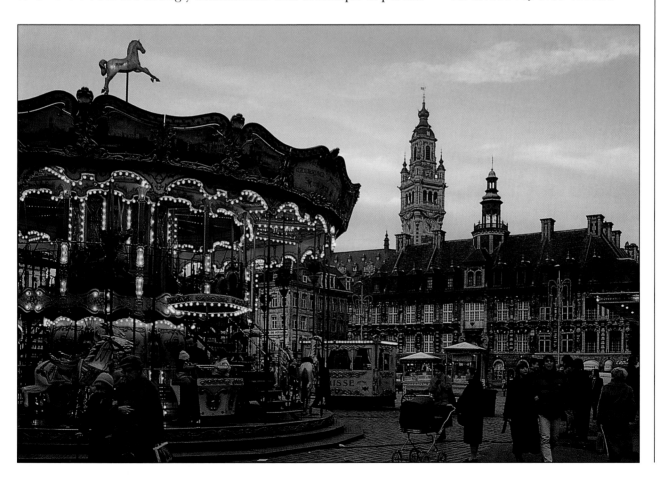

Above Early-morning sunlight has added both warmth and texture to the old stones of the fortified gateway at Domme, in the Dordogne. I used a 50mm PC lens on my Mamiya 645 to avoid tilting the camera and the resulting angled verticals. It was shot on Fuji's ISO 50 film with an exposure of 1/60 at f11

larly useful when the sky is rather pale, or when you are shooting into the light. With all filters, however, their effect is usually significantly stronger on the film than appears visually, and it is best to guard against over-filtering. You will obtain a more accurate impression of the film image by using an SLR viewfinder with the lens stopped down manually.

Neutral graduated filters enormously enhance the effect of dark stormy skies, and often quite dense versions are necessary. Exposure calculations need to be made with some care, as readings taken with a graduated filter in place tend to create overexposure. The best method is to take a reading from the foreground details without the filter, ensuring that all, or most, of the sky is excluded, and then use this setting with the filter in place.

Pictures of this type are often improved by a degree of underexposure, and it is wise, when shooting on transparency film, to bracket exposures. There is a risk when using wide-angle lenses, in particular, that the line of graduation becomes visible. It helps to judge the position of the filter by viewing the image with the lens stopped down and adjusting it so that the line is lost among horizon details. Some filter manufacturers, especially those supplying the movie industry, make filters with more subtle graduations which can be more suitable with wide-angle lenses.

Lighting for Architecture

Photographing buildings presents a rather different set of problems from those encountered with landscape photography. The lighting angle tends to be far more critical for architectural work because the subject is usually closer to the camera, it has more pronounced and abrupt contours and the choice of viewpoints is far more limited. In sunlight, for instance, in the space of just an hour or so the sun's altered position in the sky can enormously affect the direction and quality of the lighting on a building.

Whereas in landscape photography the choice of viewpoint tends to be made in consideration of the direction and quality of the light, with buildings the viewpoint is often the deciding factor and the priority is reversed. The most crucial decision thus hinges on the time of day, or the conditions in which a shot is taken. This is particularly so in urban locations, when there is often a very limited choice of viewpoints. The time during which sunlight creates a pleasing effect from a particular viewpoint can sometimes be quite brief.

This is a major consideration in travel photography, when famous buildings and landmarks are the subject. When such pictures are of special importance it is advisable to plan schedules so that several visits can be made at different times. In some cases, early-morning sunlight gives a stunning image and noon light a disastrous one, and vice versa. For very important picture assignments I like to arrange things so that I have the chance of both evening and morning light. Postcards are often a good indication of the effects

Above This view of the Abbey church of Conques in France's Lot valley was lit by the glow in the sky after the sun had gone down below the horizon. I used a 150mm lens on my Mamiya 645 with an exposure of 1/15 sec at f8 and a 81B filter to add a little warmth to the image with Fuji's ISO 50 film

Overleaf The weak sunset of a February evening has created a pleasing colour quality in this East Sussex landscape. I used a 150mm lens on my Mamiya 645 camera with a neutral graduated filter to help retain colour and tone in the sky while allowing me to use a full exposure to obtain detail in the darker foreground. The film was Fuji's Velvia

possible from various viewpoints, and it is usually feasible to judge the time of day when they were taken, thus providing a useful short-cut to such decisions.

Unfortunately, the 'ideal' light in this context may lead to rather clichéd, bland images, and it is often the case that the photographs of well-known places which really capture the imagination are those taken in unusual or unexpected lighting conditions. Pictures taken at dusk, sunrise or in the rain, for instance, can transform the impression of even very-well-known buildings photographed from familiar viewpoints. I once took a shot of the Hospice de Beaune in the snow, and although the most famous feature of this Burgundy landmark, the gilded mosaic roof, was obscured, the photograph has been in steady demand simply because it presents an unfamiliar and interesting impression of a well-known building.

Weather conditions favourable for a striking sunrise or sunset can be useful for pictures of those buildings or structures – castles, bridges and so on – with interesting shapes and silhouettes.

In towns and cities the possibilities afforded by mixed lighting at dusk or at night can also be exploited to produce pictures with a more unusual and theatrical colour quality. This type of lighting also helps to avoid the untidy nature of some urban scenes, allowing elements like parked cars and pedestrians to be shrouded in shadow.

With illuminated buildings, shooting at dusk can be a useful way of overcoming flat and uninteresting daylight caused by cloudy weather. It's best to shoot such pictures before it gets too dark, since

Below This detail of the doorway at the Abbey church of Conques in France was lit by the soft light of open shade. I used a 200mm lens on a Nikon FE2 to isolate a small section of the carvings with an exposure of 1/30 at f8 on Fuji's ISO 50 film and an 81B filter to add some warmth to the stone

the light remaining in the sky reveals the building's outline. Furthermore, its blue tone acts as an effective foil to the warmth of tungsten floodlighting when daylight-type film is used.

The mood created by light should also be considered in relation to the type of building being photographed. While a harsh midday sunlight and a deep-blue sky might look effective with, say, an angular modern building of mirrored glass and pre-cast concrete facades, the softer mellower light of evening or early morning is likely to establish a more sympathetic mood for an historic building of worn stone and classical lines.

Photographing a building in a way which shows its setting is often an effective means of introducing atmosphere. Here the considerations become closer to those encountered in landscape photography, but the camera position is still the most crucial decision. An effective method of finding a suitable distant viewpoint is to stand in front of the aspect of the building which you wish to photograph, and to look at the surroundings for potential viewpoints. In towns there might be the upper floors of other buildings, or in the countryside distant roads or hillsides for shots of subjects like castles or churches. A large-scale map and a pair of binoculars are very useful aids for this approach.

While sunlight is often a desirable quality for pictures showing a building in its entirety, and for more distant shots, a softer light can be more effective for close-up images of architectural features. The subtle textures of stone or wood, for instance, are lost in a hard directional light of bright highlights and dense shadows. Such

Below This interior of the casino in Baden Baden was photographed with available light using daylight-type film. The room was lit mainly by tungsten light with some daylight entering through the windows, but I decided to use daylight film as I felt that the resulting warm colour cast added to the atmosphere of the room

contrast can also be excessive with buildings containing highly reflective features like mirrored glass and chrome.

The softer light of an overcast day is also often preferable for interior shots where window light is used as the dominant source. Sunlight can make the brightness range excessively high and create very uneven lighting. Although in relatively small interiors artificial lighting can be used either exclusively, or to supplement daylight, a large area, like a cathedral for instance, needs to be lit predominantly by daylight. By choosing viewpoints and framing the image carefully it is possible to obtain evenly lit large interior spaces which would be impossible, or very difficult, to light artificially. It is necessary to exclude windows from the frame as much as possible, since they are likely to create flare. A tripod is essential for such pictures as long exposures will usually be needed.

Light as Subject

In the majority of photographs the lighting, although crucial, is usually subservient to the subject but there are occasions when it assumes a more dominant role and becomes the *raison d'être* of an image.

Perhaps the most obvious example of this is a sunset, in which the light source itself becomes the picture and other elements are chosen to complement it. A sunset is a very appealing subject and few photographers can resist the possibilities offered by a particularly striking one. However, a sunset alone, no matter how stunning, is unlikely to produce more than a superficially satisfying image.

The most telling use is perhaps when a silhouetted object with an interesting shape or outline is juxtaposed against the sun or sky. Indeed, if the prospect of a powerful sunset seems at all likely, it is well worth spending an hour or so before the deadline in order to find some really striking foreground interest which can be used in this way.

Pictures of the sun itself can be especially effective when a long-focus lens is used to create the effect of compressed perspective. In this way the sun is effectively magnified in relation to the foreground object, and when a distant viewpoint is used with a very-long-focus lens the juxtaposition of a large sun behind, say, the skeleton of a tree or a church spire, can be very powerful indeed.

The right conditions for such shots do not occur all that frequently, as the best results are usually obtained when the sun is quite close to the horizon and, ideally, partially masked by haze or mist. Under these circumstances the image can be exposed to show shape and colour in the sun, while allowing detail to be retained in the foreground interest. If a shot is taken when the sun is too strong, or too high in the sky, it will simply burn out and the image will lack subtlety.

With a stronger sun it is sometimes possible to obtain interesting effects by using a wide-angle lens which can create a starred effect; star-burst filters seldom have the same quality or appeal. This effect can also be exploited when the sun is reflected in a smooth surface such as a lake or the windows of a building. It often helps to choose a viewpoint which enables the sun to be partially obscured by details in the foreground, like foliage.

Unless the sun is very weak indeed it is necessary to take exposure readings which exclude it. This is equally true when the

Opposite The spray from the water and the partial obstruction of the horizon has weakened the sun just enough to make possible this shot of the Victoria Falls in Zimbabwe. A few minutes later it was far too bright to be able to include in the shot. I used a 28mm lens on a Nikon F3 with a neutral graduated filter to help reduce the brightness of the sun. The exposure reading was taken by angling the camera away to exclude the sun, and I bracketed about a stop each side choosing a frame which had the best compromise between shadow and highlight detail

Below I used a 300mm lens on my Mamiya 645 to shoot this winter landscape in Kent's Medway valley. The film was Fuji's Velvia and I bracketed the exposure around 1/15 sec at f11 using a tripod together with the camera's mirror lock and a remote-release to ensure the image was shake-free.

sun itself is obscured but the sky is very bright. An effective method in both cases is to take an exposure reading from the area of sky immediately above, or to one side of, the sun.

Often the most striking sunset images are obtained after the sun has gone down, when it leaves an afterglow in the sky. This is especially interesting when there are layers of cloud, as the effects often continue to change for up to an hour after the sunset. Such shots can often be combined with reflective foregrounds, like an expanse of water, to produce strikingly rich and colourful images.

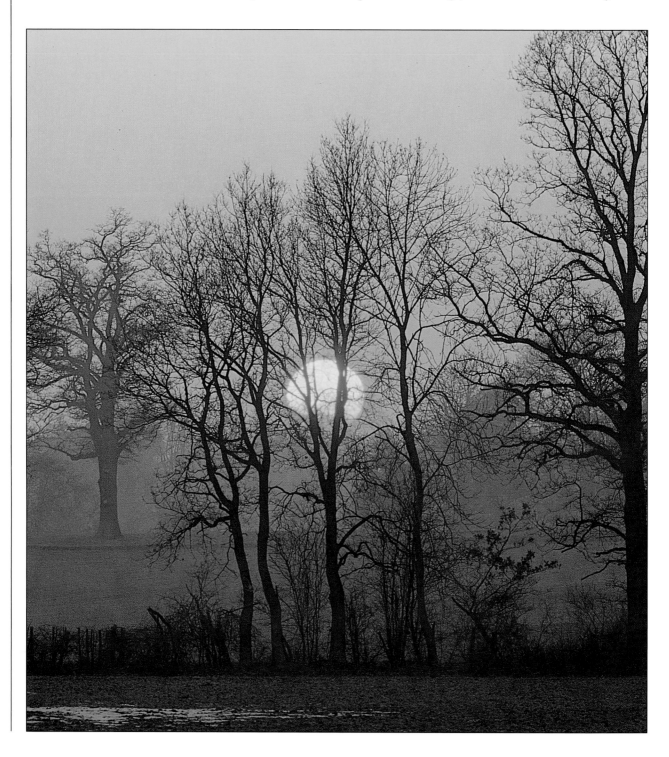

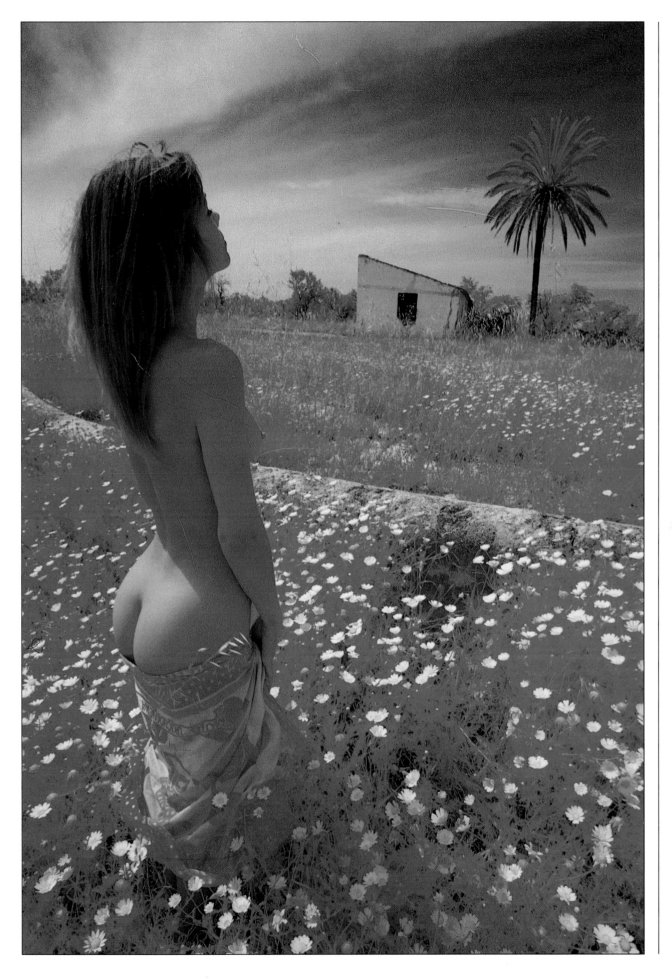

Index

Previous page The strange colours of this nude photograph were produced by shooting on Kodak's infra-red-transparency film using a Cokin Tobacco filter. I bracketed around the metered exposure and the frame with the most interesting effect was half a stop darker than the central exposure. I used a 35mm wide-angle lens on a Nikon F3